D1161759

VIVA HOLLYWOOD

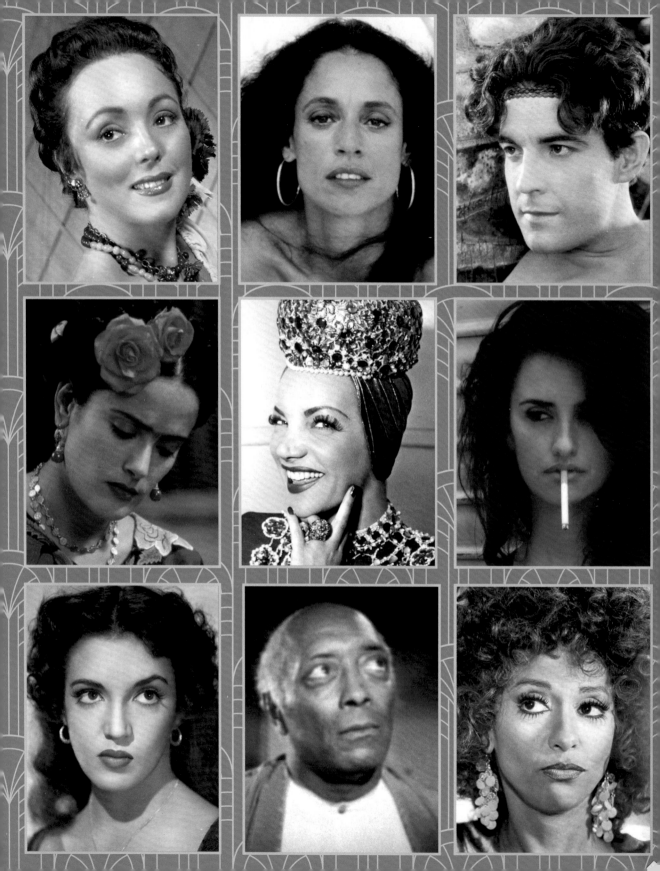

VIVA HOLLYWOOD

THE LEGACY OF LATIN AND HISPANIC
ARTISTS IN AMERICAN FILM

LUIS I. REYES

Running Press
PHILADELPHIA

Copyright © 2022 by Luis I. Reyes.

Hachette Book Group supports the right to free expression and the value of copyright. The purpose of copyright is to encourage writers and artists to produce the creative works that enrich our culture.

The scanning, uploading, and distribution of this book without permission is a theft of the author's intellectual property. If you would like permission to use material from the book (other than for review purposes), please contact permissions@hbgusa.com. Thank you for your support of the author's rights.

Running Press
Hachette Book Group
1290 Avenue of the Americas,
New York, NY 10104
www.runningpress.com
@Running_Press

Printed in Canada

First Edition: September 2022

Published by Running Press, an imprint of Perseus Books, LLC, a subsidiary of Hachette Book Group, Inc. The Running Press name and logo are trademarks of the Hachette Book Group.

The Hachette Speakers Bureau provides a wide range of authors for speaking events. To find out more, go to www.hachettespeakersbureau.com or call (866) 376-6591.

The publisher is not responsible for websites (or their content) that are not owned by the publisher.

Print book cover and interior design by Amanda Richmond.
All photos courtesy Turner Classic Movies and Luis Reyes Archives, with the following exceptions: page ix: photo by Timothy White, courtesy Carol Marshall; pages x, 81, 203: Satir Gonzalez; page 205, left: El Rey Network; page 239: Bel Hernandez/Latin Heat; page 256: MGM/Eon United Artist Releasing

Library of Congress Control Number: 2022936073

ISBNs: 978-0-7624-7848-4 (hardcover), 978-0-7624-7849-1 (ebook)

FRI

10 9 8 7 6 5 4 3 2 1

TO MY DAUGHTER
ARLINDA REYES AND
SON LUI REYES, WHO WILL
CARRY ON THE LEGACY.

Contents

Foreword by
JIMMY SMITS

I t's an honor to be asked to write the foreword for *Viva Hollywood* for several reasons, not the least of which is the fact its author, Luis I. Reyes, is a true Renaissance Man as well as a valued friend. We're both kids from the streets of New York and have a shared heritage. I believe that's helped to fuel our close bond. We're cut from the same cloth.

Luis and I have been tight ever since we met on the set of the comedy western *The Cisco Kid* back in 1994. He was the unit publicist. I played the Cisco Kid, one of the few Latin screen hero figures. Cisco always knew the value of publicity, so Luis and I got along famously.

Luis is many things in one: writer, author, film historian, movie publicist, and a chronicler of the Latinx experience in cinema. In interviewing so many Latin film pioneers over the decades, like Rita Moreno, Anthony Quinn, Edward James Olmos, and so many others, he has become a pioneer himself.

One of the things that has always interested me about Luis is his extensive knowledge of

movie history, born of an early passion for the arts and cinema that he translated into a lifelong career in the film industry. I also came to discover that Luis was an expert in understanding the Latino experience in the film and TV world. He first proposed writing a book about it in 1990 and was told in no uncertain terms that there wasn't enough of a history there to fill a book. But Luis knew that the legacy was a rich one packed with stories and anecdotes well worth the world's attention. The resulting 500-page volume, *Hispanics in Hollywood*, gave a complete picture of the many contributions of Latinos in the industry. In persisting in his research, Luis helped to bridge the diversity

Jimmy Smits is an Emmy Award–winning actor best known for his work on television (*L.A. Law, NYPD Blue*), stage, and film (*Old Gringo, Mi Familia, In the Heights*), among many other roles. Photo by Timothy White.

gap during the period before multicultural awareness finally started to matter.

In *Viva Hollywood*, Luis superbly melds his love for film with the contributions of Americans of Latin descent who have positively impacted the tapestry of American movies. The book is informed by interviews with many well-known performers who have faced challenges and with determination crossed over into the mainstream: artists such as Cheech Marin, Jennifer Lopez, Antonio Banderas, Martin Sheen, and Salma Hayek. Luis himself has impacted the way Latin artists and creators are viewed throughout the industry. We may still be underrepresented in Hollywood—a fact that remains a sore subject in need of a reckoning—but with *Viva Hollywood*, Luis helps open the world's eyes to us as an artistic force. The book is another giant step toward shining a vivid spotlight on inclusion, stereotype-smashing, and transcendent talent in Hollywood cinema.

Introduction

I grew up in New York City's Upper West Side. As with many of my baby boomer generation, I watched movies in opulent movie palaces such as Radio City Music Hall or at a neighborhood movie house. And on that magical box called television. The movies would transport me from the mean streets and my family's tenement apartment to escapist adventures peopled with extraordinary characters.

I would watch movies like *The Comancheros* with John Wayne, *The Guns of Navarone* with Anthony Quinn, and sword and sandal epics like *Hercules* with Steve Reeves and the sultry Cuban dancer Chelo Alonso. Although my parents loved—and I was keenly aware of—the Spanish-speaking Mexican comedian Cantinflas, I preferred the wacky antics of Jerry Lewis.

Local television would offer The Million Dollar Movie, which would show black-and-white film classics like *King Kong* all week long, several times a day. There was usually a movie in the afternoon right after school before the evening news came on. I was mesmerized. When color television sets came into play, there was primetime NBC Saturday Night at the Movies, which showed relatively recent color films. I was transfixed by all the movie stars, but I particularly identified with those who looked and sounded somewhat like my Puerto Rican and Dominican family: the likes of Anthony Quinn, Burt Lancaster, Rafael Campos, José Ferrer, Desi Arnaz, Gilbert Roland, Woody Strode, Katy Jurado, Rita Moreno, and Raquel Welch. Yeah, Raquel Welch. Her roots are Bolivian, but let's be real:

Legendary classic Hollywood screen star Cesar Romero and author Luis I. Reyes in 1992.

no one quite looked like Raquel Welch, at least not in my neighborhood. Her famous poster—the one of her wearing an animal-skin bikini—hung on the wall of my tiny bedroom until I left for college.

After I graduated from the University of the Pacific in northern California, a move to Los Angeles to pursue a career in entertainment landed me at the Latinx actors' organization Nosotros, founded by Ricardo Montalban. At their annual star-studded gala awards ceremony to recognize Latino achievements, I had a chance to meet many of my screen favorites.

I quickly became aware that there was no written documentation recognizing the collaborative participation of Latinx artists in Hollywood. They had been largely overlooked or left out of film histories, even though trailblazing Hispanic and Latin artists have blasted through limitations imposed by Hollywood and society to provide entertaining movie portrayals, indelible images, and unforgettable cinematic moments for more than a century.

In the early days especially, some Latinos and Latinas working in film saw it all as a job, no different from a worker in a factory, which studios resembled, except that the product manufactured was movies. Like many of the generation who faced the challenges of the Great Depression and World War II, these artists were not sentimental and did not assign great importance to their screen work outside of making a living. Actors became associated with a certain kind of role, and some were satisfied

with it because it provided security. Others were not.

Those with higher artistic aspirations fought against being typecast and the stereotypical portrayals that were expected of them. One extra player in the 1990s described working on films as "storybooks come to life," while others like actress Donna Martell in a 2020 interview were more matter of fact: "If you were brunette, you played Mexican, and that was fine with me. I worked a lot." Actor Ricardo Montalban remembered the excitement of being signed to an MGM contract during the heyday of the studio system.

When I interviewed surviving pioneering artists so many years later, many of them were surprised that anyone was interested in the work they did. Few, if any, were aware of the broader implications of their screen careers. There was little consciousness for most of the first half of the twentieth century that films would last and take on greater cultural significance as an art form across future generations.

In 1981, I set about researching, archiving materials, and interviewing as many surviving film pioneers as possible, and this resulted in the publication of the 1995 book I coauthored with Peter Rubie, *Hispanics in Hollywood*, a film and television encyclopedia. Fast-forward twenty-seven years, and Turner Classic Movies and Running Press asked me to write a new lavishly illustrated salute to Hispanic and Latin film artists in *Viva Hollywood*. As you'll read, the book highlights the participation, struggles, and achievements of the major stars, unsung

players, and key behind-the-scenes figures in classic Hollywood and contemporary American theatrical feature films.

Much has changed in Hollywood and in American society in the intervening years, yet some things remain the same, and this book has given me a chance to take a new perspective on people and events of the past as seen from the present. Stereotypes and negative images persist in the form of drug cartel kingpins and an endless parade of beleaguered undocumented immigrants. Yet, social justice movements, enlightened perspectives, and authenticity have allowed access to diverse talent in a global media context. Latinx filmmakers in Hollywood are forging new narratives and challenging outdated ideas of identity.

The US Latinx population makes up 18.8 percent of the total population, or 60.6 million strong, according to the 2020 census. This group accounted for more than 21 percent of all movie tickets sold in the States in 2019, per the Motion Picture Association of America. The terminology has changed the landscape too. For purposes of the book, I use the term "Latinx" or "Latin" as a nonbinary and gender-neutral umbrella term for Americans of diverse Latin American descent, regardless of race and ethnicity. The term "American Latino" refers to Americans of Latin descent who were born and or raised from an early age in the US. "Hispanic" refers to individuals of Spanish descent. "Chicano" (male or female) is a term of self-identification by Mexican Americans in the Southwest who came of age in the '60s and '70s, who reclaim their US and Mexican collective experience. I also use the terms "Latino" and "Latina" in the masculine and feminine. Specific artists are identified by their background origin. Other artists historically identified as "Latin" because of their Romance-language European origins, whether French, Italian, or Greek, are not included. Television is not reflected unless there are major career overlaps. *Viva Hollywood* does not cover *all* the Latinx talent in Hollywood, as that would require a much more extensive book, so a few personal favorites may be missing.

Present-day screen stars represent a bridge to Hollywood's past, from pioneering Spanish-born silent screen idol Antonio Moreno to Antonio Banderas, from the woman described as the most beautiful to have graced the silver screen, Mexican Dolores del Rio, to Salma Hayek, and from Puerto Rican EGOT winner Rita Moreno to Jennifer Lopez.

These artists transcended stereotypes, opened doors, and serve as beacons of inspiration for future Latinx performers and the communities at large that they represented. These stars have earned a place in the collective memories of moviegoers and have played a large role in the cultural significance of Hollywood as it continues to evolve into a more inclusive, diverse, and visionary American cinema. I hope you will enjoy reading about their remarkable careers and noteworthy achievements in the pages of this book.

Luis I. Reyes
January 1, 2022

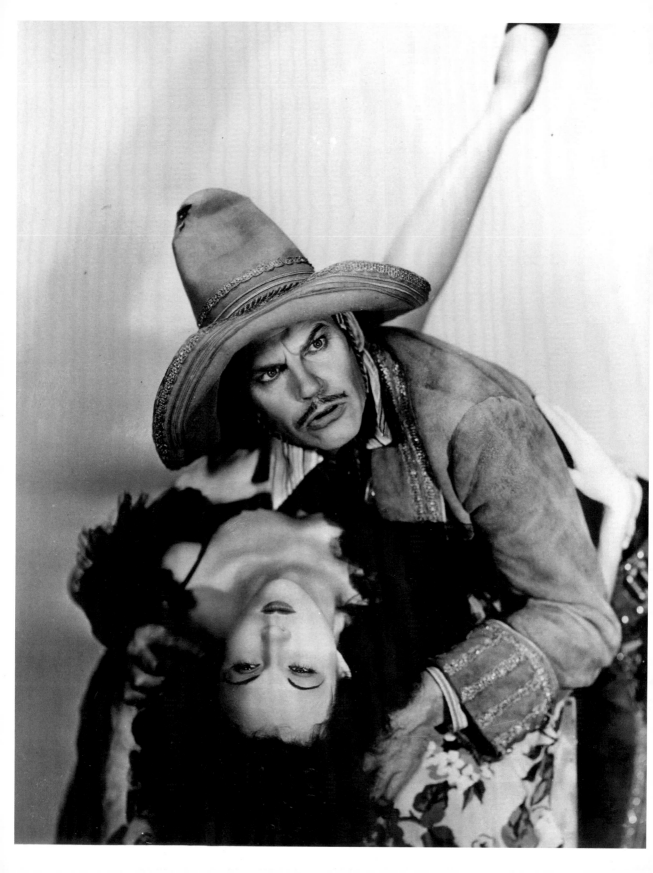

Latin and Hispanic Film Origins: How It All Began

Hollywood cinema has had a complicated relationship with race and ethnicity since its very beginning. That's long been the case with one of the largest and most influential populations in the United States, Americans of Latin descent, composed primarily of Mexican Americans, Puerto Ricans, Cuban Americans, and Central and South Americans. Since the earliest silent days, four all-too-familiar types have been associated with the Latino/Latina in film: the bandito, the Latin lover, the demure señorita, and the saucy spitfire.

Whether positive or negative, such iconography has certainly proved resilient and enduring. Hollywood also created and perpetuated nuanced variations of these stereotypes, among them the "greaser" and the dashing caballero. The caballero (which actually means "horseman") was a reference to the elite, aristocratic dons of the Spanish ranchos era.

Another archetype is the nurturing and long-suffering *mamacita* (mother figure). The Latin lover can be traced back to the folk legend of the Spanish seducer of women, Don Juan. Meanwhile his counterpart, the spitfire, is rooted in Prosper Mérimée's 1845 novella *Carmen* and its more famous Bizet opera iteration.

Bandido and señorita screen stereotype images circa the 1930s.

Douglas Fairbanks in 1920 brought to the screen the fictional Hispanic hero
of romantic Old California in the silent swashbuckler *The Mark of Zorro*.

And let's not forget the ubiquitous image of the lazy, simpleminded Mexican peasant slouched against a cactus, sleeping beneath his sombrero. Because of racist ideologies, social practices, and the Production Code, these images exemplified the vast majority of roles available to Latin actors. It wasn't until much later that Hollywood took advantage of their talent and creativity for a richer exploration of this group and its vibrant culture and history.

The western movie genre became the predominant source for these clichéd images, and for better or worse, they provided work opportunities. In films of the early twentieth century, when the movie industry was in its infancy, Mexican Americans found employment as background extras, playing supporting roles, or as wranglers and stunt players. Many of these were silent "greaser" films. As difficult as it may be for modern audiences to grasp it, the slur was often in the actual title.

Entertainment of this age capitalized on Americans' fears of Mexico, Mexicans, and Latinos in general. "Greaser" was a term stemming from ignorance and simmering intolerance; using it to refer to a non-Anglo or

lower-class individual affected how Latinos/ Latinas were perceived, individually and as a group. Many dime novels of the 1880s described an oily, swarthy villain or bandit who, more often than not, was Mexican or of mixed race. This originated from Mexican American laborers in the Southwest who used grease on their backs when unloading hides and cargo or axle wheels, and continued as a legacy of derogatory language that persisted for decades.

Motion pictures, of course, are a mixture of art and commerce that reflect the ideals, values, and biases of the society that produces them. The most popular misconceptions and stereotypes of Latinos and Latinas in the United States and elsewhere have roots that date back much further than the nineteenth century. For example, the sixteenth-century political and religious rivalry between England and Spain extended into the New World colonies that exploited the resources of the continent's Indigenous peoples. Spain established a settlement in St. Augustine, Florida, in 1565, the oldest city in what is now the United States. The Spanish colonizers developed an overland trade route from Mexico City to its northernmost province in Santa Fe, New Mexico. Both were founded long before the English settlements at Jamestown in 1607 and the arrival of the Pilgrims in 1620. As these civilizations collided, the Indigenous peoples of the Americas paid the greatest price.

After the American Revolution of 1776 and the creation of the United States from the thirteen English colonies, Mexico won its independence from Spain in 1821. Distrust and misunderstanding soon developed, creating an uneasy relationship between the United States, a homogeneous Anglo culture with expansionist ambitions, and Mexico, a mixed-race Spanish Mexican culture set on conserving its sovereign territories. The War of Texas Independence (1835–1836), the Mexican-American War (1846–1848), and the California gold rush (1849) contributed to deep-seated fears of and prejudices toward Mexicans and Mexican Americans among European Americans north of the border.

When Irish Catholic immigrants joined the predominantly Protestant US Army during the Mexican-American War, some found

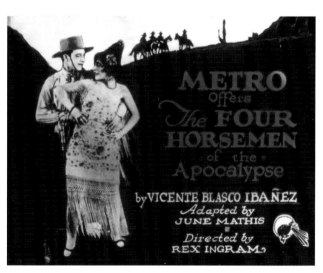

Dancer/actress Beatrice Dominguez, born and raised in San Bernardino, California, was immortalized on screen when she danced the Argentine Tango with Rudolph Valentino in the 1921 silent classic that made him a star, *The Four Horsemen of the Apocalypse*.

the discrimination so intolerable that they deserted and went south to join the opposing, predominantly Catholic Mexican forces. This led to the formation of a ragtag mini-army of Catholic soldiers known as the Saint Patrick's Battalion. These events form the basis of the film *One Man's Hero* (1999), starring Tom Berenger. The war ended with the signing of the 1848 Treaty of Guadalupe Hidalgo, and Mexico ceded in defeat 51 percent of its territory. The United States gained Mexican borderland provinces including California, Arizona, New Mexico, Nevada, Utah, and western Colorado, securing the westward expansion across the continent from the Atlantic to the Pacific Ocean. The increased dominance and authority of European American laws, language, and economic activities steadily marginalized a majority of Mexican Americans in those formerly Mexican provinces.

European Americans in the United States presented unflattering and rapacious images of Latinos/Latinas, particularly Mexicans, in newspaper editorials and political cartoons throughout the nineteenth century. Disparaging comments were published even in the

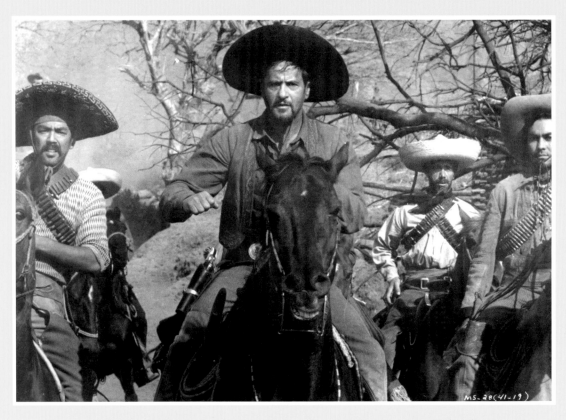

Eli Wallach (center) as Calvera leads his bandits in *The Magnificent Seven* (1960).

Western star John Wayne meets a beautiful Mexican señorita and her landed father in *The Man from Monterey* (1933).

Congressional Record. Many European American authors conveyed the prevailing attitudes, values, and ideas of Manifest Destiny, asserting the right of a conquering group to define others. They often wrote ignorant and negative commentaries about the Mexican American people they encountered, and this bigoted imagery carried over to the movie industry.

The adventure and romantic fiction popular in the late 1800s spun yarns of a wild American West peopled with—among others—cowboys, outlaws, bandits, and beautiful señoritas. These books were written for the masses, in clear and understandable prose that brought to life specific locations and peoples. Most of these writers had never been west of the Mississippi and drew from travel accounts, newspaper reports, and gossip.

They didn't just reinforce racist stereotypes; they created and perpetuated them. That general process continued for several generations.

The Spanish-American War of 1898 resulted in further imperialistic expansion of the United States when it acquired Puerto Rico, Guam, and the Philippines. The nation also submitted Cuba to its hegemony. It ushered in the era of President Theodore Roosevelt, the construction of the Panama Canal, and condescending white supremacist paternalism of politicians and the press toward "our little brown brothers." The "yellow journalism" practiced by the Hearst newspapers helped fuel misconceptions of our neighbors south of the border. The Mexican Revolution (1910–1920) fascinated and alarmed America, with a violent and bloody war so

close to its southern border. The American and world press was inflamed with sensational headlines that alternated between violence done to Americans in Mexico and along its northern border and a Robin Hood–like persona of the Mexican bandit turned revolutionary hero, Pancho Villa.

Drawing on earlier conventional ethnic types in newspapers, theater, literature, photography, and advertisements, the new medium of motion pictures perpetuated them and gave rise to new variants. The overriding negative images of Mexicans and Latinos in general in Hollywood motion pictures became a staple of its earliest western films. Simplistic morality plays of the nascent film industry like *The Great Train Robbery* (1903) had clear-cut heroes and villains, and they were extremely popular with audiences. The first makers of movies produced hundreds of westerns. They were made with minuscule budgets and turned huge profits domestically and worldwide. Early westerns left no doubt about who was the hero: the lone, tall, lean, independent cowboy, who became an iconic symbol of the American character. The image was personified by such early stars as Bronco Billy Anderson, Hoot Gibson, Harry Carey, and William S. Hart, to name just a few. Latins were more likely to appear in films with titles such as *The Greaser's Gauntlet* (1908) or *Bronco Billy and the Greaser* (1914). The greaser was a convenient villain stereotype who would get his comeuppance before the film's end from the "real American hero."

The burgeoning motion picture industry secured a living and a future for many Latinos and Latinas in and around Los Angeles by creating jobs and opportunities. Yet, racism and ignorance made it difficult for them to reach stellar heights in the industry. Early filmmakers were drawn to Los Angeles for several reasons, the most obvious being that the West Coast was far away from Thomas Edison's New York–based motion-picture patent agents. L.A. was also a nonunion town, so wages were lower than they were back East, and the workforce was made up primarily of Mexican and Asian American workers. Furthermore, films were made primarily outdoors in available light, so the perennial sunshine and warm weather allowed for year-round productivity.

The development of the movies from peep-show nickelodeons to simple photo plays (early twentieth-century proscenium-centered moving picture representations of stage plays) left mass audiences eager for more. Many were newly arrived immigrants, and they, like so many others, were receptive to the relatively sophisticated psychological impact of silent dramas by directors such as D. W. Griffith, Lois Weber, and Cecil B. DeMille. *In Old California*, directed by Griffith for the Biograph Company in 1910, was a significant Hollywood production about Latinos. This seventeen-minute-long period photo play about an aristocratic Spanish Mexican family played by Anglo actors coincided, conveniently, with a new romantic narrative about early California

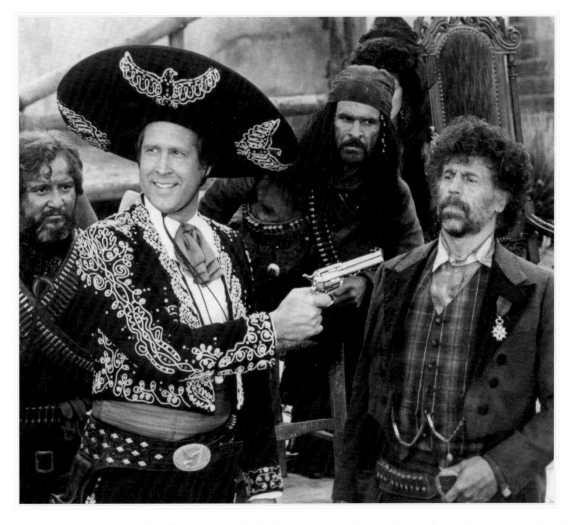

In the western comedy spoof *The Three Amigos* (1986), Chevy Chase as Dusty gets the drop on Alfonso Arau as bandit chieftain El Guapo. Observing are bandits (*left to right*) played by Jorje Cervera, Candy Castillo, and Tony Plana.

life. This was used to promote tourism and sell real estate, a utopian vision exemplified by labels emblazoned on agricultural products with lavish artistic renderings of beautiful, idealized señoritas with bounties of grapes and California-grown citrus fruits. Screen images of red-tiled adobe village backlot studio sets projected Mexico just waiting for gringos to bring law and order to an untamed mythic celluloid West.

The Motion Picture Production Code—sometimes known as the Hays Code—a set of moral standards instituted by the US film industry to regulate itself in 1930 (though not enforced until 1934)—forbade the on-screen mixing of the races in a romantic context. This put further career constraints on non-white performers. Mexican, Spanish, and South or Central Americans, were generally exempt,

however, because they were considered white in the official US census, despite the discrimination they, along with many immigrants from some countries of Europe, faced.

Hollywood projected an idealized image of America, often overlooking or reframing harsh realities. Many of the studio heads were eastern European immigrants who bought into the American Dream but knew nothing about the people and cultures already there. Indeed, throughout US cinema history, the contributions of many ethnic groups have been overlooked. A large portion of Hollywood's greatest filmmakers of the golden age were not American by birth. William Wyler (*The Best Years of Our Lives, Ben-Hur*), Billy Wilder (*Sunset Boulevard, Some Like It Hot*), and Fred Zinnemann (*High Noon, From Here to Eternity*) were German and Polish émigrés. Michael Curtiz (*Casablanca*) was Hungarian, Frank Capra (*It Happened One Night*) was Italian, Elia Kazan (*On the Waterfront*) was a Turkish-born Greek American immigrant. Famed cameraman James Wong Howe immigrated from China, and Anna May Wong was the first American-born Chinese film star. Sessue Hayakawa was the first Japanese émigré film star in Hollywood.

Oscar Micheaux was a pioneering African American filmmaker who, along with hundreds of performers, could showcase his talents only on restricted screens. Native Americans played a considerable role in Hollywood westerns but were relegated to background parts while Euro-American stars played the leading Indigenous

roles. Additionally, Indigenous people were routinely portrayed unrealistically—often as savages who threatened the white world. Similarly, many well-known screen actors and actresses changed their names to match the screen images created by the Hollywood dream factories and to distance themselves from their ethnicities. Margarita Cansino was transformed into Rita Hayworth, Julius Garfinkle was changed to John Garfield, and Luis Alonso attained fame as Gilbert Roland. Like many others, Latinos and Latinas were often forced to shed their ethnic identities to succeed in Hollywood. There just weren't very many parts for Latins playing Latins.

In addition to the dialogue-free background roles that provided films with atmosphere, Mexican Americans living in and around Los Angeles were called upon to portray Arabs, Jews, Pacific Islanders, and Native Americans in such features as D. W. Griffith's *The Birth of a Nation* (1915) and *Intolerance* (1916), Raoul Walsh's *The Thief of Bagdad* (1924), and the Rudolph Valentino vehicles *The Four Horsemen of the Apocalypse* (1921), *The Sheik* (1921), and *Blood and Sand* (1922).

When Douglas Fairbanks had difficulty finding extras for Arab roles in his *Thief of Bagdad*, director Raoul Walsh suggested going to the Mexican area of Los Angeles on a recruiting mission: "A dark-faced Mexican with a head-rag hiding everything except his eyes and nose and mouth will pass for an Arab any time."[1]

But even in this era, a few Latinos occasionally made it to the forefront of the

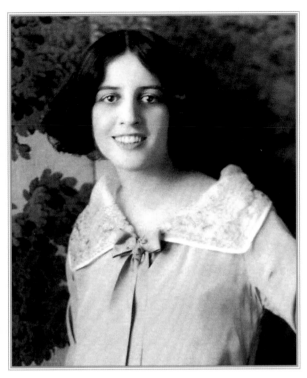

Myrtle Gonzalez, born in Los Angeles, appeared in more than eighty films between 1913 and 1917 and was one of Hollywood's first Latina film heroines.

industry as actors, directors, cinematographers, and other behind-the-scenes artists and craftsmen. Frank Padilla and Harry Vallejo (*Tarzan of the Apes*, 1918) were noted silent film cameramen, and Alan Garcia was a casting aide to Charlie Chaplin.

Meanwhile, Beatriz Michelena and Myrtle Gonzalez were among the first leading ladies of the silent screen. Born in New York City of Spanish descent, Michelena was an opera singer and stage actress who eventually starred in and produced her own films. From 1913 to 1920, she was the box-office star attraction for the California Motion Picture Company of San Francisco. One of Michelena's most popular and successful films was *Salomy Jane* (1914),

from a novella by celebrated California writer Bret Harte. Michelena played various leading characters in melodramas, but in spite of getting her start in the operatic theatrical tradition, she never created a larger-than-life screen persona. She served as an early role model to other rising stars of the time who took control of their images and careers, such as Theda Bara, "The Vamp."

Gonzalez was born in Los Angeles and studied voice and music. With her captivating eyes and enchanting smile, she was soon discovered and became an action heroine in outdoor adventures, many of which featured women in the leading roles. From 1913 to 1917, Gonzalez received star billing in eighty Vitagraph and Universal Pictures film shorts and features, including *The Heart of Bonita* (1916), *The Sage-Brush Gal* (1914), and *Captain Alvarez* (1914). Her career was tragically cut short at twenty-seven, when she fell ill and died in the devastating 1918 influenza pandemic.

Back when the motion picture industry was still open, there were no unions or craft disciplines, and opportunities were available to anyone who could do the job. Latins have been a vital part of the industry since this era. As the different production film entities out West in Hollywood grew larger, consolidated, and gradually unionized, social hierarchy and pressures took a stronger hold in the Hollywood community and industry that initially allowed regular—albeit restricted—opportunities for employment in the movies.

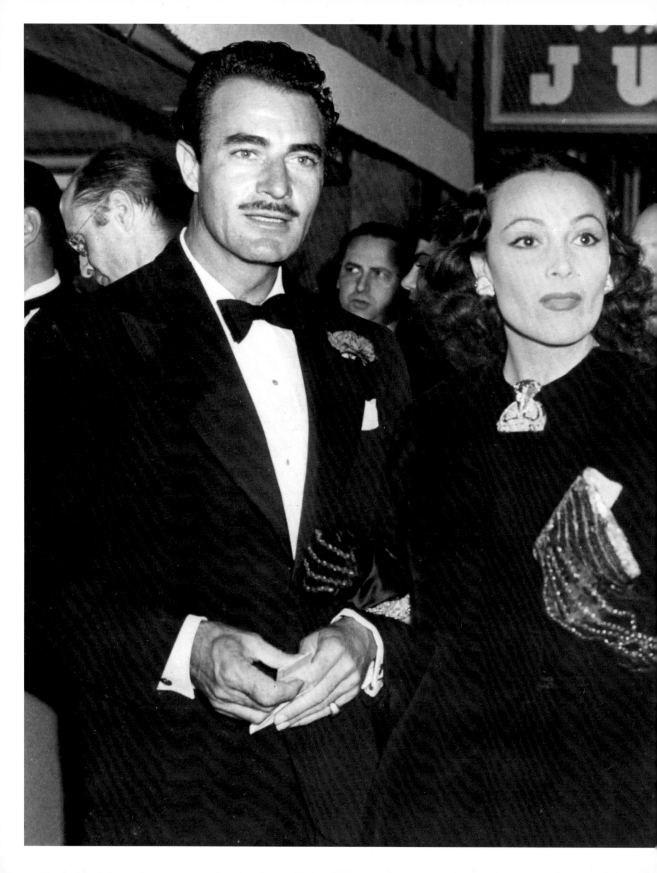

Matinee Idols, Latin Lovers, and Dancing Señoritas

An exceptional constellation of talented young Latin artists overcame geographical and metaphorical barriers at a remarkable time in history. Their journeys, individually and collectively, helped create and continue to transform the art and industry of Hollywood movies. They were pioneers.

When they began they were as young as the artistic and business universe they helped build. They were unique individuals, and their legacies remain a part of motion picture fact and lore. Antonio Moreno, Ramon Novarro, Dolores del Rio, Gilbert Roland, and Lupe Velez crossed oceans and international borders from their countries of origin, Spain and Mexico, to meet and thrive in Hollywood. With determination and a bit of luck they left their

mark on both silent and sound movies. They navigated their way along pathways of bias and ignorance to build long and successful careers.

Over time they earned enormous sums of money and enjoyed the glamorous Hollywood lifestyle as well as the adoration of movie fans the world over. As international celebrities, they lived in a bubble; sometimes for the better, occasionally for worse. They adapted to changes in culture and technology as others fell out of

Gilbert Roland is accompanied by Dolores del Rio to the 1939 Hollywood premiere of *Juarez* in which Roland has an important role as Colonel Lopez.

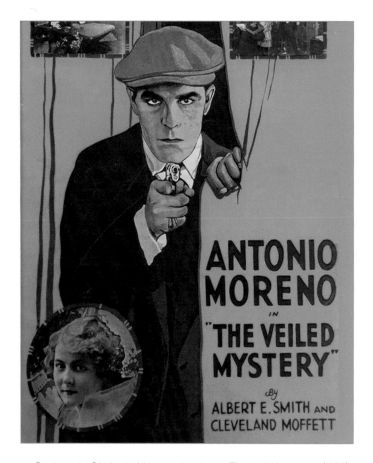

Poster art of Antonio Moreno starring in *The Veiled Mystery* (1920).

the race. Among the most significant of shifts was the transition from silent to sound cinema that took place from 1926 to 1930. *The Jazz Singer* (1927), with synchronized song and dialogue, ushered in the era of sound, which took off in leaps and bounds. Whereas voices never mattered before, suddenly actors with accented English faced limitations. Dolores del Rio did not even speak English at the time, but she was a quick study. A new star system emerged from audiences' vocal identification with certain screen individuals and types. Tenacity, talent, and perseverance characterized the individuals who triumphed over the microphone.

Antonio Moreno was a determined streetwise kid from Spain. Ramon Novarro, though a major star, succumbed to his inner turmoil. Dolores del Rio's ethereal beauty complemented her talent, and she empowered herself outside of Hollywood in the Mexican film industry. Gilbert Roland never forgot he was Luis Alonso, and the outrageous Lupe Velez was true to who she was and lived her life like a modern rock star. The pioneering work of these Latin performers set the stage for many talented men and women to come, artists such as the inimitable Rita Hayworth.

ANTONIO MORENO

Moreno emerged as the screen's first major Hispanic star in a Hollywood career that spanned almost five decades, from 1912 to his last important film appearance in director John Ford's *The Searchers* in 1956. He was born Antonio Garrido Monteagudo

in Barcelona, Spain. His father died at a young age and Antonio found himself a street urchin who had to rely on his wits and resourcefulness to survive, and he worked guiding tourists. With the help of US sponsors, he immigrated at age fourteen and went to school in Massachusetts. Moreno developed a passion for stage acting. After high school graduation, he joined a traveling theater troupe, winning the part of a young Spanish prince. It was a role that suited him to perfection, and the play *Two Women* made it to Broadway. Antonio Moreno was on his way.

Upon the advice of his acting colleagues, he tried his hand at "pictures," as movies were universally called then. He had the right photogenic look, and his Spanish accent would not be an impediment in silent movies. He landed minor roles in short films at the Biograph Company, located at the time in the Bronx. He can be seen as an extra in D. W. Griffith's *The Musketeers of Pig Alley* (1912) and

An Unseen Enemy (1912), which marked the film debut of soon-to-be screen stars Dorothy and Lillian Gish.

With his handsome features and strong physical carriage, leading roles soon followed for Moreno, often credited on screen as Anthony Moreno in his early films. Women swooned over his first screen appearance in *The Voice of Millions* (1912). After performing with such leading ladies as Mary Pickford, Blanche Sweet, and Dorothy and Lillian Gish, he migrated to Vitagraph Studios, where he became one of its more prominent stars. He then joined Pathe Pictures and costarred as a hero with Irene Castle and, most famously, with Pearl White in *The Perils of Pauline* (1914). While the film serial was short on action, it was smothered in melodramatic sentimentality.

Moving picture serials, or "chapter plays" comprised twelve to fifteen episodes, each fifteen to twenty minutes in duration, designed

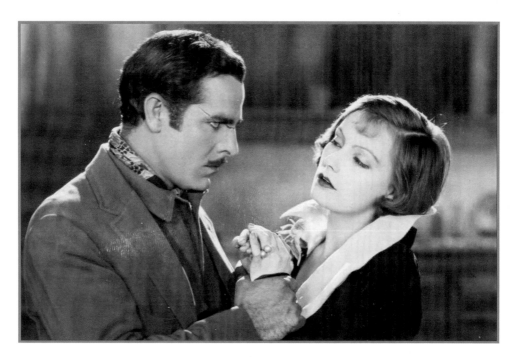

Greta Garbo and Antonio Moreno in *The Temptress* (1926).

to screen each successive week at a theater. Each chapter play would end with a hero or heroine in a precarious situation with little apparent chance of escape. Thus, the cliffhanger was born. Movie audiences were eager to return each week to see the problem resolved and to follow the continuing storyline. Moreno appeared in so many serials that he was dubbed the "king of the cliffhangers."

John Rance, Gentleman (1914) was a twenty-minute featurette in which Moreno portrayed a sea captain seduced and then abandoned by a wealthy married woman played by Norma Talmadge. His more notable films include *The Spanish Dancer* (1923), one of the first photographed by famed Chinese American cameraman James Wong Howe, and *The Trail of the Lonesome Pine* (1923).

Moreno was called a Latin lover during the craze set off by Rudolph Valentino, primarily because of his name and background; it had little to do with the parts he played. A list of his screen characters reveals overwhelmingly non-Hispanic names such as Cyrus Waltham, Ulysses Farragut, and Charles Adams, his Caucasian roles far outnumbering his Latin characters.

Moreno costarred opposite the already legendary Swedish MGM star Greta Garbo in her second silent US film, *The Temptress* (1926), in which she plays a woman who preys on men who cannot resist her charms. Moreno also starred with Clara Bow—better known as the "It" Girl—in the film that made her a household name, *It* (1927), a star vehicle with two appealing leads. In the film, a department store salesgirl, Betty Lou (Bow), sets her sights on her boss, Cyrus T. Waltham (Moreno), wins his heart, and then almost loses him. "Hot socks! The new

boss!" exclaims a salesclerk when the leading man enters the scene. "Sweet Santa Claus, give me him," sighs Betty Lou.

Moreno successfully transitioned to sound films in the early 1930s but not as a leading man. Gradually, he sank in the ranks as a supporting player and character actor. Forever resourceful, he sought new opportunities wherever they were presented. Because the attraction and mystique of Hollywood films spread worldwide, including to Latin America, during the transition, he starred in many Spanish-language versions of Hollywood films (MGM's *The Bad Man* / *El hombre malo*, *The Big House* / *El presidio*) and turned to directing. He went to Mexico and directed the first popular Mexican sound feature film, *Santa* (1932), starring Mexican actress Lupita Tovar, fresh from her success in the Spanish-language version of Universal's *Dracula* (1931). Moreno brought nearly twenty years of formative Hollywood filmmaking experience to his direction of *Santa*. The film— whose title means "saint," or "holy," in Spanish—is a melodrama about an innocent Mexican country girl (Tovar) who is seduced and abandoned by a soldier named Marcelino (played by Donald Reed, an Argentine actor who worked in Mexico and Hollywood). Alone and desperate, Santa's life begins to unravel, and she takes to prostitution to survive. *Santa*'s success in Mexico and throughout Latin America helped to establish the Mexican film industry. Moreno would go on to direct four feature films, both in Mexico and in Hollywood.

The multi-talented Moreno remained an influential figure in the pantheon of Latino actors. Years later, he coached Mexican actress Katy Jurado for her acclaimed Hollywood film debut in *High Noon* (1952). She portrayed Helen Ramirez, the strong-willed saloon keeper and former lover of Gary Cooper's Marshall Will Kane. Since, unbeknownst to director Fred Zinnemann and producer Stanley Kramer when they hired her for the Oscar-winning film, she did not speak a word of English, Moreno secretly helped her learn her dialogue phonetically.

As he matured, Moreno became a much in-demand supporting actor, with his distinguished silver fox looks and distinctive Spanish-accented voice. He appeared in such notable films as *Seven Sinners* (1940), alongside Marlene Dietrich and John Wayne, and *Captain from Castille* (1947)—an epic production filmed in Mexico—as Francisco De Vargas, the aristocratic Spanish father of Pedro De Vargas (played by Tyrone Power).

Crisis (1950), starring Cary Grant, reunited Moreno on screen with his silent film contemporaries Ramon Novarro and Gilbert Roland. Set in an unnamed South American country on the verge of revolution, *Crisis* features Grant as a brain surgeon facing a moral crisis when he performs a delicate operation to save the life of a brutal dictator, played by José Ferrer. Moreno made the most of his minor role as the dictator's personal physician.

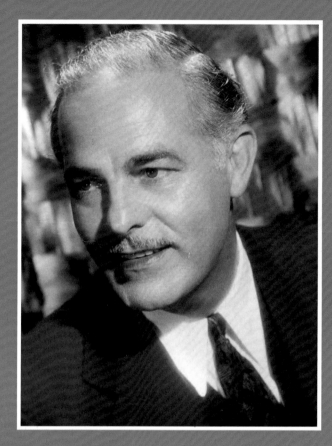

Antonio Moreno portrait, circa 1950, in his mature years
as a supporting character actor.

In Universal's horror classic *Creature from the Black Lagoon* (1954), Moreno portrays Dr. Carl Mala, a member of the scientific exploration team that sets out to find the rest of a fossilized skeleton in the Amazon rain forest. The team discovers a humanoid fish creature. The mystery and terror are set in motion. Shot in 3D, the film was a box-office hit whose popularity endures among horror fans, inspiring Mexican director Guillermo del Toro's Oscar-winning *The Shape of Water* (2017).

In John Ford's influential western *The Searchers*, Moreno portrayed the Mexican vaquero Emilio Figueroa, who leads John Wayne's Ethan Edwards to find Chief Scar and ultimately his abducted niece. The actor's last film appearance was a cameo in the seldom-seen low-budget *Catch Me If You Can* (1959), which was shot in Cuba and starred Gilbert Roland. Moreno died in 1967 in his Beverly Hills home, leaving an enduring legacy through his distinguished image and diverse body of work as the first male Latin film star in Hollywood.

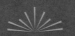

RAMON NOVARRO

I n a 1958 interview with George Pratt at the Eastman House, Ramon Novarro related what director F. W. Murnau told him at the height of his popularity: "Your value is you being you the way you are. Later on, you can become a great actor."

Mexican-born Novarro was one of the great leading men and top box-office stars of the silent and early sound films of the 1920s and 1930s. His winning screen persona was easygoing, exuberant, and boyishly handsome. As a Latin actor who was also gay, this icon broke numerous barriers. Although his homosexuality was zealously hidden from the filmgoing public by the big studios, it was an open secret in Hollywood. The actor had a long-term live-in relationship with journalist Herbert Howe, who later became his publicist. He was sold to the public as a great lover of women, when the reality was in sharp contrast with the screen figure.

Novarro was born José Ramón Gil Samaniego in Durango, Mexico, the eldest of eight children. His father was a dentist who provided a comfortable living, and young Ramón received music and singing lessons. The Samaniegos were aristocratic, prospering under the thirty-year rule of Porfirio Díaz, but found themselves in opposition to Pancho Villa. The family fled to Los Angeles, California, to escape the Mexican Revolution in 1914.

In Los Angeles, Ramón took any job he could find to help support the family. Work as a singing waiter led to an offer to tour the vaudeville circuit as a singer and dancer. Upon returning to Los Angeles, he worked as a nude model at an art school and as an extra in silent pictures. He played a bit role as a Mexican bandit in the western *The Jaguar's Claws* (1917), and appeared as an extra in *The Four Horsemen of the Apocalypse*, the film that made Rudolph Valentino a screen idol. The Italian star's rise marked the first time a darkly exotic foreigner would become both hero and sex symbol. Thus, the "Latin lover" screen image took hold and altered Hollywood's idea of a leading man.

Having made friends with *Apocalypse* director Rex Ingram, Novarro was groomed

Francis X. Bushman as Messala and Ramon Novarro as Judah Ben-Hur face off before the memorable chariot race in *Ben-Hur: A Tale of the Christ* (1925).

for stardom under the filmmaker's mentorship. Ingram cast Novarro in *The Prisoner of Zenda* (1922), in which he portrayed the evil-minded Rupert. At first, Ingram thought Novarro too short and too young for the role. He had Novarro grow a mustache and a goatee, and the aspiring actor learned to comfortably wear a monocle for a more mature look. He was screen-tested several times and finally landed the role opposite Alice Terry, who later became Ingram's wife and Novarro's lifelong friend, starring with him in five major films. *Zenda* was a smash hit and brought Novarro (billed as Ramon Samaniego) his first taste of critical praise and

recognition. Producer Samuel Goldwyn wanted to sign him, but out of loyalty, Novarro signed a personal two-year contract with Ingram for much less money.

After Ingram changed his name to Novarro, the actor made quite an impression in *Where the Pavement Ends* (1923), spending most of the movie near naked, wearing only a loincloth, in the role of a native boy in love with a missionary's daughter. The tropical romance, filmed on location in Florida and Cuba, was a popular personal success for the rising star. Novarro worked again with Ingram and Terry in *Scaramouche* (1923), the screen adaptation

of Rafael Sabatini's seventeenth-century swashbuckling novel. His next film, *The Red Lily* (1924), about an ill-fated Parisian love affair, was directed by Fred Niblo, who would be a pivotal force in Novarro's major career triumph, *Ben-Hur* (1925). Valentino's success in *The Sheik* prompted Novarro, Ingram, and Terry to make a similarly themed Arabian adventure romance, *The Arab* (1924), in which Novarro portrays the son of a Bedouin chieftain who falls in love with a missionary's daughter. Because he fit the part, Novarro was soon regarded the next Rudolph Valentino, which took on more resonance when Valentino unexpectedly died in 1926.

Although often compared, the two actors were actually very different in appearance. Valentino was dark, tall, and muscular with a strong profile. Novarro was of medium height and slender, with boyish features. He resisted being typecast as the Latin lover by demonstrating versatility in his screen roles. The phenomenal success of the blockbuster epic *Ben-Hur* immediately catapulted Ramon Novarro to the apex of stardom in the silent era. The film also established the reputation of the new Metro-Goldwyn-Mayer Studios as a producer of prestigious and profitable screen entertainment.

The story of a young Jewish nobleman who leads his nation against the conquering Romans, *Ben-Hur* was based on the novel by former Union Army general Lew Wallace in 1880. It was first turned into a popular stage play and in 1907 made into a short film. In 1922, Louis B. Mayer acquired the film rights after tough negotiations with representatives of the Wallace estate. Instead of paying the then-unheard-of asking price of $1 million dollars, Mayer agreed to pay 50 percent of the film's eventual earnings. June Mathis, one of the few women executives in Hollywood and the screenwriter of such Valentino hits as *The Four Horsemen of the Apocalypse* and *Blood and Sand*, wrote the screenplay for *Ben-Hur* and was charged with the production. Mathis wanted to cast Valentino in the title role, but he was in a contract dispute at Paramount Pictures that made him unable to work for another studio.

George Walsh, a relative unknown, was cast as Judah Ben-Hur initially, with the well-known Francis X. Bushman as his nemesis, Messala. The massive film, unprecedented in budget, size, and scope, began production in Rome in October 1923, to shoot against authentic backgrounds and to take advantage of lower production costs. Italy had expertise in this kind of filmmaking as the local film industry produced the Italian silent epics *Cabiria* (1914) and *Quo Vadis* (1913). With the added Hollywood expertise, how could the film miss?

Ben-Hur was beset with problems from the start. Production began without a completed script. After a year, unsatisfactory footage and escalating costs forced Louis B. Mayer and his production head Irving Thalberg to halt filming. During this time, a studio merger took place between Metro and Goldwyn, combining with Louis B. Mayer to form Metro-Goldwyn-Mayer. MGM decided to replace key vital personnel

such as its unimpressive lead actor, Walsh, and director Charles Brabin. Fred Niblo was selected to take over the directorial duties and a new leading actor was sought. The studio strongly considered rising star Novarro and established leading man John Gilbert. Novarro won out because of his youth, easygoing manner (which would be tested in Italy), and athletic ability. The actor was called to Thalberg's office, told he won the role, and put on a train to New York the following day to board the next ship to Europe. This was done secretly. Niblo was not told he was getting a new star until Novarro arrived in Italy.

Under Niblo's direction, the production resumed slowly, and the footage looked much better. There were still occasional mishaps on the set. Novarro, nearly naked in a galley slave sequence, had to sit on a raft on an unseasonably cold Mediterranean Sea for several days, and he was singed by fire during a sea battle sequence. The actor was almost accidentally killed when, during a training run, a chariot crashed into him. Luckily, he escaped unhurt, but he felt the weight of the massive production.

To complicate matters even further, Italy's dictator, Benito Mussolini, fostered political animosity among the Italian crew, resulting in more production delays. Mayer arrived in Italy soon after to supervise the new team himself; not liking what he saw, he ordered *Ben-Hur* to be completed at the MGM studios in Culver City. Back on US shores, Mayer told the press, "Novarro is a marvel. He will knock them cuckoo. I cannot say enough for him. He has enchanted me."[2]

Production went more smoothly on home ground, but sets had to be rebuilt and scenes reshot (1925). A massive set for the Circus Maximus chariot race was built on land near MGM. A master shot required thousands of extras in the arena, dressed in Roman attire. The studio made it a work holiday and required all studio personnel to act as extras. When Novarro, his head topped by a leather helmet, and Bushman, wearing a winged helmet, squared off in their chariots for the big race sequence, a whopping forty-two cameras were set up to capture all the angles and action. It took six weeks to film under the supervision of action/horse stunt specialist B. Reeves Eason. One of the assistant directors was William Wyler, who would later become a famed filmmaker and helm MGM's Oscar-winning 1959 version of the tale.

When viewed today, *Ben-Hur*'s highlights are the sea battle, the chariot race, and Novarro. In its review, *Variety* proclaimed that Novarro was "made for all time by his performance." The *New York Herald-Examiner* wrote, "Novarro is magnificent."

The epic was an overwhelming critical and commercial success, and the legendary fame of Ramon Novarro will forever be tied to *Ben-Hur*. The triumph of the film and, in turn, of MGM is in no small measure due to the star turn of one of the Latin community's first screen icons in one of silent cinema's groundbreaking productions.

After *Ben-Hur*, most of Novarro's films went on to be big box-office draws. *The Midshipman*, directed by Christy Cabanne, was his first starring role with solo, above-the-title billing.

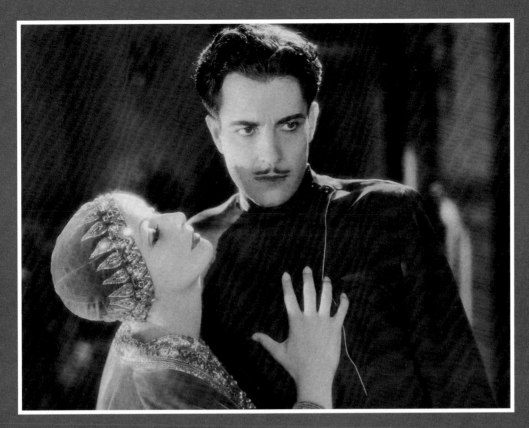

Ramon Novarro and Greta Garbo in *Mata Hari* (1931).

Because of *Ben-Hur*'s extended eighteen-month shooting schedule, Novarro in his downtime was assigned by MGM to star in and complete the contemporary drama. He portrayed Randall, a naval academy student compromised by a classmate's sister. The role showcased Novarro at his physical and charming best, playing an all-American character without any obvious ethnic undertones. Another of his biggest hits was *The Student Prince in Old Heidelberg* (1927), directed by the storied Ernst Lubitsch. Novarro was excellent as a prince in love with an innkeeper's daughter, played by Norma Shearer.

Novarro's last silent picture was *The Pagan* (1929), a South Seas island romance directed by W. S. Van Dyke and costarring Dorothy Janis and Renée Adorée in a story about a native boy in love with the daughter of a white trader. Although without dialogue and considered a silent, the film was synchronized with sound. The highlight was Novarro singing the popular and haunting "Pagan Love Song," by Nacio Herb Brown and Arthur Freed. The film was magnificently photographed on location in Tahiti, French Polynesia.

Devil-May-Care, directed by Sidney Franklin and released in 1929, was Novarro's first talking film, and it helped make him America's twelfth biggest box-office draw of the year. The musical comedy *In Gay Madrid* (1930) followed. In *Call of*

Ramon Novarro in the South Seas romance *The Pagan* (1929).

the Flesh (1930), also set in Spain, a convent girl falls in love with a carefree saloon singer with operatic aspirations. She leaves the convent, and they run off together. With the coming of sound, to retain foreign markets, Hollywood produced foreign-language versions of major films, usually with different cast members, on the same sets. Novarro also starred in Spanish- and French-language versions of this film, and in both, he spoke the dialogue and sang all the songs. (Studios also made original Spanish-language features that provided opportunities for Spanish-speaking actors and performers who came from all over Latin America and Mexico.)

Novarro portrayed Lt. Alexis Rosanoff in the 1931 hit *Mata Hari*, starring Greta Garbo as the titular exotic dancer and German spy on a mission to obtain crucial documents from a Russian general. A young and impossibly romantic Russian aviator (Novarro) falls in love with Mata Hari, but her mission is jeopardized by their romantic entanglement. An art deco visual design and elaborate costuming by Adrian highlight the film.

With the success of *Mata Hari*, Novarro renewed his MGM contract for three years and made four pictures in 1933. The first under his new contract, *The Barbarian* (1933), was a

contemporary remake of *The Arab* in which he played an Arabian guide who falls in love with a tourist. His costar was Myrna Loy in her first leading role. The MGM publicity department spread a rumor that Novarro and Loy were romantically involved to boost interest in the film, but in her memoir Loy wrote, "It was preposterous. Ramon wasn't even interested in the ladies."[3] Loy remembered Novarro as "A quiet gentleman whose personality was in direct contrast to his flamboyant screen roles."

The Cat and the Fiddle (1934) paired Novarro with actress/singer Jeanette MacDonald. In the same year *Laughing Boy* teamed him with Mexican Hollywood star Lupe Velez as Native Americans in a film adaptation of a Pulitzer Prize–winning 1930 novel. The film is notable for being shot on location at the Navajo Nation in Arizona, although the use of actual Navajos as background players punctuated the inauthenticity of the two stars. Novarro completed his contractual tenure at MGM, and his films' box-office returns dwindled, eventually leading him to retire from the screen and pursue other avenues. "They pigeonhole you as a romantic actor, and they are not interested in your acting ability. They are only selling a personality," remarked Novarro in a 1958 interview. He continued, "When I finished at MGM, I was really so tired you don't care to act or anything. You are squeezed out of everything you have, and you have no more desire to prove to them that you are able to do this or that. They continue to give you the same old tired parts."[4]

In addition to pursuing his first love, music, Novarro formed his own production company and ventured into directing. He wrote, directed, and produced with his own money the Spanish-language film *Contra la corriente* (*Against the Current*, 1936)—a simple love story about two athletes at the 1932 Los Angeles Olympics. Many of his family members, who now resided with him in the city, worked on the production.

Despite moving on with his career, Novarro's exit from the screen moved swiftly and with pernicious consequences. His lifelong conflict as a gay man with a strict Roman Catholic upbringing heightened as his career began to crumble and, finally, he took refuge in the bottle. His persistent self-doubt and alcohol dependency took a toll emotionally and physically in his later years. Financially, he didn't have to worry since he had saved money and had invested wisely in real estate and other ventures. But the pull of the limelight was still there. He worked sporadically after leaving MGM but was largely absent from Hollywood until the late '40s, when he reappeared as a supporting character actor. He returned to his old studio in 1950 for two films: *The Outriders*, a western with Joel McCrea, and *Crisis*, with Cary Grant and José Ferrer.

Crisis was directed by screenwriter and first-time director Richard Brooks, who was verbally abusive to Novarro, humiliating him in front of the other cast members and crew with homophobic slurs. This treatment affected Novarro's confidence and his performance.

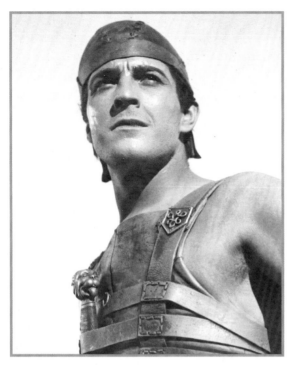

Ramon Novarro will forever be remembered as the star of the epic silent film classic *Ben Hur* (1925).

No one said anything to Brooks until Gilbert Roland confronted the director and admonished him for his behavior. As told to the author by Roland, he said to Brooks, "You give this man all the respect. If it wasn't for him, this studio and you would not be here today." Brooks never said another ill word to Novarro for the rest of the filming.

Partly because of this experience, Novarro steered clear of screen work until almost ten years later for *Heller in Pink Tights* (1960). The veteran actor had a significant supporting role in his last feature film appearance as De Leon, a villainous land baron in an unusual western starring Anthony Quinn and Sophia Loren, directed by MGM alum George Cukor.

Hollywood and press interest in Novarro revived when he attended the world premiere of the 1959 MGM remake of *Ben-Hur*, directed by William Wyler and starring Charlton Heston in Novarro's role.

Nearly a decade after this high point, Novarro met a tragic end. Life in the closet and his related insecurities coalesced on a fateful night in 1968. He hired two young brothers who were known for street hustling and invited them to his mansion in the Hollywood Hills. He had hoped for an evening of debauchery, but instead the two men beat and killed him. They were eventually apprehended and stood trial. They were found guilty of murder but served only nine and ten years, respectively, of a life sentence and were paroled. It seemed to suggest that the murder of a gay man was inconsequential.

But, of course, it was indeed a matter of consequence, specifically for Novarro and more generally for what was beginning to call itself the "gay community." Gradually, Novarro was recognized as a gay movie icon, which contributed to the nascent gay rights cause. It was brought into sharp focus a year later with the Stonewall Uprising in New York City in June 1969. A new era had begun, and the tragic death of Ramon Novarro was a contributing factor.

Today, Novarro is considered a pioneering LGBTQ+ figure of early Hollywood. He was an internationally recognized film star, who by virtue of his screen presence, dispelled both sexual and ethnic stereotypes.

GILBERT ROLAND

G ilbert Roland's ever-present leather wristband, cigar or cigarette defiant on his lip, pencil-thin mustache, black hair adorning handsome features, and deep baritone prepared him to become a matinee idol. From his beginnings in silent

films, he demonstrated panache and a work ethic that marked a career spanning six decades. Born Luis Antonio Damaso de Alonso in 1905 in Chihuahua, Mexico, young Luis thought he would follow family tradition and become a bullfighter. His father, grandfather, and great-grandfather were born in Spain and descended from a long line of bullfighters. Luis was the second of six children born to Don Francisco and Consuelo Alonso.

During the early days of the Mexican Revolution, which began in 1910, the Alonso family ran afoul of Pancho Villa when he banished all Spaniards from northern Mexico. The family moved to Ciudad Juarez, on the border opposite El Paso, Texas, when Luis was six years old. When Villa's army captured the city, the Alonsos fled across the Rio Grande and settled in El Paso. Luis sold newspapers and shined shoes in front of the El Paso del Norte Hotel. Many years later, when the hotel was

torn down, he purchased a bench outside of it and placed it in the patio of his Beverly Hills home as a reminder of his humble beginnings.

Luis saw his first silent movie in El Paso and, in his own words, "fell in love with all the people on the screen."[5] At thirteen, he made his way to Los Angeles and found work as an extra. He appeared in countless motion pictures in that capacity, and in 1925 he was hired as a stunt double for Ramon Novarro in *The Midshipman*. Finally, agent Ivan Kahn noticed Luis. In an interview with the author, the actor later recounted, "An extra girl who was very beautiful asked if I would get her a cup of water. In those days, things were so simple. The extra girls only wanted water. The set was a big Venetian square for a film whose title I can't recall. The water was on the other side of the square. Ordinarily, I would have walked around the set. But this time, for some reason, I took a shortcut. There I was in a fine costume

all alone on the set, which was brilliantly lit. When I reached the other side, someone said, 'What's your name?' I said Luis Antonio Damaso Alonso. 'Come to my office tomorrow,' he said. He signed me to a contract and sold me to B. P. Schulberg for *The Plastic Age* (1925)."[6]

His first billed appearance was in *The Lady Who Lied* (1925), as Luis de Alonso, but at Kahn's insistence, he took on a new name. They settled on Gilbert Roland, a combination of two of Luis's favorite screen stars: John Gilbert and Ruth Roland.

The Plastic Age concerns the wild college kids of the Prohibition-era Jazz Age. Roland and the film's star, Clara Bow, both only twenty years of

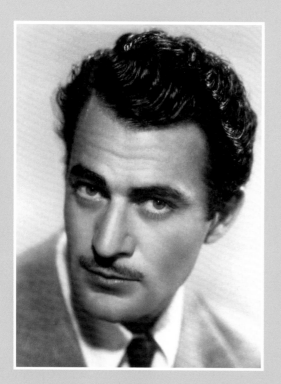

Gilbert Roland from the early 1930s.

age, were smitten with each other from the start. The exigencies of her rising career and a controlling father—who hated Roland because he was Mexican and Catholic—brought an end to their relationship.

Undeterred, Roland moved on and achieved stardom after Norma Talmadge chose him to play her suitor in a film adaptation of Alexandre Dumas's nineteenth-century novel, *Camille* (1926), directed by Fred Niblo. Mirroring the film, the young Roland and the older Talmadge fell in love off screen and had an affair. She was married to the film's producer, Joseph Schenck, who at one point threatened Roland with bodily harm. They costarred again in her first talkie, *New York Nights* (1929), but the affair eventually ran its course.

In *She Done Him Wrong* (1933), Roland starred opposite Mae West in the film that made her a superstar and cemented her hypersexualized image with the line "Why don't you come up sometime and see me?" It didn't hurt Roland to be seen with Mae West in a film nominated for an Academy Award for Best Picture in 1934, but his career as a leading man in significant features waned as the '30s progressed. He still found work in programmers at lesser studios and occasional supporting roles in A films. In 1937, he received good notices for his performance in the Spanish Civil War drama *The Last Train from Madrid*, costarring Dorothy Lamour, Lew Ayres, and a young Anthony Quinn. In real life, Roland's father returned to Spain in the early days of the war and was tragically shot down in

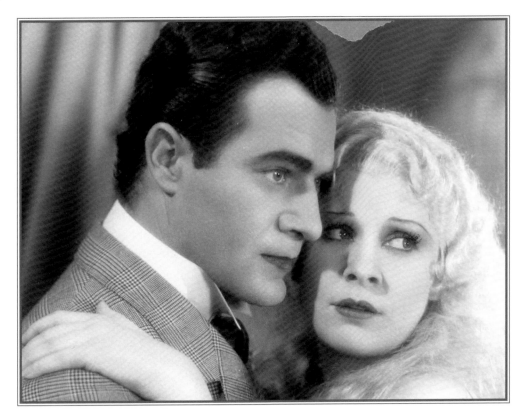

Gilbert Roland and Mae West in the Oscar-nominated Best Picture *She Done Him Wrong* (1933).

the town square of Palencia, the little village where he was born.

Roland appeared in two prestigious films for Warner Bros. in small but important roles: *Juarez* (1939), starring Paul Muni, Bette Davis, and Brian Aherne, in which he played Col. Miguel Lopez, who found himself divided over his loyalty to the Austrian monarch Maximillian and Indigenous rebel leader Benito Juarez, and the swashbuckler *The Sea Hawk* (1940), in which he starred with Errol Flynn.

During World War II, Roland enlisted and served in the US Army Air Corps. After the war ended, he was hired by Monogram Pictures to assume the role of the Cisco Kid, the character

introduced by American pulp writer O. Henry in 1907 in the short story "The Caballero's Way." Originally the Cisco Kid was an Anglo outlaw on the Tex-Mex border, but beginning with his first silent screen appearance in 1914, Cisco became decidedly more Latin with the interpretation of each actor who took on the role. Roland's portrayal was more authentically Mexican than the vaguely brown-faced interpretation by Warner Baxter and the stylish, showy portrayal by Cuban American Cesar Romero. Roland's Cisco was more romantic with the ladies, with confidence and a swagger about him. He spoke colloquial Mexican Spanish, dressed in traditional vaquero attire, and drank tequila on

screen the proper Mexican way. Monogram was considered the bottom rung of the studios and had minuscule budgets compared to the majors, but the small studio provided filmmakers artistic freedom as long as they stayed within budget. This allowed Roland the opportunity to add authentic cultural elements and employ dozens of Mexican extras, singers, and musicians throughout the six Cisco films in which he starred, released between 1946 and 1947.

In Roland's Cisco films, more often than not, the white cattle rustler or bank robber was the villain or antagonist in plotlines involving a rancher being swindled or a woman in an ill-fated marriage. Years later, he recalled in an interview, "The Cisco Kid might have been a bandit, but he fought for the poor and was a civilized man in the true sense of the word." He continued, "I wanted to be sure the Mexican was not portrayed as an unwashed, uneducated savage clown."[7]

Roland credited director/writer John Huston for reinvigorating his postwar career by casting him in a showy role as a Cuban Calypso musician

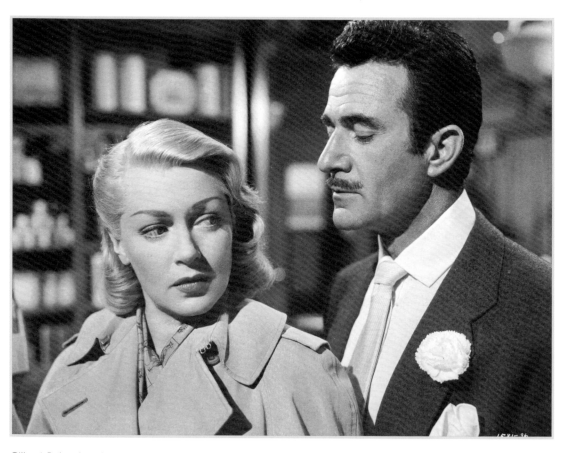

Gilbert Roland and Lana Turner in the Hollywood exposé *The Bad and the Beautiful*, directed by Vicente Minnelli.

and revolutionary in *We Were Strangers* (1949). The actor recalled, "I seemed to click all over again. I think that picture did more for me than *Bullfighter and the Lady*, which everyone seems to think made me a star for a second time."[8] *Strangers* was not well received by the public, but it was widely seen in the Hollywood community, putting Roland in people's minds again.

Bullfighter and the Lady (1951) was produced by John Wayne's production company at Republic Pictures and filmed in Mexico. Republic wanted Wayne to star, but he declined, believing he was wrong for the role. He thought well enough of the script and the director to produce the film at a modest budget under his banner. The story was semi-autobiographical, based on director/writer Oscar "Budd" Boetticher's experiences as a young American bullfighter in Mexico. The core of the story is the relationship between a young bullfighter, played by Robert Stack, and an older matador, played by Roland. Roland brought his bullfighting heritage to the role, and he thought the part would land him the recognition of his peers with a Best Supporting Actor Oscar nomination. During the filming, Roland asked the director to shoot close-ups of his crucial death scene. Running a little behind schedule, Boetticher was hesitant, but Roland insisted, and the director finally complied. Unbeknownst to Roland, Boetticher ran out of film and, not wanting to wait for a reload, pretended to shoot the close-up without any film in the camera. The following day, Roland went to the studio screening room to watch the footage and did not find it.

He asked the director about it, and Boetticher admitted the truth. Roland never spoke to him again and disowned the finished film.

His role was further compromised when the picture was severely edited by Republic Pictures and director John Ford for its US release because of supposed latent homosexual imagery. Even though the film was called the *Bullfighter and the Lady*, in its final form, the focus was clearly on the love between the older bullfighter and his admiring young protégé. The romance with the lady was inconsequential to the story. The film was not edited for its Latin American release, and a complete print was found and restored by the UCLA Film & Television Archive and Boetticher in 1990. Still, Roland declined to attend a screening.

The 1950s was a prosperous period as Roland came into his own persona as a supporting actor in a succession of major feature films. He usually played the best friend of the leading man, with an occasional romantic lead. In Anthony Mann's *The Furies* (1950), Roland plays Juan Herrera, the head of a family of Mexican squatters who believe they have a right to the land. Juan has an implied intimate relationship with Barbara Stanwyck, and her new stepmother wants to run the Herreras off the ranch, leading to Juan's tragic hanging. Roland excels in his role, and there is tender chemistry between him and Stanwyck. He played a subdued variation of his Latin lover screen persona as Gaucho Ribera in the absorbing Hollywood exposé and all-star MGM drama *The Bad and the Beautiful* (1952),

directed by Vincente Minnelli.

Next, Roland landed the lead role and received top billing in what became his personal favorite among his movies, *The Miracle of Our Lady of Fatima* (1952). The film recounts the 1917 appearance of the Virgin Mary before three children in a meadow near Fatima, Portugal. Roland plays Hugo da Silva, a peddler who supports and protects the children in their struggle to be believed by government and church authorities. Roland brought to the role his charismatic star quality as a vulnerable, undeterred, slightly cynical man of action whom moviegoers related to. He next played Punch Pinero, a prisoner in *My Six Convicts* (1952), directed by Argentina-born Hollywood import Hugo Fregonese on location at San Quentin penitentiary. In *Beneath the 12-Mile Reef* (1953), released in the new widescreen CinemaScope process, Roland was a Greek American sponge fisherman whose son falls in love with the daughter of a rival family in a coastal Florida community.

The still-sought-after actor traveled to Morelos, Mexico, for the western adventure *The Treasure of Pancho Villa* (1955), in which he starred as a Mexican rebel leader opposite actor Rory Calhoun's US mercenary. The men steal a trainload of gold to fund Villa's efforts in the Revolution. Also in Mexico, he costarred in the similarly themed but much better *Bandido!* (1956), this time opposite Robert Mitchum as a mercenary gunrunner, with Roland playing a wily revolutionary leader.

Roland went to England to costar opposite two-time Oscar winner Olivia de Havilland in *That Lady* (1955), a lavish sixteenth-century historical costume drama about Princess Ana de Mendoza and King Philip II of Spain, who harbored a secret love for the princess. Ana falls in love with the new minister of affairs, Antonio Perez (Roland), which enrages the king and leads to tragic consequences. Based on a stage play, the film marked the impressive film debut of Paul Scofield as King Philip and Christopher Lee, who later rose to fame in a series of gothic horror movies made for the British Hammer Films.

In 1958 Roland returned to Morelos for *Last of the Fast Guns*, a western starring stuntman-turned-actor Jock Mahoney and featuring Argentina-born actress Linda Cristal, who had established herself in Mexican films and was under contract with Universal Pictures. Roland, impeccably dressed in white, is Miles Lang, a ranch foreman who helps the American gunfighter search for his brother, who has gone missing in Mexico.

Roland continued to advance his prolific career. He ended the decade with a succession of top films that carried him into the early part of the '60s, including *Three Violent People* (1956) with Charlton Heston; *The Midnight Story* (1957) with Tony Curtis; *Guns of the Timberland* (1960) with Alan Ladd; and *Samar* (1962), filmed in the Philippines with George Montgomery. He memorably portrayed Zach Colino, a circus trapeze artist who tightrope walks across the raging Niagara Falls in Irwin Allen's all-star spectacular *The Big Circus* (1959). His wife was

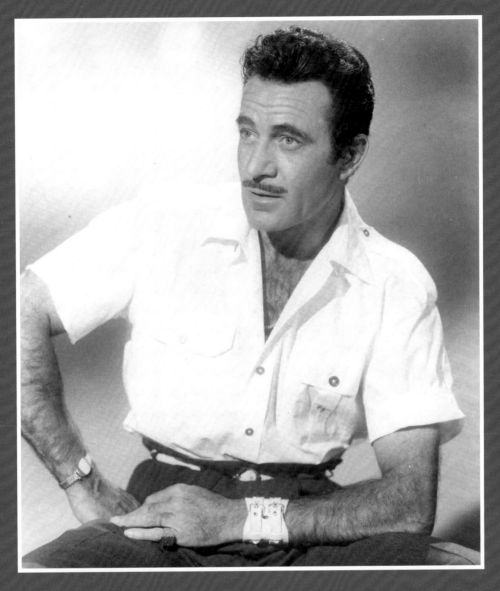

Gilbert Roland 1950s publicity portrait wearing his signature wristband.

played by Adele Mara, born Adelaide Delgado, of Spanish immigrant parents in Dearborn, Michigan. She appeared in westerns at Republic Pictures and most notably in *Wake of the Red Witch* (1948) and *Sands of Iwo Jima* (1949) with John Wayne.

In 1964 Roland starred in John Ford's flawed but exquisitely photographed late-career epic western *Cheyenne Autumn*. Having known the actor since the silent days, Ford referred to him as "Luis." Here he cast Roland as the Native American leader Dull Knife; Dolores del Rio as his wife, Spanish Woman; and Ricardo Montalban as Little Wolf. The

film depicts the story of the Cheyenne people's flight from the reservation and their thousand-mile trek to their ancestral Wyoming homeland, with the US cavalry in hot pursuit.

Roland was one of the many US actors who went to Europe to work in spaghetti westerns during the mid-1960s craze set off by director Sergio Leone's *A Fistful of Dollars* (1964). During his European sojourn, Roland starred in the heist western *Any Gun Can Play* (1967) as Montero, one of a trio of outlaws. In this prolific period he also starred in three other spaghetti westerns, released in 1968.

In 1959, Roland appeared in his own television series, *Amigo*, in which he portrayed an El Paso detective who works on both sides of the Mexican border. Director Don Siegel shot the one-hour pilot in El Paso for MGM Television. All the broadcast television networks nixed the completed show because, as Roland was told by network programming executives of the time, "a series with a Mexican lead actor would not draw an audience."[9]

Nevertheless, Roland guest-starred in numerous television series of the '50s, '60s, and '70s and was featured in the western TV mini-series *The Sacketts* (1979) with Glenn Ford. His last major screen appearance was in 1982 in the western *Barbarosa* (Red Beard), directed by Australian Fred Schepisi and starring Willie Nelson and Gary Busey. Roland played the Mexican hacendado (landed rancher) Don Braulio Zavalla, who sends his son to kill the outlaw Barbarosa (Nelson). The veteran actor

has an impressive scene in which he recounts a tale to a group of children around an earthen fire in the hacienda. Roland's vocal intonations, his melodious voice, and his sheer presence carry the scene.

Gilbert Roland's career spanned sixty years of cinematic technological innovations from the silent era: the transition to sound, Technicolor, widescreen CinemaScope, and television. He worked with US cinema's most legendary directors and stars. He made it look easy on screen, but he worked earnestly at his craft, leading to a body of work consisting of more than two hundred film and television appearances. "I don't have any delusions about myself as an actor. I'm grateful for being able to find enough work all these years," he reflected.[10]

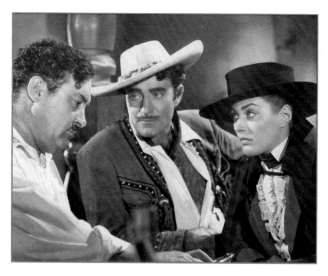

Gilbert Roland played the Cisco Kid (center) in six films between 1946 and 1947 including *Beauty and the Bandit*. Joe Garcio as the bartender, and Ramsay Ames as Jeanne Dubois.

DOLORES DEL RIO

There can be very little argument that Dolores del Rio was one of the most beautiful women to have ever graced the silver screen. The celluloid legend of both Hollywood and Mexico was born Maria de los Dolores Asunsolo in the northern

Mexico mining and cattle town of Durango. Talent and looks were apparently in her blood, as she was a second cousin of Ramon Novarro. Her refined, well-educated family thrived during the Mexican Porfiriato (the thirty-year presidential reign of dictator Porfirio Díaz). With the outbreak of the Mexican Revolution and Villa threatening all the hacendados (wealthy ranchers) in the region, del Rio and her mother dressed as peasants and fled to join family in Mexico City. There, the Asunsolos regained their position in society, being somewhat insulated from the violence and chaos of the Revolution being felt in the countryside. The young Dolores was enrolled in a finishing school and enjoyed the genteel social life in the capital available to supporters of reformist president Francisco Madero, who kept Villa in check, at the time. She enjoyed music and dance, and in 1921 she met socialite Jaime del Rio, twenty years her senior. They

married and traveled throughout Europe, only to return to Mexico when del Rio exhausted most of his fortune two years later.

In 1925, Hollywood film director Edwin Carewe was honeymooning in Mexico City with his new bride, Mary Aiken, when he saw Dolores dancing at a party and was captivated. The director believed he could make her a great film star. When he invited her to Hollywood, she uttered the only word she knew in English: "Yes." Her husband saw this as a prime opportunity to regain some of his lost fortune and fulfill his ambition to write. Somewhat inexplicably, he allowed del Rio to accompany the director and his wife to Hollywood, with plans to arrive later. What the new Mrs. Carewe thought of this unusual arrangement is not known.

Carewe immediately put del Rio under exclusive contract and groomed her for stardom. Carewe and publicist Henry Wilson sent out a steady stream of publicity,

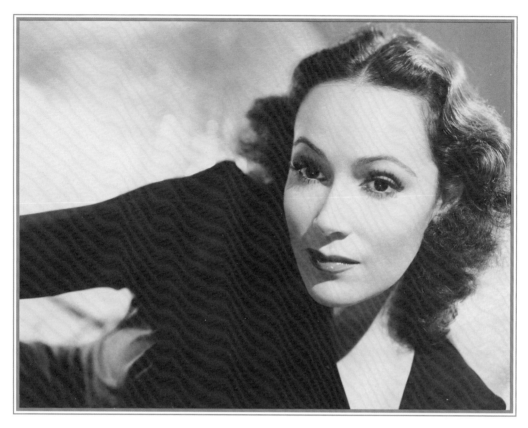

Dolores del Rio was described by none other than the legendary Marlene Dietrich as "the most beautiful woman in Hollywood."

including stories and photos of their new discovery. When she was promoted in the press as Spanish or Castilian—being white and European was considered superior to being Mexican, with its Indigenous pedigree, a discriminatory view that has not wholly disappeared today—she quickly insisted on being correctly described as Mexican.

Her first movie with Carewe was *Joanna* (1925), in which she had a small role as Carlotta da Silva, a woman of Spanish Brazilian heritage. More minor roles followed until Raoul Walsh's World War I comedy *What Price Glory* (1926) catapulted her to stardom as Charmaine, the French barmaid who attracts the attention of US army buddies Capt. Flagg and Sgt. Quirt (played by Victor McLaglen and Edmund Lowe). In 1928 del Rio starred in *Ramona*, based on the Helen Hunt Jackson novel of early California romance on the plight of the Spanish Mexicans and Native Americans, who were the victims of oppression by newly arrived European Americans. The film and its subject matter was sensitively handled by Carewe, who may have been the first Hollywood filmmaker of Native American (Chickasaw) heritage, though his ethnicity and history were not known outside his immediate circle. A *New York Times* film critic described del Rio's

performance as "An achievement. . . . Not once does [del Rio] overact, and yet she is perceived crying and almost hysterical when she is not careful in all the moods of the character. Her beauty is another point in her favor."[11]

The movie was a big hit, and she sang the title song, which became a best-selling record. Walsh, who enjoyed working with del Rio, cast her again in his *The Loves of Carmen* (1927), as a young gypsy girl who works in a cigar factory and falls in love with Lt. Don Jose (Don Alvarado). Del Rio shone again in *Evangeline* (1929), directed by Carewe, the story of a woman caught in the war between France and England and her journey to America to find her long-lost love. Before filming began, Carewe filed for divorce from his wife. At the same time del Rio's marriage ended, leading to much speculation about a potential marriage between the two. If there was a romance, it did not last long, and marriage never materialized; del Rio claimed that there were no romantic intentions between the two. Carewe, feeling the sting of unrequited love, harassed del Rio with contractual lawsuits. *Evangeline* marked the end of the seven-film artistic collaboration between the beautiful actress and the film director.

Jaime del Rio left for Europe and died months later of a blood ailment. Her husband's sudden death, her emotional personal and professional break with Carewe, and anxiety over the transition to sound films, caused Dolores del Rio to withdraw from the public. Health issues and a rumored nervous breakdown

Director Raoul Walsh and Dolores del Rio on the set of *The Loves of Carmen* (1927).

contributed to keeping her off the screen for a year. Her mother came to live with her to see her daughter through a challenging period.

"For me, it was a difficult thing to survive," the actress told an audience at a 1981 tribute in her honor at the San Francisco Film Festival. "In 1929, for the first time, I had to speak. It was very, very, very hard to learn your beautiful language," she said at the time. She continued, "When I first arrived in Hollywood, I didn't speak a word of English. Of course, you didn't have to at that time. It was all pantomime; everything was the expression—you know, to use the body."[12] Del Rio successfully transitioned

to sound motion pictures with *The Bad One* (1930). She starred as Lita, a Spanish woman, in this musical drama, which reunited her with one of her *What Price Glory* costars, Edmund Lowe.

The actress began dating celebrated MGM art director Cedric Gibbons, whom she met while working on the Klondike gold rush adventure *Trail of '98* (1928). They were married in 1930. Their home, which Gibbons designed for his wife, became a hub of Hollywood social activity, with the glamorous Dolores at the center of attention.

Continuing her work, del Rio had tremendous success as a South Seas maiden wearing little more than strategically placed leis in King Vidor's *Bird of Paradise* (1932), shot on location in Hawaii and costarring a young Joel McCrea. It was reported that producer David O. Selznick told Vidor he didn't care what the story was as long as the finale had del Rio sacrificing herself by jumping into a fiery volcano.

Her biggest sound hit after the silent era was a musical comedy romance, RKO's *Flying Down to Rio* in 1933. "What have these South Americans

Dolores del Rio as Luana, with her strategically placed leis that do not move while she dances the hula in *Bird of Paradise* (1933).

got below the equator that we haven't?" an American tourist quips to her girlfriends at a Miami nightspot. Del Rio as the Brazilian socialite Belinha glances at and elicits a response from the Americano bandleader that draws him to her while he ignores the others. The all-blond American girls hypersexualize the brunette Belinha, reflecting Euro American mores and attitudes about Latins.

Flying Down to Rio is a light, frothy musical comedy that was the perfect escape for audiences during the Great Depression. No one could have known it at the time, but the boisterous, bubbly film heralded the advent of several Hollywood film phenomena, not the least of which was launching the dance team of Fred Astaire and Ginger Rogers. The film helped launch other Hollywood careers as well. As created by the art directors at RKO studios, Rio de Janeiro, Brazil, was an exotic fantasy. The musical's South American locale and aviation theme were suggested by RKO head of production Merian C. Cooper, an avid traveler, filmmaker, and a Pan American Airways board member promoting air tourism to South America. Artistic and commercial aspirations collided and coalesced in the imagery and events of that endearing, slightly wacky film.

Although its top-billed stars were Dolores del Rio, Gene Raymond, and Raul Roulien, the film was undeniably stolen by engaging supporting players Astaire and Rogers. The two became the singularly famous and adored screen dance team of the 1930s, marquee figures starring in nine successful musicals for RKO.

Del Rio's Belinha De Rezende is an educated, high-society Brazilian woman, chaperoned by her aunt. Her alluring beauty attracts Roger, played by Gene Raymond, a flirtatious, blond, blue-eyed US bandleader and aviator. Roger follows her to Brazil, where his band is in residency at a popular hotel. He is surprised that Belinha is the fiancée of his old Brazilian friend, Julio (Raul Roulien). Roger and his musical troupe are set to open at a luxurious hotel nightclub but cannot secure the proper local permits in time for the grand opening. Roger devises a musical aerial show with chorus girls on the wings of biplanes to evade permits and generate publicity, ensuring the band's stay. Although some minor complications arise, the accommodating Julio's sympathetic, nice-guy character steps aside so Belinha can go with his handsome Americano buddy.

Del Rio debuted the two-piece swimsuit on screen, starting a nationwide fashion trend. She dances with Fred Astaire to the tune "Orchids in the Moonlight." The film's elaborate musical production "The Carioca" is a fabricated dance. "Carioca" is how residents of Rio refer to themselves. It was to be a sexually stimulating dance that brings men and women together by touching foreheads. On screen the lengthy ten-minute number is divided into three parts. First, a Mexican American starlet, Movita, sings along with Alice Gentile, an Illinois opera singer, in the Rio hotel nightclub. The dance progresses as the Afro-Brazilian dancers are replaced by light-skinned Brazilians, followed

by a solo by African American singer/actress Etta Moten, who also appeared in *Gold Diggers of 1933* singing the haunting "Remember, My Forgotten Man." Moten is beautifully photographed wearing a traditional Brazilian Bahiana costume (pre–Carmen Miranda extravagance). Black background dancers perform in a style more like the American shimmy than the Afro-Brazilian samba. When Fred says to Ginger, "I'd like to try this thing just once," and they get up to dance, they take the first steps toward stardom. The film was a box-office hit for RKO and del Rio's second success following *Bird of Paradise*, but the studio did not renew her contract. She moved on to a contract with Warner Bros., where she starred in *Wonder Bar* (1934), a musical with Al Jolson. She had a leading role as Ynez, part of a nightclub dance team, opposite Ricardo Cortez—Jewish actor Jacob Krantz, whose name was changed by Hollywood to capitalize on the Latin lover craze—as her partner, Harry. The film features a stunning tango sequence between del Rio and Cortez in which he repeatedly assaults her with a bullwhip as part of their act. Del Rio, whose character is in love with the unfaithful Harry, mortally stabs him at the dance finale. The audience assumes it is part of the act and applauds while Harry slips offstage to die.

Madame Du Barry (1934) was an elaborate Hal B. Wallis and Jack Warner production starring del Rio in the title role as the famous mistress of King Louis XV of France. The star was outfitted in stunning costumes designed by Orry-Kelly

Brazilian Raoul Roulien as Julio and Dolores del Rio as his fiancée Belinha in *Flying Down to Rio* (1933). His film career ended abruptly and tragically with the death of his wife in a hit and run car accident in Hollywood involving a young John Huston that caused Raul, after a protracted legal fight, to abandon films and return to Brazil.

that enhanced her regal bearing and beauty. The role of an independent and manipulative courtesan was worthy of del Rio, but the movie was too sophisticated for many Depression-era audiences, and the censors toned down the sexual suggestiveness.

From such big-budget productions, del Rio quickly found herself starring in lower-budget movies (then known as programmers) such as *International Settlement* (1938) and *Lancer Spy* (1937) that didn't require much of her except to be adorned in lavish costuming.

After several films that underutilized her talents, del Rio realized the importance of a director like Carewe, who had been instrumental in her early career. She divorced Gibbons in 1940 and began a long-term relationship with Hollywood's new "boy wonder," Orson Welles, whom she accompanied to the premiere of his landmark film *Citizen Kane* (1941). Welles cast her in a small, thankless role as a dancer in a leopard costume in his production of *Journey into Fear* (1943). Absorbed with his commitment to finishing *The Magnificent Ambersons* (1942) and traveling to Brazil and Mexico for his State Department documentary *It's All True* (1943), he had little time left for del Rio. The relationship resulted in little personally or professionally for del Rio and ended in 1943. Within a year, Welles married Hispanic American star, Rita Hayworth. Though still a recognizable marquee name, del Rio was at a crossroads and needed to reinvent herself. As an artist who took her craft seriously, she confronted the fact that she had some big decisions to make. She would seek a director, such as a Carewe or Walsh, who provided nurturing guidance in films. And she needed a venue that would facilitate that. She decided to relocate from Hollywood to Mexico City, joining a burgeoning and increasingly respected film industry in Mexico.

It was the right move for her, both personally and professionally. A statement she made to the press in the 1930s was about to be realized: "I would like to play in stories concerning my native people, the Mexican race. It is my dearest wish to make fans realize their real beauty, their wonder, their greatness as a people. As I see the vast majority today regard Mexicans as either a race of bandits or laborers, dirty, unkempt, and uneducated. That is quite erroneous. Hence my big ambition to show it all, the best that's in my country."[13]

Del Rio found a fruitful artistic collaboration in Mexico with director/writer Emilio Fernández and his writer Mauricio Magdaleno and cinematographer Gabriel Figueroa. *Flor silvestre* (*Wild Flower* [1943]) paired her with Mexican leading man Pedro Armendáriz. She received international recognition with her next film, *Maria Candelaria* (1944), the story of a beautiful Indigenous flower girl named Maria. In the floating gardens of Xochimilco near Mexico City, she is shunned because she is the daughter of a prostitute. A painter comes to the community and sees her as an embodiment of Indigenous Mexican beauty. She agrees to pose for him, but when he asks her to remove her clothes, she refuses and runs away. He finds another Indigenous woman to pose nude to finish the painting but retains Maria's face. The locals believe the finished painting is Maria and, in righteous outrage, stone her to death. In 1946 *Maria Candelaria* won the Grand Prix, then the top prize at the Cannes Film Festival, and the following year won the prize for Best Cinematography at the Locarno Film Festival. It was picked up for distribution by MGM, which dubbed it into English and released it as *Portrait of Maria*.

Lupe Velez MGM glamour portrait circa 1930s.

LUPE VELEZ

She was tiny in physical stature. She was fiercely independent. She was volatile. She was charismatic and pretty as a painting. There was a magnetism about her. She was multitalented. And she was determined. She was Lupe Velez.

The Mexico-born star had an impressive start in Hollywood, working early on with some of the most talented filmmakers of the era, including Douglas Fairbanks, D. W. Griffith, Lon Chaney, Victor Fleming, William Wyler, Henry King, Cecil B. DeMille, and Edwin Carewe. Her stardom happened seemingly overnight.

The actress was born Maria Guadalupe Villalobos Velez on July 18, 1908, in San Luis Potosi, Mexico. Lupe's father was Col. Jacobo Villalobos Reyes, known as "el Gallo" (the Rooster), an officer in Porfirio Díaz's army before and during the early days of the Mexican Revolution. Lupe later recalled as a young child riding horseback with her father and witnessing the violence of the revolution. Her mother, Josefina Velez, was an operatic singer. To escape the revolution and curtail her wild behavior, Lupe was sent to a convent school in San Antonio, Texas.

She returned to Mexico City in 1924, where the family had moved, studied dance, and entered the Mexican vaudeville revista circuit as a dancer. With her vivacious personality and talent, she soon became a popular theater headliner. Early on, Velez began making headlines for engaging in public rivalries and spats with other female performers. A fiery temperament would be a key element in her persona on screen and off for the rest of her career.

American stage director Richard Bennett saw Lupe perform and invited her to Los Angeles for the part of a cantina dancer in the play *The Dove* (1926). By the time she arrived, the part had been cast. She made fast friends with celebrated Broadway stage comedian/singer Fanny Brice, who introduced her to Broadway impresario Florenz Ziegfeld. Ziegfeld offered her a spot in his show. Before she could take advantage of his offer, she landed a screen test at MGM. It was a whirlwind time for Velez.

The studio did not sign her, but independent film producer Hal Roach, best known for his slapstick comedies, saw the test. He thought Lupe had possibilities as a comedienne and signed her. Roach placed her in the short *Sailors Beware* (1927) with his top comedic duo, Stan Laurel and Oliver Hardy. Her limited English was not an impediment in the waning days of silent films and served her well in the sound era; she was able to exploit her accent as an engaging bit of exoticism. Douglas Fairbanks, the most prominent American film star and leading man of the era, went from an all-American hero to a swashbuckling action-adventure star in a series of successful films such as *Robin Hood* (1922), *The Mark of Zorro* (1920), *The Thief of Bagdad*, and *The Black Pirate* (1926). The star was searching for an actress to play a spirited village girl in his new production of *The Gaucho* (1927). After meeting Velez, he was so taken by her vivacious and expressive personality that he cast her in the film. Soon the fan magazines and newspapers were fed publicity about Fairbanks's new discovery.

In *The Gaucho*, the audience first sees Velez, billed simply as "Mountain Girl," mooning over a wanted poster for El Gaucho (Fairbanks). When he enters a cantina in her village, she throws herself at him. El Gaucho tosses his whip, encircling her, and the two dance the tango, their bodies joined at the hip, hands at their sides. He tries to kiss her, but she moves away. In a scene that would be repeated on and off screen for years to come, Lupe throws a vase at a dancer vying for El Gaucho's favors.

The film was a certified box-office sensation. The *Los Angeles Times* wrote of Velez, "One can prophecy very good success for her because she is fiery and seemingly quite unselfconscious."[16] Hollywood stood up and took notice.

D. W. Griffith cast her in his final silent film, in the title role of *Lady of the Pavements* (1929), set in the late eighteenth century among European nobility. Velez plays Nanon, a cabaret singer recruited by an aristocratic woman to pose as a noblewoman in a scheme to expose her fiancé's pretensions and win his undying love, which backfires when he falls for Velez.

In director Tod Browning's *Where East Is East*, Velez was paired with Lon Chaney, the man of a thousand faces, as Toyo, the young daughter of scarred big game hunter Tiger Haynes (Chaney). Henry King's *Hell Harbor* (1930) presents Velez as Anita Morgan in a tale about the loves and conflicts of pirate's descendants on a Caribbean island. Filmed on location in Tampa, Florida, *Hell Harbor* was an early sound film that suffered from the transition. It was a hybrid of sorts, combining some of the best elements of silent cinema with the inventiveness—and awkwardness—of early sound.

In 1929, Lupe portrayed Lola Salazar, the beautiful daughter of a Mexican nobleman in *Wolf Song* opposite up-and-coming young star Gary Cooper. In the film, her newfound love, trapper Sam Lash (Cooper), is torn between the freedom of life on the frontier and the implied shackles of marriage. Against her father's wishes, Lola elopes with Sam, only to return home

Lupe Velez and Gary Cooper at the height of their romance in the 1920s.

The publicity campaign worked, and *Wolf Song* became a smash hit. A 1929 newspaper photo caption cited the stars' relationship this way: "Lupe Velez, the fiery little Mexican tamale of the handsome newcomer in the person of Gary Cooper . . . Rumors of the engagement of the pair bring forth denials from both, though they admit that they are in love. Motion Picture careers are interesting them at this time."

Cooper became one of the most important and beloved male film stars of the '30s, '40s, and '50s. He won two Academy Awards for Best Actor, for *Sergeant York* (1941) and *High Noon*, but in his early career, he was regarded as a "momma's boy," under the thumb of his mother, Alice Cooper. She disapproved of his relationship with Velez and described her as "that Mexican thing," "vulgar," and "tasteless." Lupe engaged her in a war of words in the press, leaving Gary caught in the middle. The romance was once publicity gold, but now it threatened to hurt Cooper's rising star image.

Under pressure from his mother and the film studio, he broke off the affair. Velez later married former Olympic gold medal swimming champion and MGM's Tarzan, Johnny

humbled when he leaves her abruptly for the wilderness. He reconsiders, and on his way back to her, is attacked and wounded by Native Americans. Despite obstacles, he makes it back to Lola. Velez and Cooper sizzle on screen, a sizzle that extended off screen into a tumultuous three-year affair. She was twenty-one years old, and Cooper was twenty-eight, but Velez was a bigger, more established star at the time. Paramount Studios, to which Cooper was under contract, heavily publicized the love affair between petite, sultry Velez and tall, easygoing Cooper.

Laurel and Hardy and Lupe Velez in the classic comedy egg
sequence from *Hollywood Party* (1933).

Weissmuller, in 1933. Their five-year marriage
was tempestuous from the start. Volatile
incidents played out in public venues and were
reported in fan magazines and the press.

Despite her growing "Mexican wildcat"
reputation, she was referred to in movie ads
as "dazzling little brunette star of *Resurrection*"
(1931) and "vivid enchantress of *The Gaucho*"
in a promotion for a personal appearance.
Newspaper reports in Cincinnati and Chicago
referred to her as "motion picture actress Lupe
Velez," omitting her Mexican origins.

She left Hollywood in 1932 to appear in Florenz
Ziegfeld's Broadway show *Hot-Cha!* When it closed
after 119 performances, she returned to Hollywood
to star in a sound remake of Cecil B. DeMille's *The
Squaw Man* (1931). Back on the West Coast after
another Broadway show, she was teamed with

comedian Jimmy Durante in three films. In the
first, *Strictly Dynamite* (1934), Velez is Vera Mendez,
Durante's partner in a radio station.

In MGM's comedy feature film *Hollywood
Party* (1934) with Durante, Velez had a standout
comedy sequence in an egg-breaking routine
in which she is more than a match for the
comic duo of Stan Laurel and Oliver Hardy.
Showcasing her impressive comedic gifts, it
ranks as a highlight of her career.

In December 1937, Velez returned to Mexico,
where she had an enormous fan base, to make
her first film for that country's rising movie
industry. *La zandunga* (1938) (the title refers to a
Mexican folk waltz) was directed by acclaimed
Mexican director Fernando de Fuentes, who was
fresh off the hit *Allá en el Rancho Grande* (Over
at the big ranch, 1936). Velez played a beautiful

village girl courted by three local suitors. The movie premiered in March 1938 in Mexico City, and Weissmuller accompanied her. He told the press he loved Mexico because it gave him his beloved Lupe. But all was not as rosy as it seemed; five months later, Velez filed for divorce. The movie, however, was well received in Mexico and throughout Latin America. The *New York Times* called *La zandunga* "a delightful, well-proportioned picture."[17] Velez was well aware of the images of Mexicans and other Latinos in American movies. She expressed her thoughts in press interviews upon receiving accolades for her work in *La zandunga:* "When Americans make Mexican pictures, the men all wear sombreros and the women high combs. They don't do that everywhere [in Mexico]. Mexicans laugh [referring to audiences], but it's no use telling American producers."[18]

Velez struck gold when she was offered the lead in the RKO comedy *The Girl from Mexico*. She starred as Carmelita Fuentes, a high-strung singer in a Mexican rural café discovered by New York ad man Dennis Lindsay (Donald Woods), who has been tasked with finding a Mexican singer for a campaign. Carmelita is attracted to the handsome Americano, and after much comic complication and obtaining a work visa, she agrees to go with him to New York. There Carmelita wins Dennis's heart and starts getting into trouble. She finds an ally in his Uncle Matt (Leon Errol) and enemies in Aunt Della (Elisabeth Risdon) and Dennis's suspicious WASP fiancée Elizabeth (Linda Hayes). In the grand Hollywood tradition, Carmelita and Dennis marry at the film's end.

Velez's Carmelita is a bundle of bilingual energy, the calamity-prone screen personality that she made her own. She poured her over fourteen years of show business experience into this persona. As Velez made the stereotype bigger than life, she also made herself vulnerable to cultural discrimination. With an authentic Mexican voice rattling off Spanish on-screen, Velez sent a message to her Spanish-speaking audience from behind the stereotype. She would use Spanish expletives and throw insults around, like calling Dennis's girlfriend Elizabeth "Cara de Perro" (dogface). The US audience heard only colorful-sounding gibberish. Carmelita can be viewed as an early example of Chicana empowerment. She may have been an ingenue in the big city, but she was also a smart working woman, a talented singer, and she always knew how to get her way in the end. In his *Cinematic Insane* blog, William McKinley describes Lupe as Carmelita this way: "She has impeccable timing, an infectious screen presence and improvisational screen chemistry with Leon Errol."[19]

In her exhaustive study, Kristy A. Rawson theorizes that Velez represents the "unruly woman," or *inquieta* in Spanish, a restless, free-spirited, sexual woman who disrupts societal norms in a loud, expressive way. "Velez could get away with it because as a 'hot-blooded Latin woman'; no white woman in Hollywood behaved the way she did."[20]

When *The Girl from Mexico* opened,

of the time. The Mexican Spitfire series was one of the first produced from a character written for an earlier film. In *Mexican Spitfire*, the first in a series of seven feature-length B comedies centered on her misadventures, Carmelita Fuentes, now Carmelita Lindsay, upon returning from her honeymoon with Dennis, finds her marriage threatened by the machinations of Aunt Della and the former fiancée, Elizabeth. Carmelita manages to thwart their schemes in a series of zany situations.

Lionel Hauser wrote the original story, "The Girl from Mexico." A prolific screenwriter with credits in many genres, he also cowrote the screenplay with Joseph Fields. Charles E. Roberts wrote most of the films in the Mexican Spitfire series. Roberts later mined a similar writing vein for Republic Pictures in a series of three films starring Cuban-born starlet Estelita Rodriguez, who was promoted as a young Lupe Velez in *Havana Rose* (1951), *Cuban Fireball* (1951), and *The Fabulous Senorita* (1952).

In between Spitfire movies, Velez took on assignments at other studios that showcased and expanded her musical comedy talents, to varying degrees of success. *Honolulu Lu* (1941) stars Velez front and center, singing and dancing as Consuelo Cordoba, an entertainer at a nightclub frequented by American sailors in Honolulu. Leo Carrillo is her scheming uncle Esteban Cordoba, who enters her in a Miss Honolulu competition. A veteran

moviegoers loved Carmelita. They stood in line and filled the Rialto theater in New York City for three weeks. It was a smash, and RKO head George Schaeffer green-lit a spin-off starring Velez again in the role and signed her to a $1,500-a-week contract.

The Girl from Mexico was conceived as a stand-alone comedy; RKO had not planned on a series when it was produced. However, film series based on popular radio characters, comic strips, or novels were favorites with moviegoers

character actor, Carrillo plays a role similar to that of Uncle Matt in the Spitfire series. As Consuelo, Velez performs hilarious onstage impressions of famous actresses, topped off by a wild imitation of Adolf Hitler. Ironically, *Honolulu Lu* was released in the theater four days after the enemy attack on Pearl Harbor, Hawaii. This rollicking musical comedy with Velez and sailors was the wrong antidote for a nation about to enter World War II.

In *Ladies' Day* (1943), Velez is movie star Pepita Zorita, who visits a baseball game and catches the eye of star pitcher Wacky Waters (Eddie Albert), who loses his pitching prowess when he falls in love. His teammates' wives kidnap Pepita to ensure he keeps his concentration on the game to win the upcoming pennant.

After completing her contractual Spitfire commitments, Lupe returned to Mexico to star in a well-received Spanish-language film adaptation of Émile Zola's classic 1880 novel *Nana*. Upon returning to Los Angeles, she began an intimate relationship with a bit player named Harold Maresch Ramond and became pregnant. Allegedly, he did not want to marry her. On December 13, 1944, in her Beverly Hills home, she dressed elegantly for bed, wrote a note to Ramond and another message with instructions for her secretary. Then Lupe lay down and took her own life and the life of her unborn child by ingesting at least fifty Seconal pills. Her housekeeper found her body the following morning.

Her volatile and unpredictable behavior and mood swings can be attributed to a possible case of bipolar disorder, proposed by a biographer in later years, which may have contributed to her suicide at thirty-six.[21] She was also a devout Catholic for whom abortion was unthinkable, but raising a child alone outside of marriage was a prospect she may have found overwhelming, in addition to the scandal she would have faced had it become known to the public. How ironic that in her last film in the series, *Mexican Spitfire's Blessed Event*, Carmelita discovers she is pregnant, but all ends happily.

Gilbert Roland was among the notables who attended Velez's Hollywood funeral service. She was buried in a place of honor in Mexico City, where thousands of fans turned out to bid her farewell.

Kenneth Anger's 1959 book of largely unsubstantiated gossip, *Hollywood Babylon*, described Velez's last moments in a racist and lurid manner. Anger's report that she was found dead with her head in a toilet quickly became an urban legend, accepted as truth by the public then and by successive generations. Celebrated American avant-garde artist Andy Warhol made *Lupe* in 1965, a primitive film inspired by Anger's account of the night of the suicide. Warhol's artistic spin on it was to cast the blond and white Edie Sedgwick as Velez.

Today, many people know her name but very little about her life or her versatility as a performer. Spontaneous and outspoken, sexy and stormy, Velez lived her life like a modern-day rock star and became a pop culture icon of her day, pushing boundaries of ethnicity, sexuality, art, and comedy.

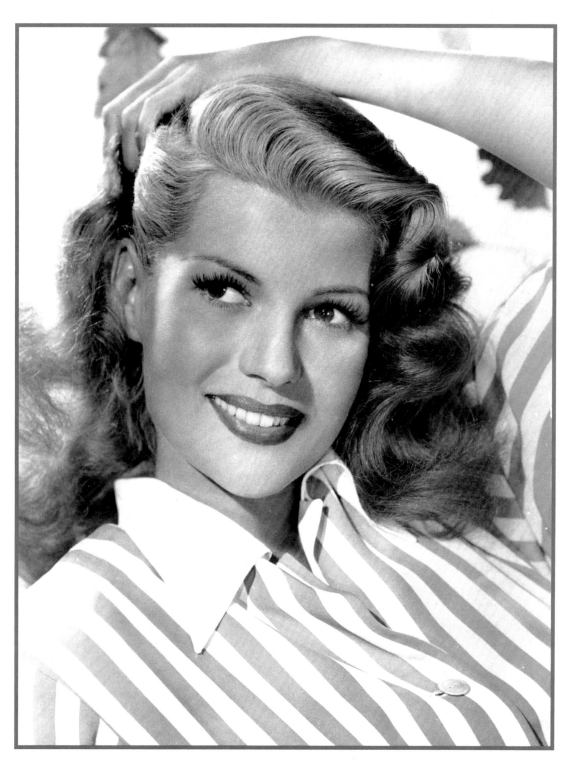

Rita Hayworth was known as the "All-American Love Goddess."

RITA HAYWORTH

Graceful. Sensual. An enthralling presence. That only begins to describe Rita Hayworth, a gifted dancer and actress who rose from Brooklyn to become a global entertainment icon just right for her moment in history. Starting life as Margarita

Carmen Cansino, she was transformed into a sex symbol and an "all-American girl"—one of the most beautiful stars of the 1940s. Margarita was born in New York City, the daughter of Spanish Andalusian dance master Eduardo Cansino and his Irish American wife Volga Hayworth, a former Ziegfeld showgirl. Rita was the eldest of three children and the only girl.

Rita's father and his sister Elisa were known as the Dancing Cansinos. They toured theaters and the vaudeville circuit throughout the United States. As a parent, Eduardo was a strict disciplinarian and kept a tight rein on young Margarita. She practiced flamenco dancing every day and rarely interacted with anyone outside of her family. Eventually the Cansinos moved to Los Angeles, where Eduardo opened a dance studio and school for aspiring performers on Sunset Boulevard. The Great Depression forced the school to close, and Eduardo sought alternative means to generate income. He

occasionally worked at film studios, appearing in Spanish and Mexican dance sequences in silent and sound films, and he considered reviving his dance act, but Elisa was no longer available. "I was barely twelve when my father closed the school and prepared a nightclub act for him and me. Our first engagement was in Tijuana," recalled Rita in a 1964 interview.[22]

With makeup and padded clothing, Margarita appeared to be much older than her years. She and her father found employment in Prohibition-era Mexican nightclubs and casinos. They also entertained on luxury gambling ships moored three miles off the coast of California in international waters. Though Rita was mostly sheltered by Eduardo and her mother, there she was exposed to adult nightclub patrons, vice, and solicitations from men who didn't realize how young she was. From today's standpoint it seems obviously inappropriate and borderline abusive to put

a vulnerable minor in that situation. But without the protection of child labor laws that exist today, many child performers of the early twentieth century found themselves in similar circumstances.

One night in 1934 the vice president of Fox Film Corporation, Winfield Sheehan, was in the Tijuana nightclub where Eduardo and Margarita were performing. Impressed with Margarita's looks and dancing, he arranged for a screen test back in Hollywood. Despite being a painfully shy teenager, the test was successful enough to land Margarita a contract, and she was soon appearing in films under the shortened name of Rita Cansino. The aspiring actress was given diction and drama classes, and in 1935, she made her screen debut in a dance sequence in the Fox film *Dante's Inferno*, starring a young Spencer Tracy. In her first few movies, Rita was cast in ethnic roles. She portrayed Mexican, South American, Spanish, and Egyptian characters in a series of low-budget dramas and westerns, often in brief dance sequences in a cantina or saloon. For several roles they dyed her hair black and darkened her skin with makeup for the camera. There was talk of casting Rita in a remake of *Ramona* opposite Gilbert Roland. But when Fox became 20th Century Fox and Darryl F. Zanuck became head of production, Rita and Roland were out of the picture. *Ramona* (1936) was made with Loretta Young and Don Ameche instead.

Eager to leave home, Margarita married Ed Judson, a car salesman twice her age, with a knack for marketing and promotion. He

Rita Cansino in the early 1930s before she was transformed into Rita Hayworth.

envisioned her talent potential as a screen star and set about a complete makeover. Judson helped land her a contract at Columbia Pictures, but her weight and face did not conform to the accepted image of an up-and-coming starlet. Judson put her on a strict diet, dressed her in a new wardrobe, and took her out where she would be noticed and photographed. At the studio, a makeover started to take shape. Electrolysis raised her low hairline, and her long tresses were styled and dyed light auburn. Taking her mother's maiden name, she became known as Rita Hayworth. By 1939, she was transformed into a gorgeous girl-next-door who combined just the right blend of wholesomeness and sensuality. The image-makers were not trying to make her look "white"—they were trying to make her look "Hollywood." Even with

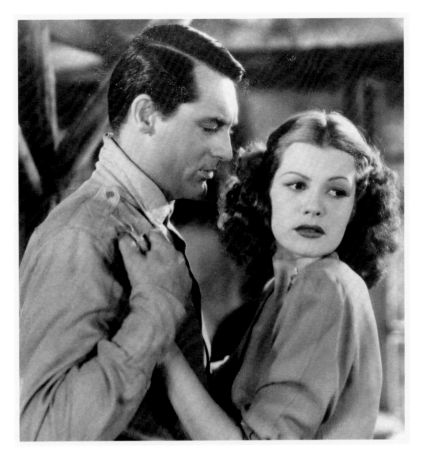

Cary Grant and Rita Hayworth in her breakthrough role
in Howard Hawks's *Only Angels Have Wings* (1939).

these changes, it still took a while for Hayworth to gain momentum in the movies.

In *Only Angels Have Wings* (1939), she landed a breakthrough role with star Cary Grant and director Howard Hawks. She portrayed Judy Macpherson, an old flame of daredevil aviator Geoff Carter (Grant). Although Jean Arthur was lead actress, Hayworth not only held her own in this tropical adventure but cemented her position as a rising star. *The Lady in Question* (1940) was the first movie to pair Rita Hayworth and Glenn Ford, both Columbia contract players. They would make four more movies together and develop a lifelong friendship.

In the title role of *The Strawberry Blonde* (1941), a romantic comedy she made on loan to Warner Bros., Hayworth again worked with a major star and renowned director, James Cagney and Raoul Walsh, respectively. In the film, Biff Grimes (Cagney) recounts the story of his first crush, Virginia Brush (Hayworth); the friend who betrayed him, Hugo Barnstead (Jack Carson); and

Amy (Olivia de Havilland), the girl he married. Hayworth was perfect as the beautiful title character and looked stunning in James Wong Howe's cinematography.

Director Rouben Mamoulian took notice and cast Hayworth in the 20th Century Fox remake of *Blood and Sand* (1941). She would play the sultry Spanish socialite Doña Sol opposite the handsome Tyrone Power, the studio's top leading man. Mamoulian recalled in an interview many years later that once he saw Hayworth walk, he knew he had found his Doña Sol. Her walk was like a dance.

Juan Gallardo (Power) is the peasant son of a famous toreador who died in the bullring. Despite his mother's misgivings, Juan and his friends travel to Madrid to follow in his father's footsteps, and he achieves some success. He returns to his village and marries his childhood sweetheart, Carmen (Linda Darnell). As his fame in the bullring grows, he catches the attention of the beautiful Doña Sol (Hayworth), a woman who uses toreadors for her pleasure and amusement. *Blood and Sand* was shot in Technicolor and won an Oscar for Best Cinematography; much of the film's design and color scheme was based on the paintings of the Spanish masters like Velazquez and Goya. The rich rainbow of color showcased Hayworth's beauty and flaming crimson hair. The Spanish setting of the bullfight drama allowed her a torrid paso doble dance number with a young Anthony Quinn.

The *Hollywood Reporter* wrote in its review,

"Rita Hayworth, who has been widely cheered for her beauty, comes through with a well-defined artistry that must win for her some of the top acting roles."[23] The critical attention given to Hayworth and record box-office receipts generated by *The Strawberry Blonde* and *Blood and Sand* impressed Darryl F. Zanuck, who borrowed her from Columbia for the two films.

On August 11, 1941, *Life* magazine published a provocative photo of Hayworth in a silk negligee kneeling on a bed covered with satin sheets, a come-hither lighting up her eyes. It caused a sensation and was one of the most requested wartime pin-ups, second only to the leggy bathing suit photo of the now largely forgotten actress Betty Grable. Hayworth instantly became a Hollywood sex symbol for soldiers who would soon go off to war, the US Navy voting her "the red head we would most like to be shipwrecked with."

In this period she asserted her independence by divorcing Judson, who took most of the money Hayworth had earned up to that time. Another dominant male figure in her life, Columbia mogul Harry Cohn, soon took note of the valuable star and exploited her talents to benefit his own studio.

In *You'll Never Get Rich* (1941), Hayworth was paired with dancer extraordinaire Fred Astaire. She matched him step for step with energetic chemistry that dazzled on the screen. In an interview years later, Hayworth recalled, "The brass at Columbia had forgotten the fact that I was a dancer until Fred Astaire, who knew my

background, reminded them."[24] She was sure of herself and came into her own with supreme confidence when she danced. In his autobiography, *Steps in Time*, Astaire wrote Hayworth danced with "trained perfection and individuality."[25] The hit film featured music by Cole Porter.

Astaire and Hayworth were paired again in *You Were Never Lovelier* (1942), a musical comedy set in Argentina. Hayworth is Maria Acuna, a stunning young woman who fears men and begins receiving anonymous letters from a secret admirer she mistakenly believes is dancer Robert Davis (Astaire). The movie features the Latin music of Xavier Cugat and his band, whose tunes were lively and infectious but not authentic to the locale.

In 1943, Hayworth met and was swept off her feet by the peerless Orson Welles. They were married within the year, during a break from filming *Cover Girl* (1944). It was Columbia Pictures' first Technicolor musical and showcased a more-beautiful-than-ever Hayworth with dancer/actor Gene Kelly, borrowed from MGM. They provide a youthful, dynamic on-screen pairing with musical sequences staged by Kelly and Stanley Donen. The smash success of *Cover Girl* propelled both Hayworth at Columbia and Kelly back at his home studio, MGM, to career heights as screen stars.

"There never was a woman like Gilda," proclaimed the ads for the movie *Gilda* (1946), and the same can be said for Hayworth in her defining role. All the best collaborative elements of a major studio production came together to create and solidify an indelible star persona: cinematography by Rudolph Maté, gowns by Jean Louis, the direction of Charles Vidor, and Hayworth's chemistry with costar Glenn Ford. Producer Virginia Van Upp envisioned the movie as a star vehicle for Hayworth. Van Upp was the screenwriter who penned the smash hit *Cover Girl*, and she was promoted to producer at Columbia by Harry Cohn. She developed a strong, trusting professional relationship with Hayworth. Van Upp cowrote *Gilda*, though her work on the script went uncredited.

In the story, which centered on the title character, two men compete for Gilda's affection, and their rivalry culminates in an unforgettable dance sequence to "Put the Blame on Mame," in which free-spirited Hayworth tantalizes and torments the men who try to control her. As the nightclub owner in *Affair in Trinidad* (1952) explains to Ford's character, "When a man is married to a goddess, he must expect other men to worship her."

To coincide with *Gilda*'s release, *Life* magazine, in its fourth cover story on the star, called Rita the "American love goddess." In her introductory scene, her husband asks, "Gilda, are you decent?" The camera then cuts to Hayworth; her hair swept up, her long mane falling back, as she replies, "Me?" It's an iconic cinema moment immortalized in the film *The Shawshank Redemption* (1994), which offers a glimpse of how audiences reacted to the jaw-dropping vision of Rita in 1946.

A strapless black satin gown designed by costumer Jean Louis underscored Hayworth's

sensuality in Gilda's most famous scene. She dances to "Put the Blame on Mame" while peeling off her matching opera gloves, striptease style, before a mesmerized audience. When comedienne Carol Burnett years later asked Hayworth what held up her strapless dress, she answered wryly, "Two things."

The Loves of Carmen (1946) was based on the 1845 Prosper Mérimée novella *Carmen*, later turned into the famous Bizet opera. Carmen, the seductive and free-spirited Spanish gypsy, was a role Hayworth was born to play considering her Spanish dance background and heritage. She hired her father as an assistant choreographer. This was the first film she produced under her own company banner, the Beckworth Corporation, which protected her income from taxation and gave her a choice of material and a percentage of the profits. She cast her potent box-office leading man Glenn Ford as the doomed young nobleman Don Jose, but Ford was badly miscast as the Spaniard. "It was one of the worst mistakes I have ever made in my life, embarrassing. But it was worth it to work with her [Hayworth] again," commented Ford in *Glenn Ford: A Life* by his son Peter Ford.[26] The Technicolor production displayed a ravishing Hayworth as Carmen and showcased her flamenco dancing talents. It was the biggest box-office hit for Columbia Pictures in 1949.

In 1948, megastar Hayworth starred with her soon-to-be-ex-husband Orson Welles in *The Lady from Shanghai*. Harry Cohn hoped for a screen pairing to match Humphrey Bogart

and Lauren Bacall at Warner Bros. Welles, who also directed, had Rita's trademark long hair cut short and dyed blonde for the role of cold-hearted Elsa Bannister. This infuriated Cohn, who claimed Welles was ruining his most valuable star. After a screening at the studio, Cohn famously said he would pay anyone $5,000 if they could explain the inscrutable movie to him. It bombed at the box office, but is now highly regarded in Welles's film canon and in the genre of film noir.

At the height of her fame, Hayworth defied expectations by abandoning her screen career for marriage to Prince Aly Khan, a wealthy international playboy, soon after she divorced Orson Welles with whom she had a daughter, Rebecca. Marriage to the globe-trotting prince necessitated a life outside the United States. After a troubled marriage to Khan and subsequent divorce, she returned to Hollywood to complete her contract obligations to Columbia Pictures. Despite the difficulties in her marriage to Khan, Hayworth emphasized the silver lining: the birth of her daughter, Yasmin Khan. *Affair in Trinidad* was Hayworth's first film in four years, and she was paired with her favorite costar, Glenn Ford. The studio hoped to create the same chemistry shown in *Gilda*, in a similarly themed but ultimately less satisfying film. Still, fans were eager see to Hayworth on the screen again, and the movie was a big commercial success.

Hayworth followed with a Technicolor version of Somerset Maugham's classic story

Rita Hayworth and Glenn Ford relax on the set of *Gilda*.

"Miss Thompson." In an updated rendition of the 1932 pre-Code potboiler *Rain*, starring Joan Crawford, titled *Miss Sadie Thompson*, Hayworth played Sadie, a happy-go-lucky entertainer stuck on a South Sea island after World War II. With her are a puritanical doctor, a missionary, and a bunch of marines. The film, shot on location in Hawaii, was a handsome production featuring a superlative performance from Hayworth. Academy Award winner José Ferrer, just off his Best Actor nomination for *Moulin Rouge*, played the missionary, and Puerto Rican–born Broadway star Diosa Costello has a supporting role as native woman Ameena Horn.

A musical high point for Hayworth is a sequence when Sadie drives the marines into an orgasmic frenzy singing and dancing to "The Heat Is On." *Variety* wrote in its review, "Hayworth catches the feel of the title character well, even braving completely deglamorizing makeup, costuming and photography to fit her physical appearance to that of Sadie Thompson."[27]

After *Miss Sadie Thompson*, a modest hit, Hayworth wed troubled Argentina-born singer Dick Haynes, who had immigration difficulties. The marriage kept her off the screen for two years, until she appeared in *Pal Joey* (1957), a musical with Frank Sinatra and Kim Novak, who was being groomed by Columbia to be Hayworth's successor. Now a mature woman, Rita held her own, but this was the beginning of her career descent.

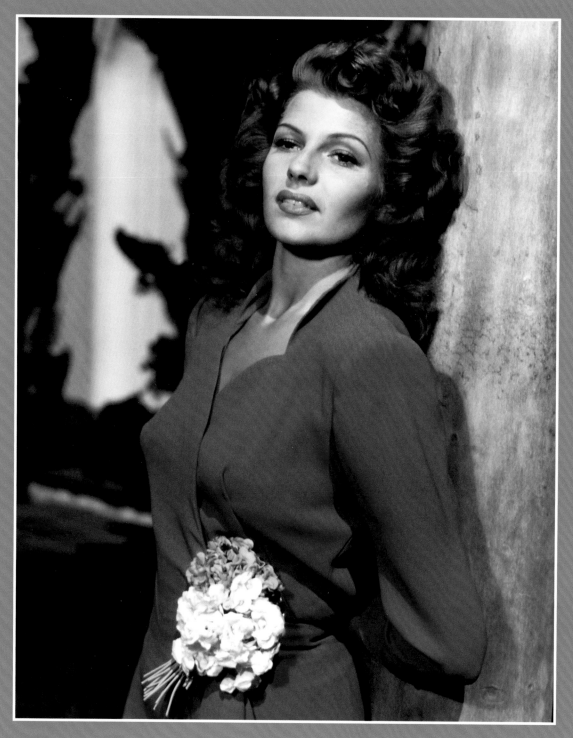

Rita Hayworth at the height of her fame in the 1940s.

She told the *New York Times* in 1970, "I guess I had some good numbers in *Pal Joey* but was surprised to be playing the older woman—Frank Sinatra was older than I was. Oh, yeah, and Kim Novak, who was supposed to replace me (as Columbia's new love goddess). I didn't look like any older woman then."[28] She appeared to little effect in *Fire Down Below* with Robert Mitchum and Jack Lemmon but had a substantial role opposite Gary Cooper in the grueling western drama *They Came to Cordura*. Divorced from Haynes, she married producer James Hill, who cast her with Burt Lancaster in the Academy Award–winning drama *Separate Tables* (1958). Hayworth received excellent critical notices for a role she knew all too well in real life as Ann Strickland, a woman dealing with aging and loneliness. She unexpectedly shows up at a seaside resort where her ex-husband John Malcolm (Lancaster) and his girlfriend reside.

Never quite recapturing her World War II–era glory, Hayworth worked sporadically in the early '60s in primarily forgettable films. She was reunited with Glenn Ford for the fifth and last time for a small supporting role in MGM's black-and-white low-budget crime drama, *The Money Trap* (1966). In just a couple of scenes, she displays her dramatic range and creates empathy for her character through the relationship she and Ford had established with moviegoers through their previous screen work. "The salvation of *Money Trap*—a minor one, granted—Rita Hayworth of all people. . . . Miss Hayworth is intensely convincing, from slurred speech to wobbly walk. The middle-aged actress has been more fair, but never more admirable," wrote Howard Thompson in his review in the *New York Times*.[29]

Beginning in the late 1950s, it became apparent to friends and work associates that Hayworth was having mood swings, confusion, and aggressive behavior thought to have been caused by alcohol, stressful relationships, and depression. Finding it difficult to remember her lines in later years, Hayworth made her last screen appearance in what amounted to a cameo in MGM's *The Wrath of God* (1972), filmed in Mexico.

It wasn't until almost nine years later, in 1980, that Hayworth was diagnosed with Alzheimer's disease. This degenerative neurological ailment robs the brain of its memory functions and eventually results in death. Hayworth's daughter Yasmin Khan took over her mother's conservatorship and cared for her personally until she died in 1987.

Interestingly, obituaries failed to mention the Cansino side of her family as survivors. Yasmin said that her mother reverted to her long-term memory by practicing with the Spanish castanets of her youth. The screen siren's worldwide fame brought international media recognition of the deadly disease; Rita Hayworth's iconic film legacy lives on and, spearheaded by her daughter, has raised funds for medical research seeking advancements in treating Alzheimer's.

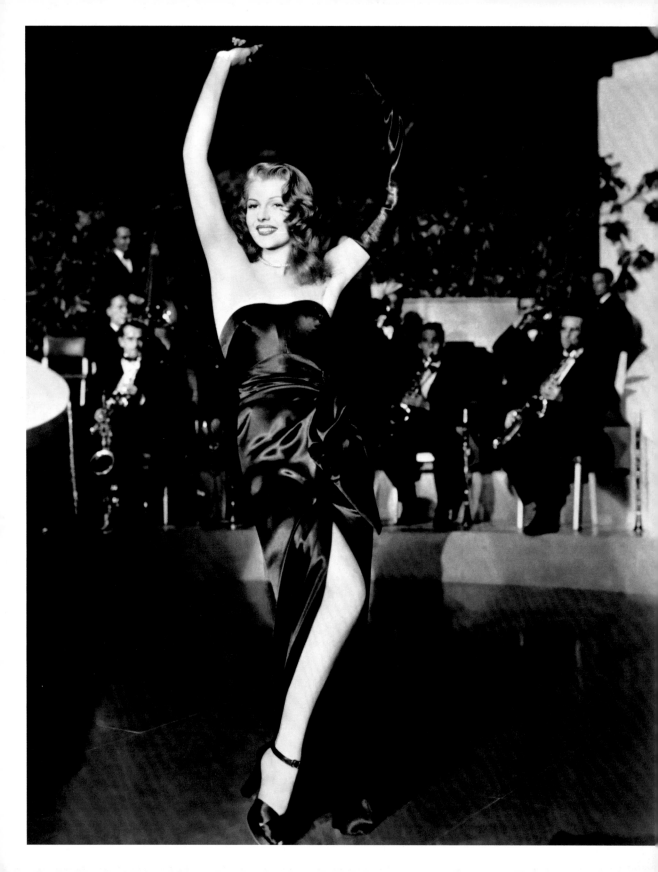

Tutti Frutti Hats & Good Neighbors: Hollywood Goes Latin for World War II

In 1933, the United States signed a pact with Latin American countries, ending the "gunboat diplomacy" it long practiced to protect its interests there, often with the threat of military intervention. This new pact, known as the Good Neighbor Policy, was instituted under President Franklin D. Roosevelt's administration to improve relations with Latin American nations. The policy continued through the 1940s and resulted in many Hollywood films featuring South American locales and an increasing number of Latin performers.

As the rumblings of impending world war became apparent in the late 1930s, many Latin American countries were under dictatorships. They had more in common with Axis powers than with the Allied democracies. The Good Neighbor Policy was strengthened because of national security and economic interests; Latin America's vast natural resources, including Brazil's rubber, were needed for the Allied war effort. The Nazi takeover closed European

"There never was a woman like Gilda," proclaimed the ads for the movie *Gilda* (1946).

Charley Martin (J. Carrol Naish), Lolita Sierra (Dorothy Lamour), and the local Mexican–American community give a patriotic World War II sendoff at the train station to Joe Morales (Arturo de Córdova), who has enlisted in the US Army and is going off to war in *A Medal For Benny* (1945).

of Mexican Americans and gives a glimpse of home-front life for their families.

Battleground (MGM 1949), directed by William Wellman from an Oscar-winning story and script by Robert Pirosh, realistically depicts the experiences of the American infantry during the decisive Battle of the Bulge in December 1944. Ricardo Montalban plays Private Johnny Roderigues, who is a member of the squad. Despite the cold and surrounded by Nazi troops, Montalban as Roderigues has a vibrant scene in which he expresses a child's delight when he experiences falling snow for the first time. A German patrol wounds him during a melee. Rather

than risk the lives of his fellow soldiers, Roderigues stays behind, burying himself in the snow under a disabled Jeep. The squad returns for him, but they are too late; he has succumbed to his wounds.

To Hell and Back (1955), the semi-autobiographical story of World War II's most decorated soldier turned movie star, Audie Murphy, featured East Los Angeles boxer turned actor Art Aragon as PFC Sanchez and Felix Noriego as a Native American code talker. These developments represent the incremental progress Hollywood was making in its hiring of Latinos and its portrayal of their experience. Perry Lopez portrays "Spanish Joe," and Victor

Millan is Private Pedro, both of whom encounter prejudice from a fellow marine in Raoul Walsh's Pacific War drama *Battle Cry* (1955), in which a character hurls an ugly racial slur at Private Pedro.

A pivotal film, *Hell to Eternity* (1960) was directed by Phil Karlson. It is the true story of Mexican American marine Guy Gabaldon and his heroic exploits on the island of Saipan, where he single-handedly captures 1,500 Japanese soldiers and civilians. Tall, blue-eyed Jeffrey Hunter played Gabaldon, and the film erases all references to Gabaldon's East Los Angeles Mexican American background. It is notable as the first mainstream film to dramatize the unjust relocation of Japanese

American citizens from the West Coast during the war through Executive Order 9066. The black-and-white drama had a modest budget but gritty, large-scale battle action and was a box-office hit.

Even though Latino armed forces personnel participated in crucial military battles, they were missing in action from most of the large-scale World War II movies of the next several decades, including *The Longest Day* (1962), *Battle of the Bulge* (1965), *Patton* (1970), *Tora! Tora! Tora!* (1970), *A Bridge Too Far* (1977), and *Saving Private Ryan* (1998). Regrettably, the idea of "missing in action" applies to too many aspects of the reality of Latinos in Hollywood.

Real-life Marine World War II hero Guy Gabaldon (center) and his screen counterpart, actor Jeff Hunter (left) who portrays him, along with actors Vic Damone and David Janssen on the set of *Hell to Eternity*.

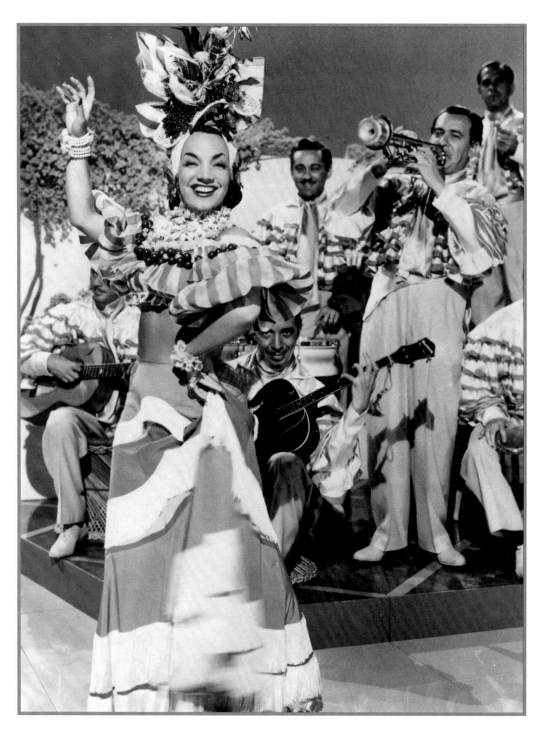

Carmen Miranda and her Bando da Lua, musicians she brought from Brazil that performed with her in movies, on stage, and in concert venues and nightclubs.

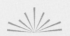

CARMEN MIRANDA

At the peak of her Hollywood career in 1945, Carmen Miranda was the highest-earning female performer in the United States. Miranda appeared in fourteen Hollywood movies, made major theater appearances, and performed in nightclubs

and concerts. She was one of the first stars to perform in the gambling mecca of Las Vegas and to appear in the new medium of television.

Born Maria do Carmo Miranda da Cunha in Portugal, her parents, Doña Emilia and José Maria Cunha, immigrated to Brazil when she was barely a year old. As a child, Miranda became fascinated by the Afro-Brazilian women of Bahia, the northeastern state where samba music originated. She would see the Bahiana women street vendors in Rio's Onze Plaza. Miranda studied the way the women walked, flirted, and moved their hands. She described it this way in a 1948 an interview in the *Times* of London: "In Brazil in Bahia, the girls carry the basket with the fruit on their head and they have big bracelets and big necklaces, and they sell fruit in the street, and I take it from the girls."[30]

As a young girl, she worked in a millinery shop, where she learned skills as a hatmaker and seamstress that would prove valuable later

in her career. Five-foot-tall Carmen combined her big green eyes and fine singing voice with necklaces, bracelets, and platform shoes to create a unique singing and dancing personality that took the world by storm.

While performing at Rio's Casino de Orca, she was approached by visiting theater impresario Lee Shubert and his wife, ice-skater-turned-movie-star Sonja Henie, who asked her to perform on Broadway. With assistance from the Brazilian embassy, which saw it as a way of fostering goodwill and strengthening ties with the United States, Miranda sailed to New York with her band. She arrived on May 18, 1939, to much fanfare. The firecracker told the press, "I say twenty words in English. I say 'money, money, money,' and I say 'Hot Dog!' I say 'Yes,' 'No,' and I say 'money, money, money' and I say 'Turkey sandwich' and I say 'grape juice.'"[31]

Miranda made her Broadway debut in *Streets of Paris* in June, appearing in the same revue

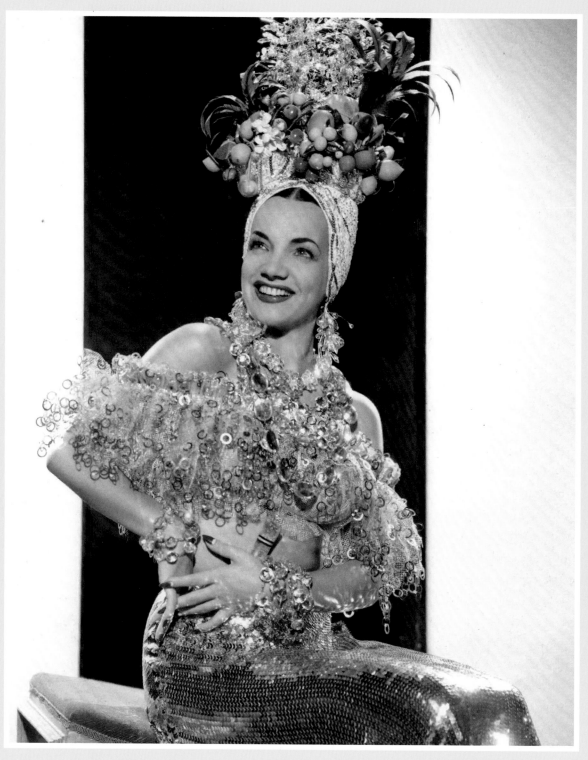

A portrait of Carmen Miranda from one of the ten 20th Century Fox musicals she appeared in during the 1940s.

with the comedy team of Abbott and Costello. She also performed at the historic 1939 New York World's Fair in the Brazilian Pavilion. New York had never seen anything quite like her, and Miranda became the most buzzed-about performer in town.

In 1940, 20th Century Fox produced the musical comedy *Down Argentine Way*, starring Don Ameche and Betty Grable. Even though the film was set in Argentina, the studio wanted Brazilian Carmen Miranda in the movie. Although Miranda could not leave her Broadway show to go to Hollywood because of contractual commitments, Darryl F. Zanuck, production head of Fox, desperately wanted her in the film. He arranged for her musical number "South American Way" to be produced and filmed separately at Fox Movietone Studios in New York, and to later be edited into the film. Carmen filmed during the day at the studio and performed on Broadway at night.

Finally making her way to Hollywood—and Fox—Miranda received star billing with Don Ameche and Alice Faye in the musical comedy *That Night in Rio* (1941), in which she had a speaking role. Though her English was limited, she utilized fractured English pronunciation and malapropisms to clever comedic effect. Miranda played Carmen in an exaggerated effervescent style, demonstrating jealous fits, shoe-throwing tantrums, and song and dance numbers in her signature Bahian wardrobe.

The styling of the Bahian clothing combined with the over-the-top additions by 20th Century Fox costumers Yvonne Wood and Kag Nelson created Miranda's iconic cinematic look. The signature style consisted of the Bahiana turban embroidered with pearly sequins topped by plastic fruit and beads, along with colorful cropped blouses, necklaces, embroidered skirts, and high platform shoes. Miranda soon became so identified with these adornments that she purchased them from Fox Studios and wore them in her live performances.

She stole every scene she was in. In its review of *That Night in Rio*, *Variety* wrote, "Ameche is very capable, in a dual role . . . and Alice Faye is eye appealing but it's the tempestuous Miranda who really gets away to a flying start from the first scenes."[32]

In the Technicolor musical comedy *Week-End in Havana*, she played nightclub performer Rosita Rivas, a girlfriend of suave gambler Monte Blanca (Cesar Romero), who finds Americano cruise ship representative Jay Williams (John Payne) just as attractive. Miranda and Romero make quite a screen team and show off their sparky comic flair. Miranda also sings show tunes and a Brazilian song, "Rebola a Bola" (Embolada), in Portuguese.

In *The Gang's All Here* (1943), Miranda is Dorita, a fiery Broadway entertainer who helps a chorus girl (Alice Faye) stage a war bond–selling variety show at serviceman James Ellison's family estate. Director/choreographer Busby Berkeley, master of geometrically designed musical productions, created the eye-popping, glossy, Freudian-laced Technicolor number with

sixty chorus girls with giant bananas joining Miranda in singing "The Lady in the Tutti Frutti Hat." It was a cinematic milestone that secured Miranda's image. She also has a beautiful musical number, introduced by respected bandleader and clarinetist Benny Goodman, to the tune "Paducah."

Copacabana (1947) starred Miranda and Groucho Marx, head of the irreverent Marx Brothers comedy team, in his only solo film effort. Mexican American singer Andy Russell (born Andrés Rábago) played himself as a hopeful young singer. Unfortunately, a comedic pairing that seemed like a guaranteed hit turned out to be a misfire. There were no sparks between the two able performers due to rote direction and a one-joke screenplay that left Miranda to carry the film through its low-budget black-and-white musical interludes. More was expected of a movie with the title of the legendary New York nightclub. After the extravagant Technicolor Fox musicals, this was a comedown for Miranda.

Despite the *Copacabana* fiasco, Miranda's career was on the upswing again when MGM signed her for two films. *A Date with Judy* (1948) was a bubbly musical focusing on two teenagers, Judy (Jane Powell) and Carol (Elizabeth Taylor), who fall for Stephen (Robert Stack), a college-age drug store clerk, while planning an anniversary party for their parents. Miranda is Rosita Cochellas, a dance instructor who unknowingly causes Judy's father Melvin's (Wallace Beery) marital problems. Melvin is secretly receiving rumba dance lessons from Rosita to surprise his wife on their anniversary when it is misconstrued that he is having an affair with Rosita. Celebrated Spanish-born bandleader Xavier Cugat appears with Miranda in the musical numbers "Cooking with Gas" and "Cuanto le Gusta."

In *Nancy Goes to Rio* (1950), Miranda is Marina Rodrigues, a Brazilian business partner in a Rio-American coffee company. The production never left MGM studios in Culver City, and the painted backdrops were—as was so often the case in the studio era—geographically off-course. Rio's famous landmarks, Sugarloaf Mountain and the Corcovado (with its *Christ the Redeemer* statue), are in plain view, in proximity, when in reality they are located miles—or better yet, kilometers—apart. Although Brazil is a multiracial society, there are no dark-skinned or Afro-Brazilians in the movie or in any Hollywood movie of the period set in Brazil.

When Miranda performed on tour in live venues in the United States with her musicians, the Banda da Lua, the band slept in segregated all-black hotels since they were banned from the whites-only hotels where Miranda stayed. The original band members were replaced in her later films, but Carmen kept the Banda da Lua on the payroll and provided them with housing. Cesar Romero reflected on Miranda's later career, saying she could never reinvent herself. "I remember attending one of her live performances, and the audience half-heartedly applauded; they had become bored with her act. She never changed."[33]

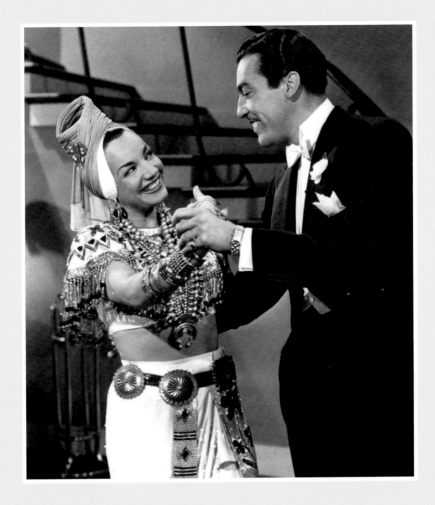

Carmen Miranda and Cesar Romero make a lively dancing and comic screen duo in their 20th Century Fox musical pairings in the early 1940s, *Week-End in Havana* and *Springtime in the Rockies.*

Romero opined that if Miranda had lived, she would have probably been rediscovered with the "camp" craze of the 1960s, which celebrated American pop culture and its icons.

Miranda's last screen appearance was in the Paramount comedy *Scared Stiff* (1953) with the comedy team of Dean Martin and Jerry Lewis. She performed a musical number, and rubber-faced Lewis did a tremendous drag impersonation of her.

A new era was launching. Television was experiencing explosive growth and popularity in homes across America at the beginning of the decade, and Miranda was one of the first stars to appear on the new medium. On August 4, 1955, she made a guest appearance on the popular *Jimmy Durante Show* in a comedy sketch. During a dance number with Durante, she appeared to miss a step and gasped for air. Durante helped her regain her footing. Miranda then smiled,

waved to the audience, and walked off stage.

After the show, she attended a reception, went home, and retired for the night. She was found dead the following morning. She was only forty-six. The misstep on the TV program the day before, unbeknownst to everyone—including Miranda—had apparently been a mild heart attack.

Miranda, the empowered, exciting woman in colorful clothes and fashion accessories, is still unforgettable nearly seventy years after her passing. She inadvertently started a fad and a fashion movement in America that was parodied and celebrated for decades to come. As early as 1941, Mickey Rooney performed a funny interpretation of Carmen Miranda in drag in the MGM musical *Babes on Broadway*. Warner Bros. Looney Tunes character Bugs Bunny does a Miranda parody in the cartoon short "What's Cookin' Doc?" (1944). In another WB cartoon, "Slick Hare" (1947), an animated rendering of Miranda performs in a brief segment with Elmer Fudd.

The Boston-based United Fruit Company redesigned their Miss Chiquita logo in 1944 into the Miranda-inspired Chiquita Banana, a woman with a hat full of fruit dominated by bananas. Chiquita sang a jingle in commercials and appeared in ads and on trademark banana product labels.

Much more recently, drag performers began incorporating Carmen Miranda interpretations into their acts, and she has become a recognizable symbol of the LGBTQ+ community. Whether worn by men or women, Miranda costumes are ubiquitous on Halloween. In an episode of the classic comedy series *I Love Lucy*, Lucille Ball—as Lucy—tries to keep her Cuban husband, Ricky Ricardo (Desi Arnaz), happy by turning their New York apartment into a fruit-laden tropical paradise. Lucy dons a fruit-laced headdress and outfit to remind Ricky of his mother and lip-syncs to Miranda's "Mamae Eu Quero." Despite the inroads made by the Good Neighbor Policy, most of middle America was oblivious to the nuances of Latin American culture. Yet so ingrained was Carmen Miranda's imagery in the American popular culture psyche that Lucy could only conjure up Ricky's Cuban mother in the image of the Brazilian Bahiana Miranda. Then and now, Carmen Miranda's imagery endures and fascinates.

CESAR ROMERO

Tall, Dark and Handsome (1941) perfectly described Cesar Romero and the roles he was suited to play. The six-foot-three actor was one of Hollywood's best looking and most suave personalities, instantly recognizable from his hundreds of movie

and TV appearances. Over the six decades of his career (1935–1994), Romero played a wide range of screen roles (gigolos, gangsters, historical figures) in genres from westerns to musicals, from light comedies to drama and horror. The talented actor also came in close contact with audiences by performing in regional dinner theaters across the country.

"I never considered myself a Latin actor," he once said. "I was born in New York City, and my mother was born in Brooklyn."[34] Cesar Julio Romero Jr. was born in Manhattan to Cuban parents. His maternal grandfather was the Cuban poet and liberator José Martí. His mother was Maria Mantilla, and his father, Cesar Julio Romero Sr., was an importer/exporter of sugar refining machinery.

At age eight, Romero dreamed of becoming an entertainer. In 1927, he realized the first step toward a show business career when, after a stint at a bank, Romero teamed up with a New York socialite and formed a dance team.

They danced ballroom-style in nightclubs and cafés throughout the city and were hired to perform in a Busby Berkeley show called *Lady Do* (1927) for fifty-six performances at the Liberty Theatre. Through this and subsequent appearances on Broadway, Romero made the jump from New York to Hollywood and landed a small role in MGM's *The Thin Man* (1934), the first in a popular film detective series starring Myrna Loy and William Powell.

Romero followed with a major lead role as the doomed lover Antonio Galvan, opposite Marlene Dietrich, who played the seductive Concha Pérez in Joseph von Sternberg's opulent *The Devil Is a Woman* (1935). The role of the young lover fit Romero like a glove, but Dietrich was out of her element, improbably playing a Spanish woman. By 1935, audiences had tired of this kind of melodrama, which was more suited to silent cinema. The film failed at

the box office and did little to boost Romero's career.

Fortuitously, Romero signed a contract with 20th Century Fox, where he remained for fifteen years. The studio made good use of him in a variety of roles. In *Wee Willie Winkie* (1937), directed by John Ford, Romero played Afghan leader Khoda Khan, who counsels America's most famous child star, Shirley Temple, in the colonial adventure film. Then he appeared as Asian prince Ram Dass, again with Temple, in *The Little Princess* (1939).

Romero was featured in a supporting role as Lopez in *The Return of the Cisco Kid* (1939). It was Warner Baxter's final film portraying O. Henry's colorful 1907 literary Latin antihero of the Old West, the Cisco Kid. Baxter won the Best Actor Oscar in 1929 for the role in the film *In Old Arizona* (1928), and a series of popular Cisco Kid films followed. Romero took over the lead in six Cisco Kid films for the studio. He brought sophistication, charm, and flair to the part. In his first outing as Cisco, *The Cisco Kid and the Lady* (1939), he dances the tango with saloon girl Billie (Virginia Field) with sublime ease in a setting full of rugged cowboys.

Romero starred to good effect as legendary dentist turned gunfighter Doc Holliday (Halliday in the film) opposite Randolph Scott's Wyatt Earp, in the western *Frontier Marshal* (1939) directed by Allan Dwan. He remembered, "I ran into director John Ford on the lot who complimented me on my work in *Frontier Marshal* and said he would keep me in mind as

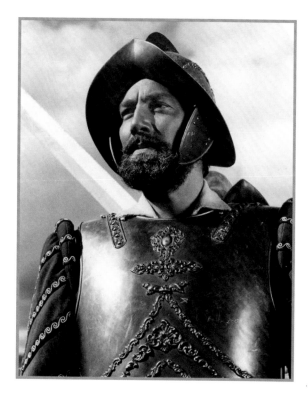

Cesar Romero as Hernán Cortés in *Captain from Castille* (1947). Filmed in Mexico, it is the only Hollywood film to depict the sixteenth-century Spanish conquest of Mexico.

he was planning a western, telling a true version of the Earp-Holliday OK Corral story. Nothing came of it."[35] Ford filmed his version as *My Darling Clementine* in 1946 with Henry Fonda and the beefy Victor Mature as Doc Holliday. Romero added, "The next time I worked with Ford was twenty-two years later in *Donovan's Reef*, when he was past his prime."

Romero's talent was also utilized in musicals starring Fox's top star at the time, Betty Grable. In *Springtime in the Rockies* (1942), Romero displayed his underutilized dance talents in a musical number with Grable. The film also featured an exciting performance by Carmen

Miranda. As in *Week-End in Havana*, the two Latin stars add significant comedic effect to the proceedings. In *Coney Island* (1943), Romero forms a love triangle with George Montgomery for Grable's affections. These light films were an antidote to Americans living in the throes of World War II. Romero soon joined the fight, enlisting in the US Coast Guard.

After the war, Romero and his good friend and fellow Fox star Tyrone Power took off on a two-month goodwill promotional tour of Latin America, sponsored by the studio and the US State Department. Power, who had served as a marine pilot during the war, flew a twin-engine Beech aircraft on the twenty-two-thousand-mile trip aided by a copilot. Romero, who spoke Spanish, acted as principal translator. They stopped in many South American countries, Cuba and other Caribbean islands, Mexico, and Central America, and visited with heads of state. Enthusiastic crowds greeted the screen stars wherever they landed.

Back in Hollywood, Romero and Power costarred in *Captain from Castille*, in which Romero played the Spanish conquistador Hernán Cortés in a bravura performance that brought to life the zeal of the explorer who risked it all for fame and fortune. He had Power, who suggested him for the film, to thank for what would become Romero's favorite among all his roles. Filmed on location in Mexico, *Captain from Castille* was an epic Technicolor production directed by Henry King that drew huge audiences. *Variety* lauded,

"The roster is buttressed by Cesar Romero in a stirringly virile portrait of Cortés."[36]

After his tenure at 20th Century Fox ended, Romero freelanced in motion pictures and television. In the science fiction film *Lost Continent* (1951), he starred as Major Joe Nolan, who, with a group of scientists, is sent on a mission to recover an atomic rocket missing somewhere in the South Pacific. This was one of the first films to deal with the Cold War paranoia that spawned dozens of thematic science fiction films in the '50s about atomic science gone astray.

Frank Sinatra, Cesar Romero, and Deborah Kerr in a scene from *Marriage on the Rocks* (1965).

Burgess Meredith as the Penguin, Frank Gorshin as the Riddler, Lee Meriwether as Catwoman, and Cesar Romero as the Joker are a quartet of villains in *Batman* (1966–1968).

performance by Acquanetta, who was promoted as the "Venezuelan Volcano" but was actually Mildred Davenport from Cheyenne, Wyoming, of mixed Native American and Caucasian ancestry. Her most significant film role in her short career was in *Tarzan and the Leopard Woman* (1946) with Johnny Weissmuller.

Due to his versatility, Romero managed to escape that kind of Hollywood pigeonholing. He remarked to this author, "I was never stereotyped as just a Latin lover in my case because I played so many parts in so many movies. I was more of a character actor than a straight leading actor."[37]

The next decade saw the star in a range of roles. He played a scheming French military attaché effectively in Robert Aldrich's post–Civil War western *Vera Cruz* (1954). Next, he traveled to Brazil for a leading role as bandit leader Manuel Silvera in *The Americano* (1955), a western starring Glenn Ford.

Romero was particularly effective in the iconic *Oceans 11* (1960), as retired gangster Duke Santos, who wants his cut of the Las Vegas casino heist loot taken by Danny Ocean (Frank Sinatra) and his army buddies. In its review the *New York Times* said, "Cesar Romero does a smooth job as the hijacker who messes up the job."[38] Romero took a turn as the villain A. J. Arno in three Walt Disney madcap comedies starring young Kurt Russell as college student Dexter: *The Computer Wore Tennis Shoes* (1969), *Now You See Him, Now You Don't* (1972), and *The Strongest Man in the World* (1975).

In 1965, Romero was cast in a role for which he is still remembered today: the archvillain

Batman TV series (1966–1968). The Joker was based on the DC Comics character, and Romero also played the role in the feature film *Batman* (1966) based on the TV series. "I thoroughly enjoyed playing the Joker," said Romero in a 1989 interview.[39] "Why producer William Dozier wanted me for *Batman*, I haven't the slightest idea what it was he saw me in, because I had never done anything like it before."

A clownish appearance, devilish laugh, purple suit, and green wig characterized his Joker. Romero played the character in a hammy and diabolically fun way, in keeping with the comic book tone of the TV show, unlike the psychological, dark portrayals by Jack Nicholson (*Batman*, 1989), Heath Ledger (*The Dark Knight*, 2008), and Joaquin Phoenix (*Joker*, 2019).

Years later, Romero became ambivalent about the role as he confessed to this author, "I had participated in a community parade, and when they saw me, all the kids and their parents exclaimed, 'There Goes the Joker. It's the Joker from Batman.' Out of my long career and everything I had done, I was being singled out for the role of the Joker." Romero reflected for a moment and said, "I guess it's good to be remembered for something. . . . I always knew I was the second banana, not the leading man, and that was okay with me; I am still here working. Many of my contemporaries are dead or no longer working. . . . Maintaining a career, longevity that is

Cesar Romero portrait, circa 1992.

key, and it's not easy. I've been fortunate."[40]

After a lifetime of livening up both the big and small screens, Romero was honored with a Life Achievement award from the Latin arts advocacy organization Nosotros in 1984. He died of complications from a blood clot while battling pneumonia and bronchitis at Santa Monica Hospital in 1994.

Maria Montez portrait, circa 1940s.

MARIA MONTEZ

Copper-haired Maria Montez from the Dominican Republic was billed as the "Queen of Technicolor" in otherworldly woman-centric adventure films at Universal Pictures during the 1940s. Montez was one of Universal Studios' biggest box-office

draws of the decade, along with the comedy team of Abbott and Costello, singer Deanna Durbin, and the Dracula, Frankenstein, and Mummy horror film franchises. Her screen presence captivated audiences in her first starring outing in a color film, playing Scheherazade, the tempting Arabian dancing girl in *Arabian Nights* (1942).

It was reported that upon seeing herself on screen in Technicolor, Montez exclaimed, "When I look at myself, I am so beautiful. I scream with joy." A few years later, she denied having said it and attributed the quote to Universal's publicity department. Despite her heavy accent, Montez succeeded in roles that emphasized her forceful personality and capitalized on her beauty, sexy costumes, and sincere performances.

Once Universal discovered Montez's onscreen niche, she was teamed in six pictures with Jon Hall, a leading man who complemented her by not drawing attention away, as an all-purpose,

charismatic leading man of limited range. Of Polynesian Caucasian descent, Hall found a similar niche in romanticized movies set in faraway places and achieved stardom with Dorothy Lamour in the South Seas film *The Hurricane* (1937). Montez's other most frequent leading man was Turhan Bey, the Austrian-born son of a Turkish diplomat and a Jewish Czech woman. Bey appeared in seven films with Montez.

Montez was born María África Gracia Vidal in Barahona, in the Dominican Republic. Her father, Isidoro Gracia, of Spanish descent, was born on Isla de la Palma in the Canary Islands. Her mother was Regia Teresa Maria Vidal. At the time of Montez's birth, her father was a prominent businessman who also held a diplomatic post as honorary Spanish consul stationed in the Dominican Republic. After she spent her childhood there, her father was transferred to a post in Ireland where, in 1930, Maria met and married an Irish banker.

with her costar, Montez sued producer/star Fairbanks, who ultimately paid the actress a $250,000 settlement.

Although the end of the war had cooled America's appetite for exotic adventure tales, Universal squeezed as much as they could from their winning formulas to the eventual detriment of the films and diminishing box-office returns. Montez, an intelligent businesswoman, saw the writing on the wall. "*Sudan* is making more money than the others, and Universal thinks on that account I should appear in more of these films," she said in a 1944 *Los Angeles Times* interview. "But I want to quit these films when they are at their peak, not on the downbeat."[42] *Pirates of Monterey* (1947) was Montez's last film under contract to Universal.

Though she had misgivings about some of her roles, as soon as Montez left the studio, she signed on to star with her husband in the kind of film that had served her well previously, *Siren of Atlantis* or *Atlantis* (1949). The sultry Queen Antinea (Montez) rules an ancient city hidden beneath the sands of the Sahara Desert, discovered by a French legionnaire (Aumont) and his buddy (Dennis O'Keefe).

Under the artistic resources and imagination of Universal, it could have been a better-than-average formulaic film, but trouble-plagued from the start, the independent production went through several directors and writers and was a box-office flop. *Atlantis*'s one redeeming value

Maria Montez and Jon Hall in *White Savage* (1943).

was the exquisite black-and-white photography of Montez by Oscar-winning cinematographer Karl Struss.

In 1949 Montez moved to Paris with her husband to raise their new baby daughter and continue with projects there. In Europe, she appeared in five films, and it was reported that she had received an offer from Universal in 1951 to return to Hollywood, but it was not in the cards. Tragically, Maria died in her bathtub at home after a heart attack caused her to drown in the hot water. She was thirty-nine years old.

TITO GUÍZAR

A native of Guadalajara, Mexico, Federico Guízar Tolentino, known as Tito Guízar, was one of the first performers to bring Mexican music to New York and the rest of the United States. In 1929, he recorded for RCA Victor Records, and he

later hosted his own radio program. He appeared in Hollywood movies from 1938 through the 1940s. Guízar launched the Mexican singing cowboy film genre with the internationally popular Mexican film *Allá en el Rancho Grande* in 1936, the same year he performed at New York's prestigious Carnegie Hall. The tall, handsome Guízar was under contract with Paramount Pictures and was featured singing in a musical segment of *The Big Broadcast of 1938*, starring Bob Hope, and in the film *Tropic Holiday* (1938). He was Blondie's love interest in *Blondie Goes Latin* (1941), before Paramount turned him into a hero/bandit in the B western *The Llano Kid* (1939), directed by Argentinean-born Edward Venturini, who had previously directed Spanish-language productions and Hopalong Cassidy westerns. A newspaper review of the time singled him out, saying, "Chief merits of the film are the personal charm and singing of Guízar and

the lovely Mexican scenery [actually Lone Pine, California] which has been beautifully photographed."

Guízar was paired with his US singing cowboy counterpart Roy Rogers in *On the Old Spanish Trail* (1947) and *The Gay Ranchero* (1948). His other film credits include *St. Louis Blues* (1939), *Brazil* (1944), and *Mexicana* (1945).

Tito Guizar and Martha Raye in *Tropic Holiday* (1938).

JOSÉ ITURBI

Largely forgotten today, José Iturbi was, from the 1930s through the 1970s, one of the world's greatest and most popular classical pianists of his generation. Though he performed in concert venues worldwide and sold millions of

classical recordings, his popularity was enhanced by his appearance in seven MGM films at the height of his career.

Iturbi was famous enough to play himself in his film appearances, and he was usually featured in a musical interlude combining a classical rendition with a more modern piece. He performed "Joint Is Jumpin'" with Judy Garland in *Thousands Cheer* (1943) and played a honky-tonk style "Route 66" in *Three Daring Daughters* (1948).

"I entered motion pictures because, first of all, I thought I'd enjoy it, which I did. I felt that classical music should be a more recognizable part of everyman's entertainment, and it has been my great hope that through motion pictures, a larger group of people would learn to like classical music and attend live concert performances," said Iturbi in a 1945 interview.[43] Iturbi was a child prodigy born in Valencia, Spain. His father, Ricardo Iturbi, built and

tuned pianos, and José took up the keyboard as soon as he could reach the keys. His love for motion pictures began at an early age too, when, to help with family finances, he played musical accompaniment to silent motion pictures in his hometown.

Arriving in California in 1939, Iturbi found his fame had preceded him. His concerts at the legendary Hollywood Bowl sold out as soon as they were announced. Film appearances followed shortly after. In 1945, Iturbi was hired by Columbia Pictures to provide the piano score to the biographical film of Frédéric Chopin, *A Song to Remember*, starring Paul Muni, Merle Oberon, and Cornel Wilde. Iturbi did not appear in the film, but his soundtrack renditions of Chopin's greatest piano repertoires helped make the movie an enormous hit. The *New York Times* wrote in its review, "Jose Iturbi, the unseen and unbilled double for Chopin (Cornel Wilde) at the piano,

World-famous concert pianist Jose Iturbi

is the real star of the picture, for it is the score which sways most brilliantly."[44] Iturbi recorded his rendition of Chopin's "Heroic Polonaise in A-flat" as heard in the movie, and it sold more than a million copies, making Iturbi the first classical artist to achieve that distinction.

His achievements were not without controversy, as classical music purists accused him of having "sold out" to commercial interests. But the maestro continued recording and performing in live concert venues worldwide until his death in 1980.

XAVIER CUGAT

Through recordings, personal appearances, radio, motion pictures, and television, bandleader Xavier Cugat pioneered and popularized Latin music and dance in the United States during the first half of the twentieth century. A slight

man with a thin mustache and toupee, Cugat displayed onstage showmanship that distinguished his band from others of the day. His performances were distinctive for a few reasons: he sometimes cradled a Chihuahua, his band dressed in colorful tropical matching outfits, and a beautifully gowned woman as lead singer highlighted the music.

Cugat was born in Barcelona, Spain. In a 1960 *Los Angeles Times* interview, he recalled, "My father was a political refugee from Spain, and we moved to Cuba when I was two. I was lucky too because we moved across the street from a violin maker, and when I was four, he gave me a present."[45] The young man developed into a musical prodigy with his violin and was accepted into the Teatro Nacional de Cuba. When legendary opera singer Enrico Caruso visited Cuba, he was impressed with the young Cugat's musical abilities and invited him to New York. Cugat got himself there, but shortly

after his arrival Caruso died unexpectedly. "There I was, no friends and not a word of English, and not much money," he remembered. "I found a restaurant with a Spanish name and someone who spoke Spanish. I played music there for food and lodging but no money."[46]

A man of many talents, Cugat possessed considerable skill as an artist and upon his move to California in 1924, he was employed as a newspaper caricaturist by the *Los Angeles Times*. However, Cugat decided to follow his musical calling, and inspired by the Afro-Cuban rhythms he was exposed to in his youth, he formed a Latin dance band with six musicians. This was a daring move in the 1920s, when Latin music was virtually unheard of in mainstream America except for the Argentinean tango, which was labeled "gigolo music."

Cugat's band found work at the famous Cocoanut Grove nightspot at the Ambassador

Latin bandleader Xavier Cugat holds his favorite Chihuahua, circa 1940s.

spots. That Rita was about twelve years old then. I didn't see her for fifteen years, and when I did, she had a new name and a lot more besides. The new name was Rita Hayworth."[47]

Success in Hollywood nightclubs brought Cugat's band to a coveted spot at New York's world-famous Waldorf Astoria Starlight Ballroom. He made his first feature film appearance, billed with his orchestra, in *Go West, Young Man* (1936), in which a hip-swinging Mae West dances to the tune "A Typical Tropical Night," backed by Cugat and his band. He later appeared with West again in *The Heat's On* (1943). The bandleader's next major on-screen appearance was with Rita Hayworth and Fred Astaire in *You Were Never Lovelier*. Astaire and Hayworth tripped the light fantastic to his orchestral accompaniment.

Hotel in Los Angeles. He also worked as a musician at Warner Bros., which was experimenting with sound before its feature-length introduction in *The Jazz Singer*. Cugat said, "The kids were working there at the time; my niece Margo was in one little short film we did, and so was Margarita Cansino, who used to dance with her father Eduardo at border

Cugat is credited with twenty motion picture appearances including thirteen MGM musicals, and his legacy lives on with his tune "Chui Chui" (from *You Were Never Lovelier*), featured in the 2006 animated film *Happy Feet*, and his 1934 theme song recorded in 1945 as "My Shawl" with Frank Sinatra, featured in *Kit Kittredge* (2008).

LINA ROMAY

Lina Romay was a lead singer in Xavier Cugat's band before becoming an actress. She appeared in nineteen movies as an actress and seven as a singer. Born Maria Elena Romay in New York City, she was the daughter of Porfirio Romay, a Mexican

diplomat, and his wife, Lillian Mae Walstead.

Romay and singer Miguelito Valdés were featured in Cugat's band in *You Were Never Lovelier*. After her appearance with Cugat in *Bathing Beauty* (1944), followed by *Two Girls and a Sailor* (1944) and *Week-End at the Waldorf* (1945), MGM signed Romay to a contract in 1945.

In *Adventure* (1945), she was showcased in the role of Maria, the former flame of a character played by MGM's most important star, Clark Gable. She told the *Los Angeles Times* in a 1945 interview, "Clark Gable and Victor Fleming, the director, helped me in every way, and I hope the audiences like the character and my work."[48]

Next, Romay was paired with MGM's popular star Mickey Rooney in an Andy Hardy series installment *Love Laughs at Andy Hardy* (1946). Romay was teenager Shirley Temple's rival as Raquel Mendoza in *Honeymoon* (1947) and later costarred opposite Randolph Scott in the lavish Warner Bros. Technicolor western *The Man Behind the Gun* (1954).

Romay married and then retired from films, but enjoyed a second career as a Spanish-language announcer at the Hollywood Park racetrack. "I know I looked like hot stuff in my movies," she declared in a *Los Angeles Times* interview years later, "and I was hot stuff."[49]

Lina Romay is the saucy singing señorita in *The Man Behind the Gun* (1954).

Olga San Juan and Fred Astaire in the classic "Heat Wave" musical dance number from *Blue Skies* (1946).

OLGA SAN JUAN

Attired in colorful tropical outfits, tiny and vivacious Puerto Rican singer-dancer Olga San Juan was Paramount Pictures' answer to Carmen Miranda, though, unlike Miranda, she was born in the United States and spoke perfect English. San Juan

was born in Brooklyn, New York, to Puerto Rican parents and raised in Manhattan's Spanish Harlem. She exhibited singing and dancing talents early. At sixteen in 1943, she was hired as a Copa Girl at New York's famous Copacabana nightclub, where a Paramount talent scout noticed her and signed her to a contract.

She performed in several short films that Paramount produced to bolster the Good Neighbor Policy, including *Caribbean Romance* (1943) and the Oscar-nominated *Bombalera* (1945), in which she was billed erroneously as the "Cuban Cyclone." She made her feature film debut with a minor role as an island girl in *Rainbow Island* (1944). Her singing and dancing talents were put to excellent use by the studio in the Bing Crosby/Fred Astaire Technicolor musical *Blue Skies* (1946), featuring the music of famed composer Irving Berlin. San Juan played Nita Nova and sang a duet with Crosby, "I'll See You in C-U-B-A," and she performed a torrid dance with Astaire in "Heat Wave." She was next in the all-star *Variety Girl* (1947), *One Touch of Venus* (1948) with Ava Gardner, and in writer/director Preston Sturges's *The Beautiful Blonde from Bashful Bend* (1949). She married actor Edmond O'Brien in 1948 and retired from performing to raise her family.

ARTURO DE CÓRDOVA

Arturo de Córdova was one of Mexican cinema's handsomest leading men. He was put under contract to Paramount Pictures in 1943, but never found a following in the United States, despite gracing some high-profile films and speaking

unaccented English. Dissatisfied with his Hollywood experience, he returned to work in Mexican cinema, where he remained an in-demand leading man.

He was born Arturo Garcia Rodriguez in Merida, Yucatan, to Cuban parents. The family moved to the United States, then to Argentina and Switzerland, where he studied languages. He returned to Merida and was hired as a radio announcer. Mexican movie producers expressed interest in him, and on the advice of a friend, he changed his name to the more theatrical Arturo de Córdova.

In Hollywood, he was cast as Augustin opposite Gary Cooper and Ingrid Bergman in the film adaptation of Ernest Hemingway's *For Whom the Bell Tolls* (1943). He starred as a swashbuckling pirate known as the Frenchman opposite Joan Fontaine in the sumptuous Technicolor film *Frenchman's Creek* (1944), and he was perfectly cast as Joe Morales in *A Medal for Benny*, playing a

friend of the never-seen title character.

New Orleans (1947) was de Córdova's last Hollywood film before returning to Mexico. He played Nick, the proprietor of a Basin Street nightclub, a haven for African American musicians who play jazz well into the morning hours. The movie is memorable for the supporting roles played by jazz great Louis Armstrong and the legendary songstress Billie Holiday in her only film role.

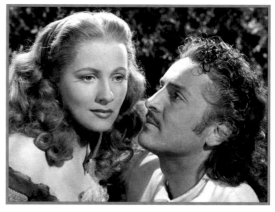

Joan Fontaine and Arturo de Córdova in the lavish, big-budget Technicolor pirate adventure *Frenchman's Creek* (1944).

PEDRO ARMENDÁRIZ

Pedro Armendáriz was Mexico's most iconic leading man of the golden age of Mexican films (1935–1965). His career encompassed work in Mexico, Hollywood, and Europe from 1935 until his unexpected death in 1963. The actor became the

cinematic personification of Mexican masculinity in much the same way his US counterpart, friend, and frequent costar John Wayne symbolized American manhood and values.

Among his Hollywood work, Armendáriz is best recognized today as Ali Kerim Bey, the Turkish head of the British Secret Service in the second James Bond film, *From Russia with Love* (1963), starring Sean Connery.

Pedro Gregorio Armendáriz Hastings was born in Mexico City to Pedro Armendáriz Garcia Conde and Adela Hastings Peña. His father died when he was nine, and his mother took him and his brother to live with their maternal grandparents in Laredo, Texas. Sometime later, Armendáriz connected with an uncle in California, made his way to San Luis Obispo, and attended California Polytechnic State (now Cal Poly). Intending to study engineering, he became interested in theater and participated in several school productions.

Upon graduation at age twenty, Armendáriz returned to Mexico City, where he found employment as a tour guide because of his proficiency in English. During a break, to amuse himself and the tourists, he began to spout a *Hamlet* soliloquy. This caught the attention of Mexican director Miguel Zacarías, who was dining at a nearby restaurant.

The young, handsome Armendáriz, with piercing green eyes and dark Mestizo features, seemed ideal for the burgeoning national cinema. His first film was *Rosario* (1935), and, over a twenty-five-year career in which he appeared in more than a hundred films, the actor became known for playing men of action, whether Indigenous peasants, revolutionaries, or gallant horsemen.

Mexican director/writer Emilio "el Indio" Fernández teamed him with star Dolores del Rio in a series of celebrated films that established the worldwide recognition of the artistic merits

of Mexican cinema and launched Armendáriz and del Rio as a screen couple. *Flor silvestre* (*Wild Flower*) was followed by the phenomenal success of Cannes Film Festival Grand Prix winner *Maria Candelaria*, both in 1943. Armendáriz also scored huge success playing the ill-fated fisherman Quino in the Mexican-RKO adaptation of John Steinbeck's novella *The Pearl*, directed by Fernández and photographed by Gabriel Figueroa.

When director John Ford went to Mexico to film *The Fugitive*, he sought the Mexican film industry's best talents. He cast Armendáriz as the army officer relentlessly pursuing a lone Catholic priest (Henry Fonda) in an unnamed Latin American country run by an anti-clerical regime. Ford and Armendáriz became fast friends during the shoot. The director, recognizing the actor's commanding screen presence and the Mexican star's added box-office appeal, gave the actor a costarring role in his next film.

In *Fort Apache* (1948), Ford's fictional retelling of Custer's last stand, Armendáriz plays cavalry Sgt. Beaufort, starring alongside John Wayne and Henry Fonda. His character is from New Orleans, described as the son of a Mexican mother. In the film, Captain York (Wayne) is sent on a dangerous mission by Colonel Thursday (Fonda) to meet with the Apache leader Cochise (Miguel Inclán). Beaufort accompanies York as a guide and translator. Though historically authentic, the Spanish dialogue for Cochise was inserted to accommodate Mexican actor

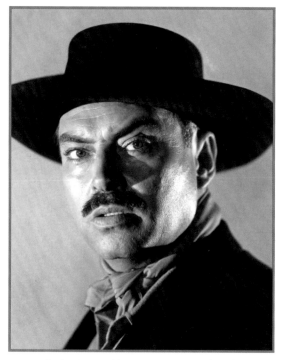

Pedro Armendáriz in *Border River* (1954).

Inclán, who did not speak English. The scene between Fonda and Inclán with Armendáriz as the interpreter is multilingual screen acting at its best and rarely done.

In Ford's interpretation of the Christmas parable of the Three Wise Men, *3 Godfathers* (1948), an MGM Technicolor western, Armendáriz stars with Wayne and Harry Carey Jr. The three men are bank robbers on the run who come upon a lone covered wagon in the desert. Inside is a young woman about to give birth, who dies soon after bearing a son. The three outlaws care for the orphaned newborn while dodging the law and surviving in the harsh desert. This beautifully filmed, sentimental western was a hit upon its release and has gained even greater popularity through the years with its repeated

showings on television and cable stations as a Christmas favorite.

Though Armendáriz had leading roles in Mexican films, he was relegated to costarring and supporting character roles in Hollywood. But he successfully alternated between Mexican- and American-made movies. In *Tulsa* (1949), opposite Susan Hayward and Robert Preston, Armendáriz is third-billed as Native American Jim Redbird, who helps a cattle rancher's daughter fight oil interests during the Oklahoma oil boom of the 1920s. Back in Mexico, a strange twist of fortunes found him starring opposite film star María Félix in a romantic comedy, *Enamorada* (1946), directed by Emilo Fernández. It is the story of a revolutionary general who takes over the town of Cholula and falls for the wild and beautiful Beatriz (Félix), the daughter of the town's wealthiest citizen. The film was a hit and was seen by American actress Paulette Goddard, who loved the character of Beatriz and envisioned an English-language remake with herself in the part. It took Goddard and producer Bert Granet several years to secure the financing for the production, which was renamed *The Torch* (1950). The movie was shot on the same Mexican locations and utilized the original film's key personnel, including director Fernández, cinematographer Gabriel Figueroa, and Armendáriz.

However, it failed to capture lightning in a bottle, losing something in its English-language remake.

In *Border River* (1954), a Universal Technicolor western with Joel McCrea and Yvonne De Carlo, Armendáriz was in fine form as General Elias Calleja, who runs the Mexican border refuge for outlaws. Mexican actor Alfonso Bedoya also shines as a henchman for the general.

Never a leading man in Hollywood films, Armendáriz played assorted ethnic supporting costarring roles in prominent motion pictures. He portrayed Mongol Chieftain Jamuga in *The Conqueror* (1956), a big-budget RKO

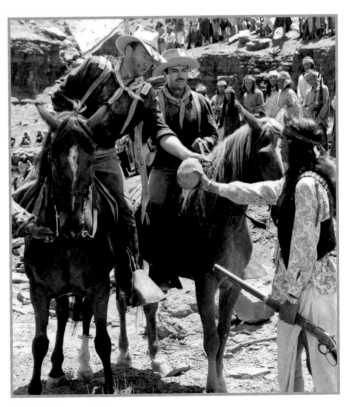

John Wayne as Capt. Kirby York and Pedro Armendáriz as Sgt. Beaufort ride into an Apache stronghold in Fort *Apache*.

Howard Hughes production that featured such improbable casting as John Wayne as Genghis Khan and Susan Hayward as a Tartar princess. Filmed partially on location in Snow Canyon, near St. George, Utah, the production would years later come to haunt all those involved in it.

In the western *The Wonderful Country* (1959), Armendáriz portrays Chihuahua state governor Cipriano Castro, who employs exiled American gunman Martin Brady (Robert Mitchum) to run guns across the border to the United States. Next up, Armendáriz traveled to Havana, Cuba, for a role in one of Errol Flynn's last motion pictures, *The Big Boodle* (1957), in which he played a police chief to Flynn's casino croupier with a checkered past. The film was made with a Mexican film crew, and the routine drama's highlight was its location filming in pre-Castro Cuba.

In *Flor de mayo/Beyond All Limits* (1959), Armendáriz played a wealthy businessman who discovers that his wife's (María Félix) former American lover (Jack Palance) has moved close by. After a series of encounters, the businessman suspects his young son is not his own progeny. This film is often mistakenly cited as the only American film Mexican screen icon María Félix starred in, but was in fact made by a Mexican production company with Pedro Armendáriz and multilingual American actor Jack Palance. It was released in the United States with Félix's dialogue dubbed into English.

In 1960, Armendáriz checked himself into a hospital and was diagnosed with kidney cancer. In the years following the 1954 filming of *The Conqueror*, many cast and crew died from rare forms of cancer. Armendáriz and director Dick Powell were the first to fall victim, followed by Susan Hayward, John Wayne, Agnes Moorehead, Thomas Gomez, Lee Van Cleef, and many St. George residents. In 1980, *People* magazine reported that 91 of the 220 people who worked on the film came down with some form of cancer, and forty-six died from it. The high cancer rate was later linked to radiation exposure at the filming location, which was 137 miles downwind from the above-ground US government atomic bomb testing site in Yucca Flats, Nevada, that was in used in the 1950s. After an atomic blast, radioactive dust could travel hundreds of miles and settle in the canyon area.

Telling no one of his condition and subsequent treatments, Armendáriz continued to work steadily. He traveled to Germany for the King Brothers fantasy adventure *Captain Sindbad* (1963), opposite Guy Williams (TV's Zorro). Armendáriz signed on to play the wily and crafty Kerim Bey in *From Russia with Love*, a British production filmed in Istanbul and at Pinewood Studios in London. Having difficulty walking and in pain during location shooting, Armendáriz had a meeting with director Terence Young and told him the truth of his precarious health upon returning to London.

In Steven Jay Rubin's *The James Bond Movie Encyclopedia*, Young, in a 1974 interview, related his experience working with the ailing Armendáriz: "The actor said he was working as much as he can to ensure his wife's and family's

Pedro Armendáriz as Kerim Bey in the James Bond 007 adventure *From Russia with Love* (1963).

financial security. 'Help me,' he asked. 'I think I can give you two more weeks. Can you finish with me in that time? I would like to get the money and finish the movie.'"⁵⁰ The director understood the gravity of the situation and, with urgency, rearranged the schedule so he could complete Armendáriz's remaining scenes as quickly as possible. On June 8, 1963, Armendáriz finished his scenes and was given a going-away party before leaving London.

Two days later he checked into UCLA Medical Center in West Los Angeles, where doctors told him his lymphatic cancer was terminal and he had a year to live, at best. Armendáriz sent his wife Carmen out for lunch, removed a pistol he carried in his luggage, and shot himself, dying by suicide rather than face a lingering, agonizing death.

In retrospect, Armendáriz's last scene in *3 Godfathers* is an eerie foreshadowing. Exhausted and without water in the desert, Pete falls and breaks a leg. He can go no further and asks Wayne to leave him a pistol for "protection against coyotes." As Wayne walks away, he hears a single gunshot behind him.

His son, Pedro Armendáriz Jr. (1940–2011), followed in his father's footsteps and became a prolific actor. He made more than 140 films in Mexico and frequently appeared in Hollywood productions, including *Old Gringo* (1989), *The Mexican* (2001), and the James Bond adventure *License to Kill* (1984).

Present and Accounted For: Hollywood Film Classics

Latino/Latina talent have been a vital presence in many classic films of the Hollywood studio era from the 1920s through the late 1960s. But theirs is often an unsung or scarcely recognized presence. In some instances they made important contributions, and in others, they were minor, but all in all, they were a significant part of the collaborative art and technology of motion picture production. This chapter highlights their important contributions of both in front of and behind the camera in such classics as *King Kong*, *Citizen Kane*, and *Casablanca*, among many others.

KING KONG

RKO 1933 / DIRECTORS: MERIAN C. COOPER AND ERNEST B. SCHOEDSACK

The visual effects in the movie *King Kong* were headed by Willis O'Brien. The men behind the magic of the landmark film, crucial members of his special effects team, were unheralded Mexican Americans, Marcel Delgado and matte painter

Mario Larrinaga. Delgado was the chief model maker and sculptor on the film.

Born in La Parrita, Coahuila, Mexico, Delgado moved with his family to California in 1909. A self-taught sculptor, Delgado met special effects pioneer Willis O'Brien when the two took art classes on model making. O'Brien developed the art of stop-motion animation for motion pictures, a technique in which model figures are repositioned by hand several film frames at a time to create the illusion of movement. Impressed with Delgado's abilities, O'Brien offered him a job at his studio, but Delgado declined as he was already employed. O'Brien was persistent. After rejecting his offer three more times, Delgado finally said yes, and the twenty-one-year-old suddenly had his own studio workshop. O'Brien tested the young man's ingenuity and creativity and gave him no direction as to what was needed. Delgado had

to devise a way to sculpt the models and make them look realistic when movement was added for the camera. Starting from scratch, having to gather reference materials that were not readily available, Delgado worked the dinosaur models for what became the 1925 silent film classic *The Lost World*. Between assignments for O'Brien, Delgado worked as a prop maker at the studio and other related jobs.

When O'Brien began work on a project for producer Merian C. Cooper called *Creation* (1931), the storyline was rejected, but the project morphed into what became *King Kong*. The now-famous story follows filmmaker Carl Denham and his crew as they venture on an expedition with a pretty young blonde actress (played by Fay Wray) to an uncharted island, in the hopes of finding and filming a legendary giant ape. Getting more than they bargained for in the form of the massive King Kong, they

eventually subdue and capture the creature and bring it back to New York City. Billed as the "eighth wonder of the world," the ape escapes at its unveiling and terrorizes the city's inhabitants on a rampage of destruction, culminating in an iconic climb up the Empire State Building.

Delgado created two eighteen-inch models of Kong used for most of the film's action. The Kong models were crafted from rubber and sculpted with musculature fashioned onto a steel frame covered with latex and rabbit fur. The models would fall apart by the end of the day's shooting, so Delgado rebuilt one while the other was being used. After the day's filming, Delgado worked late into the night on the models to have them ready for the following morning.

Delgado also sculpted a twenty-foot Kong head equipped with levers, so facial expressions could be manipulated by three technicians. With the help of his brother Victor, Delgado built the full-size armature designed by O'Brien for the Kong hand that would hold Fay Wray. For all his hard work, Delgado's Mexican background and limited English proficiency made him a target of ridicule, and he was often snubbed by his coworkers.

Willis O'Brien received a fair amount of criticism from the Hollywood establishment for turning down the Oscar the Academy offered him for *Kong* in 1933. O'Brien vowed to refuse the honor unless his crew also received awards. The Academy of Motion Picture Arts and

Sciences declined to do so. Delgado would say that the miniature work on *Mighty Joe Young* (1949), a technologically more sophisticated sequel to *King Kong*, was his best. The film earned producer Merian C. Cooper a Special Effects Oscar that Cooper gave to the deserving special effects master, Willis O'Brien. Delgado was matter of fact about his groundbreaking accomplishments and the enduring popularity of *King Kong*. Almost forty years later, in a 1970 interview, Delgado said, "No, I didn't have no feeling. It was a job that was over. You know you don't know what is going to happen. I mean, when you work in a thing like that, you just move on. You got paid whatever you got paid. That was it. That's all it means to you."[51]

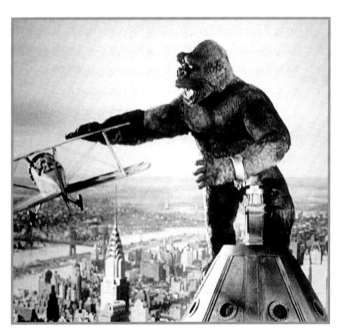

A defiant King Kong atop the Empire State Building in New York City while circling aircraft attempt to shoot him down.

Clark Gable and Leo Carrillo in
Too Hot to Handle (1938).

plays Villa's ruthless cohort, Sierra. Carrillo, a descendant of California's early Spanish-Mexican settlers was born Leopoldo Antonio Carrillo in 1880 in an adobe on Bell Block near present-day La Placita Olvera in Los Angeles. He attended St. Vincent's College, now known as Loyola Marymount University.

As a young man, Carrillo worked in railroad construction and, with his drawing skills, obtained a job as an illustrator and reporter for the *San Francisco Examiner*, where he covered Chinatown. Carrillo's fluency in Spanish, English, and Chinese and his facility with accents helped him perform in vaudeville's live theater circuit. It led to New York and a leading role in 1917 in the hit comedy play *Lombardi, Ltd.*, which ran for two years. The play toured the United States and Australia and was revived in 1927, with Carrillo reprising his star-making

role. In subsequent years he usually played Italian, Mexican, or Spanish character roles.

Back in Los Angeles, Carrillo found employment in silent and, later, sound films. Among his ninety-plus film credits, the most notable include *Mister Antonio* (1929), *Manhattan Melodrama* (1934), *In Caliente* (1935), *Blockade* (1938), *Phantom of the Opera* (1943), *The Fugitive* (1947), and *The Valiant Hombre* (1948), in which he first appeared as the Cisco Kid's sidekick Pancho, opposite Duncan Renaldo. When the Cisco Kid moved to the new medium of television, Carrillo's Pancho was one of the best-loved television characters from 1951 to 1956, eclipsing the actor's previous film work. Even his costar Duncan Renaldo thought Carrillo's characterization bordered on an ethnic stereotype, but the public, especially children, loved Pancho, so Renaldo decided not to quarrel with success.

Carrillo went on to be one of the most influential Mexican Americans during the first half of the twentieth century in California politics. He served as state parks commissioner for more than eighteen years and helped preserve many historic adobe and mission buildings. He was a man of his time, and his background served the romantic mythic narrative of Spanish Mexican California.

Carrillo was widely referred to as "Mr. California" for his tireless community and civic involvement. He was a fixture in rodeos and parades, not only around the state but nationwide. Today, a scenic stretch of Malibu coastline bears his name: Leo Carrillo State Beach.

MUTINY ON THE BOUNTY

MGM, 1935 / DIRECTOR: FRANK LLOYD

At first glance, *Mutiny on the Bounty* may seem an unlikely entry in the universe of Latinos and Latinas in Hollywood, but the film served as a springboard for two women of color, Mexican American Movita Castaneda and Polynesian American

Mamo Clark, to achieve a certain amount of success as film actresses in Hollywood. Within a limited scope, Latina performers, because of their presumably exotic physical appearances, had a casting range that enabled them to portray many ethnicities ranging from Mexican to Native American to Polynesian. Although it can be characterized as typecasting, it did provide regular employment. Inspired by historical events and based on the famous 1930 novel by Charles Nordhoff and James Norman Hall, the movie depicted the legendary mutiny aboard the British frigate *Bounty*. It starred Clark Gable, who had just won the Best Actor Oscar for his role in Frank Capra's *It Happened One Night* (1934), as the seaman Fletcher Christian. The English actor Charles Laughton, who had won a Best Actor Oscar two years earlier for *The Private Life of Henry VIII* (1933), played his nemesis, Captain Bligh.

Fletcher Christian is first mate to the tyrannical Bligh on a two-year voyage from England to Tahiti whose mission is to transport Tahitian breadfruit to the West Indies as a cheap food source for plantation slave labor. Bligh beats and starves the sailors, and, all the while, Christian and his fellow officers stand by and do nothing.

During the Tahitian interlude, Christian is ordered to stay on board, but Byam (Franchot Tone) goes ashore, where he is befriended by Hitihiti, the island chief. Byam is quickly entranced by the beautiful native girl Tehani (Movita). Christian makes it ashore at the chief's insistence, and he meets and falls in love with the chief's granddaughter, Maimiti (Clark).

Christian finally can't stand Bligh's abuse of power, and he rallies the men to overthrow the captain and take over the ship. He sets Bligh and his supporters adrift in a small boat and takes the

Bounty and the mutineers back to Tahiti. Bligh returns years later as commander of a new ship in search of the mutineers.

The movie was filmed on Catalina Island, twenty-six miles offshore of Los Angeles, and at MGM. The studio recruited Latinos, Latinas, and Pacific Islanders, many of them Hawaiian entertainers living in Los Angeles. A second unit camera crew shot background footage in Tahiti involving hundreds of Tahitian extras and a full-sized replica of the *Bounty*. The film was a critical and box-office hit and won the Academy Award for Best Picture of 1935.

Maria Luisa Castaneda was born in Nogales, Arizona. MGM executives changed her name to Movita when she was cast in *Bounty* because it sounded more Polynesian and mysterious. Landing an important role opposite major stars in MGM's most successful motion picture of the year secured recognition for the unknown actress.

Next, director John Ford cast Movita as a Tahitian native in *The Hurricane*. After appearing in significant hit productions, Movita found leading roles at a minor studio, Monogram Pictures, in *Paradise Isle* (1937), *Rose of the Rio Grande* (1938), and *The Girl from Rio* (1939).

In 1939, Movita married former Irish champion boxer Jack Doyle and moved to Dublin, Ireland. They toured Britain with a song and dance act that drew enthusiastic audiences even in the midst of daily Nazi aerial bombings during the London Blitz. At one point it was reported that they were killed in a bombing raid, but they survived.

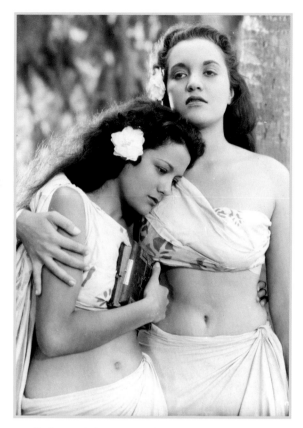

(*Left to right*) Movita and Mamo Clark play Tahitian island girls in MGM's *Mutiny on the Bounty* (1935).

After suffering physical abuse at Doyle's hands, Movita divorced her husband and returned to Hollywood. There she rebuilt her career in bit parts in such films as John Ford's *Fort Apache*, where she played Guadalupe, Colonel Thursday's (Henry Fonda) Mexican maid. In Ford's *Wagon Master* (1950), she was a Navajo Indian, and in *The Furies*, opposite Gilbert Roland and Barbara Stanwyck, she was Chiquita, a Mexican American. In spite of her strong start and retaining her beauty well into her senior years, Movita's roles slowly dwindled. She continued working in films and television,

but was usually relegated to extra or minor roles.

Movita met the young Marlon Brando, the attractive superstar who revolutionized film acting, in 1951, when he was preparing for his upcoming role as the Zapotec Mexican revolutionary Emiliano Zapata, in John Steinbeck's *Viva Zapata! (1952)*, directed by Elia Kazan. Movita served as Brando's guide in Mexico and helped him gain insight into Mexican culture. They entered into a long-term, on-again, off-again relationship until 1960, when she became his second wife. In a strange twist of fate, Brando starred as Fletcher Christian in a 1962 MGM Technicolor remake of the 1935 *Mutiny on the Bounty* in which Movita had found stardom. Brando later married his Polynesian leading lady, Tarita Teriipaia, during the long, trouble-plagued location shoot in Tahiti. Movita had their marriage annulled in 1968; they had two children, Rebecca and Miko. She never sought the spotlight or exploited her association with Brando and went on with her life, working as an extra and bit player in films and on television. She died at age ninety-eight.

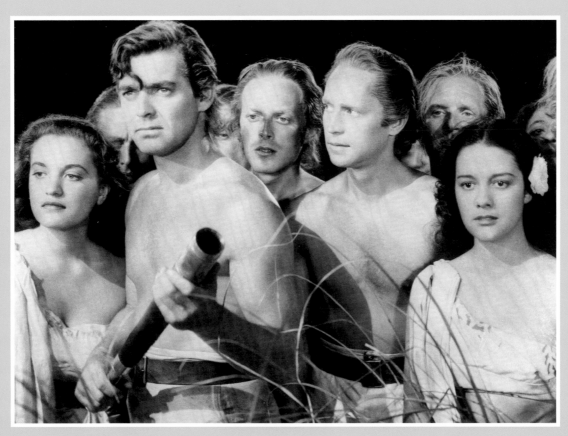

Maimiti (Mamo Clark) and Fletcher Christian (Clark Gable), along with crew members and Midshipman Roger Byam (Franchot Tone) and island girl Tehani (Movita), in a scene from *Mutiny on the Bounty* (1935).

LOST HORIZON

COLUMBIA, 1937 / DIRECTOR: FRANK CAPRA

One of Frank Capra's most ambitious films, lavishly produced in every detail, *Lost Horizon* was an unusual motion picture choice for a filmmaker who made his reputation with populist American characters and stories. With this departure on timeless

themes of war, violence, and greed, Capra provided 1930s Depression-era audiences an escapist fantasy drama of a heaven on earth.

The film is tinged with Judeo-Christian antiquated white colonial values, which makes the modern viewer ask, whose idyllic setting or idea of Utopia is this? Seemingly, the film could not divest itself of Western Christian philosophy, even though it takes place in Tibet. The Asian populace is reduced to serving the white hierarchy. What's more, Caucasian actors in yellow face portray Asians, as was Hollywood practice then. The story concerns Robert Conway (played by Ronald Colman), a British adventurer who saves his compatriots, including his brother George (John Howard), from a local Chinese revolution. But the airplane headed for safety in Shanghai is hijacked and crashes in the snow-capped Himalayas. A monk rescues the survivors and leads them to the serene, mystical valley of Shangri-la. The valley's inhabitants flourish in peaceful isolation and never grow old. Upon meeting the High Llama, Conway soon realizes that his being brought to this enchanting place was no accident.

Classic movie fans will never forget Margo as young Maria in *Lost Horizon* and the scene in which she shockingly reverts to old age upon leaving the idyllic valley of Shangri-la. Born in Mexico City, Margo was raised in Los Angeles and took dance lessons from Rita Hayworth's father, Eduardo Cansino. She also danced with Xavier Cugat's band before making her film debut in *Crime Without Passion* (1934), which she followed with *Rumba* (1935), starring Carole Lombard and George Raft. The same year, she appeared on Broadway in Maxwell Anderson's play *Winterset*, opposite Burgess Meredith, and in the film adaptation. She acted in Val Lewton's *The Leopard Man* (1943) and later had

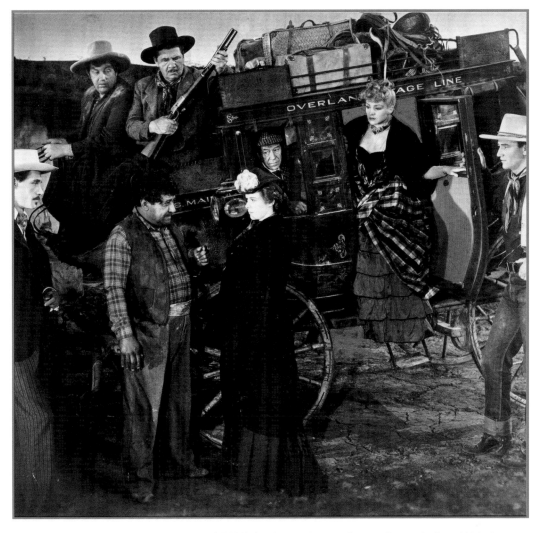

The cast of John Ford's *Stagecoach* (1939): (top) Andy Devine, George Bancroft, Donald Meek, Claire Trevor; (bottom) John Carradine, Chris-Pin Martin, Louise Campbell, John Wayne.

a small role in *Viva Zapata!* and *I'll Cry Tomorrow* (1955). After Margo married actor Eddie Albert in 1945, she essentially gave up performing and dedicated herself to her family. She was among the founders of the Mexican American community arts center Plaza de la Raza in the Lincoln Park area of East Los Angeles.

STAGECOACH

UNITED ARTISTS, 1939 / DIRECTOR: JOHN FORD

Prolific character actor Chris-Pin Martin had a prominent uncredited role as Chris, the stagecoach way-station proprietor in John Ford's seminal western *Stagecoach* (1939), the classic story of a group of strangers who board a stagecoach to Lordsburg,

New Mexico, and ride through dangerous country. The film made John Wayne a major movie star and brought a new depth and maturity to the western genre.

Martin was typically typecast as a bumbling, comical Mexican or Native American who spoke in broken English. He was a sidekick to two Cisco Kids. In the 20th Century Fox version with Cesar Romero, he was Gordito; in the later Monogram series with Gilbert Roland as Cisco, he was Pancho.

Among Martin's more notable roles is Poncho, an unwilling member of a lynch mob in William Wellman's *The Ox-Bow Incident* (1942), with Henry Fonda. He was also Lopez, a Spanish innkeeper who aids in the escape of the de Vargas family, in *Captain from Castille*.

Among his other credits are *Billy the Kid* (1930), with Johnny Mack Brown, and *The Mark of Zorro* (1940), with Tyrone Power.

Martin supplemented his income by acting as a recruitment agent in the hiring of Latino and Latina extras needed for specific films at the studios.

Martin was born Ysabel Ponciana Chris-Pin Martin Paiz in Tucson in 1893, when Arizona was still a territory. He was the son of Toro "Bull" Martin, a Yaqui Indian, and Florencia Paiz, a woman of Mexican descent.

Martin arrived in Hollywood in 1911 with a group of Native Americans who had traveled from Arizona to find work in the movies. Martin was immediately employed as an extra player in bit parts in silent, then sound, motion pictures in a career composed of credited and uncredited roles in more than one hundred films. He died in 1953 of a heart attack while giving a talk to a civic group in Montebello, California.

Elvira Rios played Yakima, Chris's Apache spouse, in *Stagecoach*. She sings by the corral

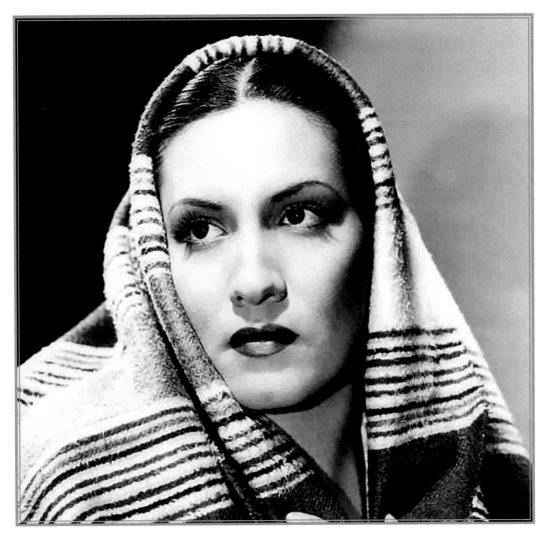

Elvira Rios plays the Native American Apache woman Yakima in John Ford's *Stagecoach* (1939).

and runs away with a group of vaqueros, abandoning her husband and the others at the stagecoach way station.

Rios was born in Mexico City, where she gained prominence as the first woman to sing the bolero, a Mexican musical style dominated by men. She was the favored interpreter for legendary Mexican composer Agustín Lara's songs and made them international hits.

Rios was brought to the United States by Manuel Riachi, an assistant to Paramount Pictures producer Arthur Hornblow Jr. She made her US film debut in *Tropic Holiday*. As Rosa, the sister of fellow Mexican singer/actor Tito Guízar's character, she sings several Agustín Lara tunes.

JUAREZ

WARNER BROS., 1939 / DIRECTOR: WILLIAM DIETERLE

One major Hollywood motion picture with top studio stars reveals the dichotomies and paradoxes of Hollywood movie making. That film is *Juarez* from Warner Bros. It is notable for being a film about Mexicans with very few Mexicans involved

either in front of or behind the camera. The film is ostensibly a biography of a historically important Mexican figure, President Benito Juárez, a full-blooded Zapotec Indian. The role of Juárez is played by Paul Muni but the storyline, as it happens, is more about characters portrayed by Bette Davis and Brian Aherne.

Emperor Napoleon II (Claude Rains) of France sets up a puppet Hapsburg emperor, Archduke Maximilian of Austria (Aherne), to rule Mexico. Mexican president Benito Juárez refuses to accept French occupation and rallies his people to fight in an epic struggle against tyranny. These events serve as the basis for *Juarez*, but the film concentrates on Maximilian and his wife, Carlotta (Davis), not on the title character.

No actual Mexicans were cast in the leading roles in *Juarez*, except for Gilbert Roland as

Colonel Lopez. The Caucasian Muni used an overabundance of makeup to resemble the Oaxacan leader of Mexico, giving him a monstrous, mask-like brown face that rendered his acting wooden. Mexican American actor Manny Diaz had a small role as a young man in a scene with Muni, but otherwise Mexican American participation was limited to the hundreds of extras from Los Angeles used in the big crowd scenes. A magnificently designed Mexican village set constructed at the Warner Bros. Ranch in Calabasas, California, lent authenticity to the film. The set was often used in westerns and was easily converted into an Italian village for *A Bell for Adano* (1945) and a Portuguese town for *The Miracle of Our Lady of Fatima* (1952).

TOO MANY GIRLS

RKO, 1940 / DIRECTOR: GEORGE ABBOTT

Cuban-born Desi Arnaz was the best-known and best-loved Latin performer in the United States during the 1950s in his role as bandleader Ricky Ricardo on the phenomenally successful *I Love Lucy* (1951–1957) television comedy series, starring

alongside his then real-life wife, actress/comedienne Lucille Ball.

Possessing charisma, good looks, drive, and musical talent, Arnaz made his way to the top of the Hollywood show business ladder. His destined success with Ball began eleven years earlier in June 1940 when they first met at RKO Studios during the making of the film *Too Many Girls*, based on a hit 1938 Broadway musical about college life directed by George Abbott, who would also direct the film version.

Although they share few scenes—Arnaz was not the star or love interest to lead actress Ball—it was love at first sight off screen. After a whirlwind courtship, they married a few months later, in November of the same year.

In *Too Many Girls*, Desi reprised his stage role as Manuelito, the star Argentine football player and ladies' man who leads a festive conga line at the finale. He landed the role after

Abbott spotted him performing at the La Conga nightclub in New York City. He introduced Afro-Cuban rhythms on the conga drum, creating a dance in which he led club patrons in a form of a modern-day line dance. Arnaz made himself the toast of the town, fueling a Latin dance craze.

In the film, moviegoers nationwide were able to see and experience on screen what they had only heard on radio or read about in newspapers. The movie was never meant to be more than a fun piece of musical entertainment. It takes place in a college in New Mexico and throws in an amalgam of stereotypical Latin imagery. The musical number "Spic N Spanish" brings together sombreros, colorful dresses, and burros, mixed with tap dancing and big band sounds set against adobe structures. Arnaz dances with Ann Miller and sings. The use of the slur "spic" throughout the song may shock modern audiences.

(Left to right) Ann Miller, Desi Arnaz, and Lucille Ball in *Too Many Girls* (1940).

The film hit the right notes, and Arnaz followed with a similar role in the comedy *Father Takes a Wife* (1941), playing a stowaway Latino performer on a luxury liner who is adopted by a shipping magnate and his actress wife. Although signed by MGM, he quickly found that suitable roles were scarce for someone with a pronounced Cuban accent. He did play a Latin soldier, Felix Ramirez, in the patriotic World War II MGM movie *Bataan*. He contributed a prayer he learned as a child in Cuba to his character's death scene in the film.

He enlisted in the armed forces during the war and upon his return from service decided to organize a band, with which he toured the country. He made a few appearances in movies and in musical short subjects, including headlining the Universal musical *Cuban Pete* in 1946 and *Holiday in Havana* in (1949). Ball, a working film actress who had not quite found

her niche in movies, spent quite a lot of time apart from Arnaz. When it came time to transfer her successful radio show *My Favorite Wife* to the new medium of television, she requested that Arnaz play her husband in the new venture.

Despite the objections of the CBS television network to a Cuban and a WASP as an onscreen married couple, Ball and Arnaz developed a musical comedy act and toured major theaters across the country, where they were fully accepted as husband and wife by audiences. Finally given the green light, they proceeded to star in and produce what turned out to be the phenomenally successful long-running television comedy *I Love Lucy*. It was the number-one rated show for most of its six-year run. In the immortal characterization of Ricky Ricardo and as the show's producer, Arnaz proved himself to be more than just a bandleader. On screen he demonstrated enviable comic skills, and off camera, he was a savvy businessman.

By producing the shows on film and retaining ownership, he created program reruns and syndication. He also helped develop the three-camera filming technique with a live audience that has been the basis for situation comedy production ever since. At the height of their popularity, Ball and Arnaz had tremendous success with their hit MGM comedy *The Long, Long Trailer* (1954), directed by Vincente Minnelli, in which moviegoers saw their favorite TV couple

on the big screen in Technicolor. The movie surpassed the studio's previous comedy hit *Father of the Bride* (1950) at the box office. With their revenue from the sale of *I Love Lucy* episodes back to CBS in 1957, Ball and Arnaz purchased the facilities of the bankrupt RKO studios where they first met. Formed as a production entity in 1951, with this acquisition, Desilu became one of the most successful independent studios, making Arnaz the first Cuban American studio head. Under Desilu Productions, the husband and wife moguls launched such iconic television series as *The Untouchables* (1959–1963), *Mission Impossible* (1966–1973), and *Star Trek* (1966–1969).

Born in 1917 in Santiago, Cuba, as Desidero Alberto Arnaz de Acha III, Arnaz came from a privileged background. His family lost their position during the Batista takeover of Cuba in 1933. Desi and his family fled to Miami, Florida, where they had to begin anew. With the help of some family friends, they secured menial jobs including cleaning birdcages at the home of gangster Al Capone. Desi attended school in Miami, where he organized a small Latin band with a few friends. He made his way to New York and landed a job as a musician with famed Hispanic bandleader Xavier Cugat.

Arnaz presented a picture postcard tourist or whitewashed representation of Cuba to American audiences. The only thing that was authentically Cuban and true to his origins was Arnaz himself. He presented himself and his music with showmanship in the same way as his mentor Xavier Cugat played Latin dance music not authentically but in a measured, polite interpretation that was accepted by mainstream US society. Audiences would likely have been horrified to discover that his signature song "Babalu" was rooted in a chant to an Afro-Cuban deity, but his infectious delivery made the crowds sing along. Desi Arnaz was a creative and innovative force who paved the way for Latinos and Latinas in front of and behind the scenes in stage, film, and television.

Desi Arnaz and Lucille Ball star in the hit MGM comedy *The Long, Long Trailer,* directed by Vicente Minnelli.

CITIZEN KANE

RKO, 1941 / DIRECTOR: ORSON WELLES

*C*itizen Kane is recognized as one of US cinema's masterpieces for its innovative film techniques, storytelling, photography, and performances. It was directed by and starred twenty-four-year-old wunderkind Orson Welles, who cowrote the screenplay

with Herman J. Mankiewicz.

Citizen Kane is the story of Charles Foster Kane, a fictionalized version of real-life multimillionaire newspaper magnate William Randolph Hearst. The film follows Kane from his humble beginnings in Colorado through gaining the immense wealth and power that allows him to trifle with everything from journalism to politics to show business. When his second wife, Susan Alexander Kane (Dorothy Comingore), aspires to stardom as an opera singer, Kane goes to the extreme of constructing an opera house for her stage debut.

Spanish-born actor Fortunio Bonanova plays the exasperated Italian opera coach Signor Matiste, who tries not to lose his patience with the talentless Mrs. Kane. In a memorable scene during a rehearsal of an aria from *The Barber of Seville*, Matiste exclaims to Susan, "Some people can sing, some people cannot. Impossible,

Impossible!" Susan has no ability, but Kane ultimately forces them to continue with the session. Matiste is there with Mrs. Kane amid the frenzy of the opening night presentation, screaming backstage, "No. No. . . .No!"

Bonanova was a trained operatic baritone who performed in Madrid and Paris. He made his film-acting debut in Spain. During a US opera tour, an extended Los Angeles engagement allowed him to appear in bit parts in movies. Bonanova emigrated to the United States in 1936, soon after the outbreak of the Spanish Civil War. He gave up his opera career, although this background would serve him well in motion pictures, where he usually played a variety of Latino, Spanish, and continental types. Among his best-known film roles— worth highlighting here—are as insurance fraud Sam Gorlopis in *Double Indemnity* (1944), with Barbara Stanwyck and Fred MacMurray;

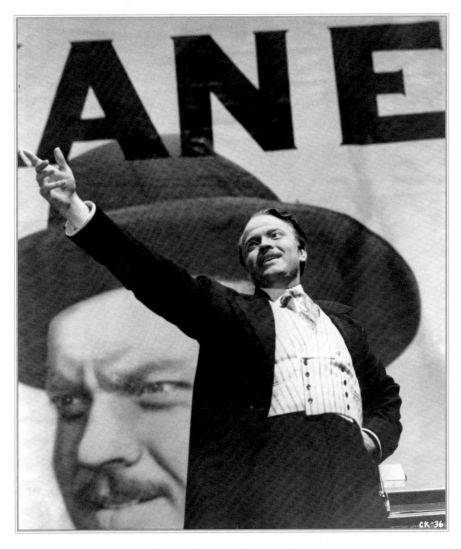

Orson Welles in *Citizen Kane* (1941).

Mr. Tomaso Bozanni in the Oscar-winning *Going My Way* (1944), starring Bing Crosby; and as Carmen Trivago, the opera star whose precious collection of Caruso recordings is destroyed by Mike Hammer in the film noir *Kiss Me Deadly* (1955).

A vital member of the *Citizen Kane* special effects staff was none other than Mexican-born Mario Larrinaga, who created matte paintings in conjunction with the optical effects created by Linwood Dunn. Larrinaga painted exterior and interior views that enlarged Charles Foster Kane's Xanadu mansion and the exterior of Kane's newspaper office.

TORTILLA FLAT

MGM, 1942 / DIRECTOR: VICTOR FLEMING

There can be no doubt that Ricardo Montalban was one of the most influential and important Mexican-American participants in Hollywood movies. When he was beginning his acting career, an MGM talent scout spotted him in a play and

asked him to test for the role of Danny Alvarez in *Tortilla Flat*. After the screen test, the casting director told Montalban that he "wasn't Mexican enough What that meant, I didn't quite know," recalled Montalban years later.[52] Ironically, the role of Danny went to Julius Garfinkle, better known as John Garfield, from the Bronx, New York.

Irish Spencer Tracy, eastern European American John Garfield, and Austria-born Hedy Lamarr were apparently Mexican enough for MGM. Tracy, in brown face, reprised his Oscar-winning Portuguese accent from *Captains Courageous* (1937), Garfield slipped in and out of his Bronx accent, and Lamarr used her own Viennese accent, which was good enough. At least Nina Campana, a Mexican American character actress who appeared in more than forty films, plays Señora Teresina Cortez in *Tortilla Flat*.

The film was based on John Steinbeck's first successful novel, about a happy-go-lucky group of "Paisanos" (a euphemism for Mexican Americans) who spend their days unemployed, homeless, and in seemingly perpetual pursuit of alcohol in idyllic 1919 Monterey, California. Steinbeck describes "Paisanos" as "a mixture of Spanish, Indian, Mexican and assorted Caucasian bloods. . .[whose] ancestors have lived in California for a hundred years or two."

When the young Danny Alvarez unexpectedly inherits two ramshackle houses from a relative, the group dynamics change, especially when Danny falls for the beautiful Sweets Ramirez. Pilon, the self-appointed leader of this motley crew, manipulates the situation to preserve the status quo.

Steinbeck goes on to write, "He lives in that uphill district above the town of Monterey called Tortilla Flat, though it isn't flat at all."

John Garfield as Danny, Nina Campana as Señora Teresina, and Hedy Lamarr as Dolores Ramirez in *Tortilla Flat*.

Steinbeck, in other words, describes a segregated and economically depressed Mexican American part of Monterey commonly called "the Barrio," separated from the mainstream affluent part of town.

To be fair, Steinbeck's original story fleshes out the film's more stereotypical characterizations. His narrative is sympathetic to the Mexican American community. Through a modern lens, several of these characters were returning World War I veterans, probably suffering from the effects of PTSD (then known as "battle fatigue") as well as racial discrimination and limited economic opportunities. But Steinbeck and the screenplay concentrated on character relationships and allusions to King Arthur's Knights of the Round Table. The book and the film crafted Monterey as a fantasy town with eccentric characters divorced from reality. Not unlike happy, banjo-strumming African Americans portrayed in films such as *Gone with the Wind* (1939) and *Song of the South* (1946), *Tortilla Flat* depicts contented Mexican Americans living in idyllic poverty.

CASABLANCA

WARNER BROS., 1943 / DIRECTOR: MICHAEL CURTIZ

A romantic, sweeping film with admittedly melodramatic tinges, against the background of an exotic wartime setting, *Casablanca* is an all-time classic of Hollywood's studio era. Rick Blaine (Humphrey Bogart) is the American expatriate

owner of Rick's Café Americain, a nightclub and casino in Casablanca, Morocco, at the outset of World War II. The nightspot is a hotbed of intrigue, gambling, black-market activities, and other illegal transactions. The city is under the yoke of the Nazis and, by extension the Vichy puppet government installed in France by Hitler's government. Casablanca's location makes it a magnet for an assortment of characters willing to risk everything for a chance to escape to freedom. Rick's beautiful ex-flame Ilsa Lund (Bergman) walks into his nightclub on the arm of her husband, French resistance leader Victor Lazlo (Paul Henreid), spurring an enthralling set of events.

Director Michael Curtiz cast most of the featured players and all of the uncredited actors in the Best Picture Academy Award–winning film, favoring a diverse group of performers, types that would authentically be found in French Morocco. Joy Page played Bulgarian newlywed Annina Brandel, whose husband comes to Rick's to gamble what little money they have left, hoping to win enough cash for exit visas. Captain Renault (Rains) has offered to give Brandel exit visas in return for sexual favors without her husband's knowledge. Her plight brings out the best in Blaine, and there is a touching moment in which he rigs the roulette table, so her husband wins enough money to pay for the visas. With her expressive brown eyes and sincere manner, the young actress made the minor role memorable.

Page was the stepdaughter of studio head Jack L. Warner and Anne Boyar. She was the daughter of Boyar and José Paige, better known as the silent/early sound matinee idol actor Don Alvarado, who starred in the first three-strip Technicolor Oscar-winning short film *La*

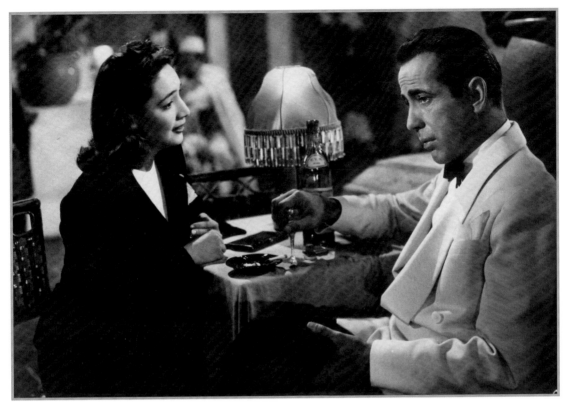

Joy Page is Annina Brandel, a Bulgarian refugee who asks Rick Blaine (Humphrey Bogart), feigning disinterest, for his advice in *Casablanca*.

cucaracha (1934); a native of Albuquerque, New Mexico, of Spanish Mexican ancestry, he changed his name to take advantage of the Latin lover craze of the late 1920s. As Don Page, he later worked as an assistant director and production manager on several Warner Bros. films and television programs.

Alvarado and Boyar married in 1924, and Joy was born the same year. They divorced when Joy was twelve, and Ann married Jack Warner in 1936. *Casablanca* was Page's first film and her best-known role—she was only seventeen. Joy projected an innocence that was needed for the character of Annina. Though Warner liked her performance in the film, he never signed her to a contract. She managed to obtain sporadic employment in minor roles in films of varying quality, mostly away from Warner Bros.

Another prominently featured Latina in *Casablanca* was Corinna Mura of San Antonio, Texas, who played the Spanish Mexican singer at Rick's casino. She is seen strumming the guitar while singing "Tango Della Rose." Corinna is brightly illuminated, entertaining patrons sitting on the dim periphery of the club while Lazlo and Berger exchange information.

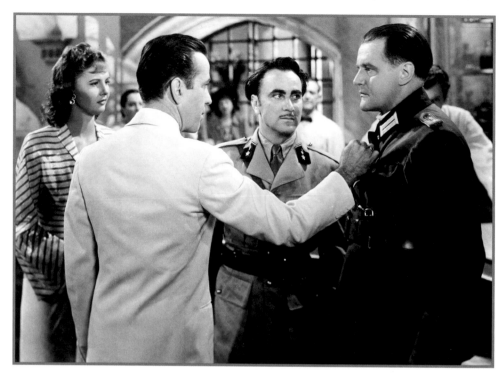

Yvonne (Madeleine LeBeau) is insulted by a French officer (Alberto Morin) who gets into a scuffle with her Nazi officer escort, which is broken up by Rick (Bogart) in *Casablanca*.

Mura later joins in singing the rousing "La Marseillaise" against a contingent of German officers singing "Watch on the Rhine."

Mura, born Corynee Constance Wall of San Antonio, Texas, played the guitar and studied opera, but preferred popular music. This led to nightclub and radio engagements. She made her first film appearance with a singing role in *Call Out the Marines* (1942). After *Casablanca*, she was cast again by director Curtiz in *Passage to Marseille* (1944), with Humphrey Bogart, as a French singer in a café. Her last film appearance was as Senora Mendoza in 1947's *Honeymoon*. Mura continued performing in nightclubs and concert venues until she passed away in Mexico City in 1965.

Puerto Rican Alberto Morin portrayed a French military officer who insults Yvonne, Blaine's spurned lover, when she enters the nightclub with a German officer. He and the German have a physical altercation, and Blaine breaks it up. Morin also had a bit part as Rene Picard in the bazaar scene in *Gone with the Wind*. During a five-decade career, the actor appeared in more than 120 movies in mostly unbilled bit or minor roles. He appeared in five films with John Wayne and played the Mexican general in *Two Mules for Sister Sarah* (1970) with Clint Eastwood. His final film role was in Robert Redford's *The Milagro Beanfield War* (1988).

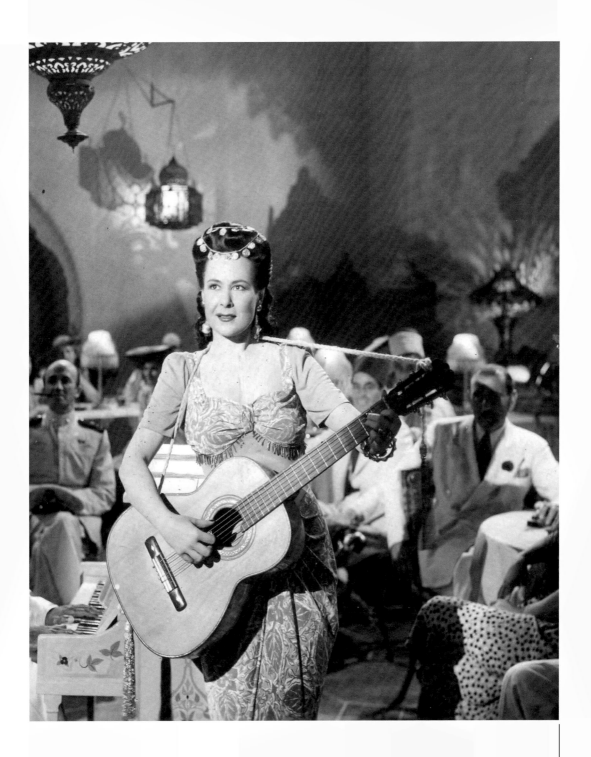

THE TREASURE OF THE SIERRA MADRE

WARNER BROS., 1948 / DIRECTOR: JOHN HUSTON

Considered an enduring and influential favorite of Hollywood's golden age, *The Treasure of the Sierra Madre* is based on B. Traven's 1927 book of the same name. It tells the tale of two down-on-their-luck Americans in 1920s Mexico (Humphrey

Bogart and Tim Holt) who join a grizzled American prospector (Walter Huston) to mine for gold in the mountainous Mexican wilderness until greed and suspicion tear them apart. The film adaptation features one of the most famous and often misquoted lines of dialogue in motion pictures, uttered by Mexican actor Alfonso Bedoya. The three prospectors are found in their mountain encampment by an intruder, Cody, played by Bruce Bennett. The next morning, Mexican bandidos, led by the cutthroat Gold Hat, descend on their camp.

Gold Hat, memorably played by Bedoya, tells Dobbs they are federales.

GOLD HAT: *We are Federales, you know, the mounted police.*

DOBBS: *If you're the police, where are your badges?*
GOLD HAT: *Badges? We ain't got no badges. We don't need no badges. I don't have to show you any stinkin' badges!*

Bedoya's response made him an iconic character in cinema history and unofficially ended Hollywood's "Good Neighbor Policy" by reintroducing the Mexican bandit stereotype. So influential was the film that Mel Brooks's hilarious western send-up *Blazing Saddles* (1974) featured a scene in which actor Rick Garcia, as a Bedoya-like Mexican bandit, famously misquoted the line: "Badges? We don't need no stinkin' badges." American writer Luis Valdez used it as the title for his 1987 play, *I Don't Have to Show You*

No Stinking Badges, which refers to the dual nature of the Latino identity within the United States.

African American filmmaker Spike Lee used *Treasure of the Sierra Madre* as the framework for his Vietnam veteran treasure hunt adventure, *Da 5 Bloods* (2020). Filmmakers such as Sam Peckinpah, Sam Raimi, Steven Spielberg, and Paul Thomas Anderson have all acknowledged the film's influence on their work.

Bedoya appeared in many Mexican movies before director John Huston cast him in the role that led to a successful career in Hollywood films, mostly in westerns. His scenes with Bogart on the mountain in *Treasure* were shot on the Warner Bros. soundstages in Burbank. This required Bedoya to travel to Hollywood from Mexico City and join the Screen Actors Guild upon arrival in order to fulfill his work visa requirements. In his *New York Times* review, Bosley Crowther wrote, "Alfonso Bedoya is both colorful and revealing as an animalistic bandit chief."[53] After that, it seemed every producer of westerns in Hollywood wanted Bedoya in their films, despite his limited English. He played villains of one type or another, with names like Charley Calico, as in his first film shot in the entirely United States following

Treasure—Streets of Laredo (1949).

Bedoya appeared in three films with Randolph Scott: *The Stranger Wore a Gun* (1953), *Man in the Saddle* (1951), and *Ten Wanted Men* (1955). He worked with fellow Mexican actor Pedro Armendáriz in *Border River*, opposite Joel McCrea. In an unusual bit of casting, he portrayed Mongolian trader Lu Chung in *The Black Rose* (1950), starring Tyrone Power and Orson Welles. William Wyler's sprawling western, *The Big Country* (1958) was Bedoya's last film. Problems with alcohol led to ill health, and Bedoya passed away in 1957, shortly after completing the film and ten months after his *Treasure* star Humphrey Bogart died.

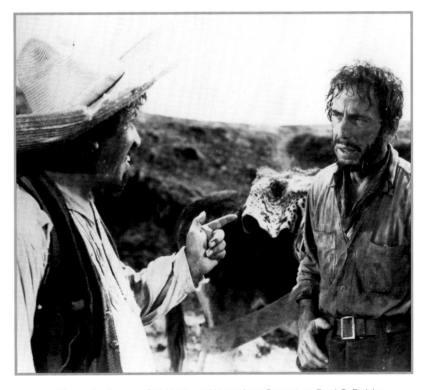

Alfonso Bedoya as Gold Hat and Humphrey Bogart as Fred C. Dobbs.

INTRUDER IN THE DUST

MGM, 1949 / DIRECTOR: CLARENCE BROWN

Audiences thought Juano Hernandez was African American, but he was also Puerto Rican. With his tall carriage, soulful eyes, stirring voice, and proud walk, Hernandez's towering central portrayal of Lucas Beauchamp, a southern Black farmer

unjustly accused of the murder of a white man in 1940s Mississippi left an impression on postwar audiences. Audiences never considered his Spanish name or Latin origins. Because he spoke perfect, unaccented English, Hernandez quickly assimilated into the narrow typecasting afforded Black actors in Hollywood cinema at that time. His powerful screen presence projected dignity and strength that could not be dismissed.

While filming on location in Oxford, Mississippi, Hernandez could not stay in the "white only" lodging where the cast and crew stayed because of Jim Crow segregation. Instead, a local Black family housed him. Critics praised Hernandez's performance, and he was nominated for a Golden Globe in the category of Most Promising Newcomer of 1950. The fifty-five-year-old veteran actor graciously accepted the well-intentioned nomination

that overlooked his long career. He would have been better served with a Best Actor or Best Supporting nomination, but racial politics affected the recognition of an Afro-Latino performer.

Intruder in the Dust was a box-office failure but a critical success. The film focuses on the quest for justice by a few individuals. A lawyer, two young boys (one white, one Black), and an old woman believe in Lucas's innocence and their efforts to clear him have dramatic value, but today, the film's resolution seems contrived with a Hollywood happy ending. This does not diminish Hernandez's performance, but in the end, Lucas walks alone. Even among the other African Americans in the town, there is no interaction or solidarity expressed. Lucas relies on his own pride and financial resources to get him out of a dead-end situation, but it takes three somewhat ineffective individuals and an

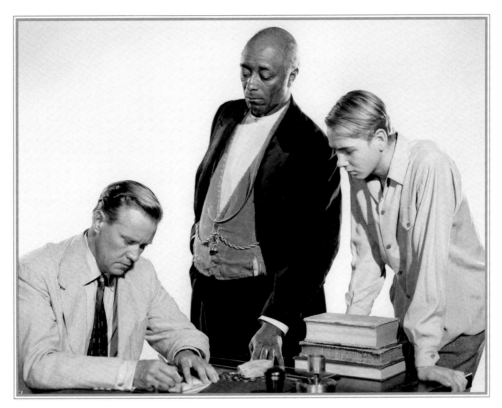

David Brian as John Stevens (*sitting*) with Juano Hernandez as Lucas Beauchamp (*standing next to him*) and Claude Jarman Jr. as Chick Mallison (*leaning on desk*).

ineffectual lawyer to save him from a lynching. The possibility of solidarity or a movement with other African Americans is never realized on screen, and the town's Black community can only stand by and watch the events unfold, powerless to effect any change and left to the consciences and goodwill of the white townsfolk to do the right thing.

The movie was released five years before the nascent civil rights movement was spurred by the horrific murder of fourteen-year-old African American Emmett Till by white racists in Mississippi in 1955. About the time *Intruder in the Dust* hit theaters, several African American World War II veterans were lynched, some in

their uniforms upon their return to the South after having liberated Europe from Nazi tyranny, not able to enjoy the same rights they fought and died for. The film remains a fascinating artifact of a transitional moment in history, and Hernandez was its major asset.

Born in San Juan, Puerto Rico, in 1896 (when it was still under Spanish rule) to a Brazilian mother and Puerto Rican father, Hernandez left the island for Brazil at a young age. He joined a traveling circus, which brought him to the United States. Once there he learned English and made his way around the country, obtaining employment wherever he could, but his love of performing led him to the Black theatrical circuit

and eventually to New York. He was a creative force in the Harlem Renaissance of the '30s, producing a local radio program. He was cast by pioneering African American filmmaker Oscar Micheaux as a Cuban gangster named Gomez in a film made for Black audiences. Ironically, it's the first and only time he played a Latino character. Hernandez also found employment on Broadway as part of the chorus of the musical *Showboat* and later was directed by José Ferrer in the interracial stage drama *Strange Fruit* (1945).

Hernandez exploded onto the big screen in 1949 and 1950 with prominent roles in four films, beginning with *Intruder in The Dust*. He followed with *The Breaking Point* (1950), with John Garfield, under the direction of Michael Curtiz. He played fisherman Wesley Park, Garfield's partner, in this adaptation of Ernest Hemingway's 1937 novel *To Have and Have Not*. He followed, with Curtiz again, in *Young Man with a Horn* (1950), as Art Hazzard, a jazz musician who mentors the lead character, played by Kirk Douglas. Back at MGM, Hernandez played formerly enslaved Uncle Famous Prill, whose life is saved from white-sheeted night riders by the moral authority and fast thinking of a preacher played by Joel McCrea, in *Stars in My Crown* (1950).

Hernandez's success led to a position teaching drama at the University of Puerto Rico in San Juan, while continuing film work when suitable roles were available. In *Trial* (1955), he found himself on the other side of the bench in the unusual role of a Black high court judge presiding over the trial of a Mexican American

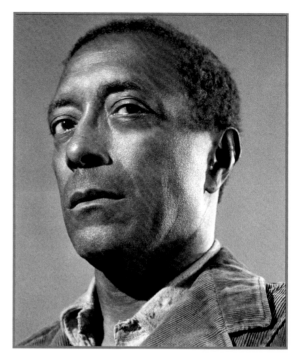

Juano Hernandez in *Something of Value* (1957).

boy accused of raping and murdering a white girl. Deep-seated fears of minorities sexually threatening white society were a common theme in movies where justice overcomes lawless racism.

Hernandez played a veteran cavalry sergeant in the all African American Buffalo Soldiers in the John Ford western *Sergeant Rutledge* (1960), and delivered a moving performance as lonely Mr. Smith in scenes opposite Rod Steiger in Sidney Lumet's *The Pawnbroker* (1964). His last important role was opposite Steve McQueen in *The Reivers* (1969), a return to folksy Southern comedy-drama by *Intruder in the Dust* author William Faulkner, in which he played Uncle Possum. Hernandez died in Puerto Rico in 1971. As a pioneering Afro-Latino actor, he helped to change the screen representation and perception of Black characters with his nuanced, dignified portrayals.

CYRANO DE BERGERAC

UNITED ARTISTS, 1950 / DIRECTOR: MICHAEL POWELL

José Ferrer was the first Latino to win the Best Actor Academy Award, for his performance as Cyrano in *Cyrano de Bergerac*, the film adaptation of Edmund Ronstadt's story of a lovelorn seventeenth-century poet and swashbuckler with a protruding

nose. Ferrer had already won the Best Actor Tony Award in 1946 for his Broadway performance in the same role, and he would be identified with Cyrano for the rest of his career. He remains the only actor on record to be nominated for an Oscar, an Emmy, and a Tony in the same role. Ferrer did not possess the good looks of a classical Hollywood leading man, but he made the most of his talents. When he succeeded in a film and with audiences, it was as an unconventional leading character, in films such as *Cyrano, Moulin Rouge* (1953), or *The Caine Mutiny* (1954).

Born in Puerto Rico, Ferrer moved with his parents to New York when he was six. He attended Princeton University, where his classmates were future movie star James Stewart and future stage and film director Joshua Logan. He acquired the acting bug while at the university, and Ferrer made his film debut in the role of the Dauphin in the historical drama

Joan of Arc (1948), opposite Ingrid Bergman, receiving an Academy Award nomination for Best Supporting Actor. In John Huston's critically acclaimed *Moulin Rouge*, Ferrer starred as both famed painter Henri de Toulouse Lautrec and his father. He is the only actor to date to receive an Oscar nomination for Best Actor for portraying two distinct characters in the same film. Critics enthusiastically received the film, noting the trick photography and the illusion of the artist's physical disabilities. Huston's use of color to establish the artist's sensibilities and moods was achieved by Oswald Morris's cinematography.

As Barney Greenwald, a naval defense attorney, Ferrer stole the second half of the acclaimed maritime courtroom drama *The Caine Mutiny* from seasoned performers Fred MacMurray and Humphrey Bogart as the unhinged Captain Queeg.

Ferrer expanded his talents into directing. Despite acclaim for his Tony Award–winning stage directing, his six feature films such as the war drama, *The Cockleshell Heroes* (1954), the melodrama *Return to Peyton Place* (1961), the comedy *The High Cost of Loving* (1958), and the musical *State Fair* (1962) demonstrate competent direction but do not exhibit any strong auteur vision or individual style. Compare Ferrer's essential directorial work with the vibrant screen tableaus of directors with comparable theatrical backgrounds, such as Elia Kazan and Sidney Lumet. Ferrer is much closer in style to stage and film director Joshua Logan.

In 1955, Ferrer directed himself in the starring role in the film adaptation of the award-winning play *The Shrike* for Universal. He then directed himself again in the MGM British production of *I Accuse!* (1958). This stirring drama about the famous Dreyfus affair, concerning a Jewish military officer in 1894 France who is falsely convicted of treason but later exonerated, is Ferrer's best cinematic directing, but audiences were not interested in the story. It was a critical but not a box-office success.

The actor never shied away from involvement in progressive and sometimes controversial productions. His acting opposite African American actor/activist Paul Robeson in the 1946 Broadway production of *Othello*, in which a Black actor played the leading role of the Moor for the first time, opposite a white woman, sparked controversy. During the McCarthy era witch hunts by the House Committee on Un-American Activities, Ferrer spoke out against the committee and found himself on a list of suspected Communists in the entertainment industry. He cleared himself, but his opportunities were limited for a time, stalling his career.

Ferrer received attention for his brief, intense portrayal of the sadomasochistic Turkish Bey in David Lean's Oscar-winning *Lawrence of Arabia* (1962). He followed this performance with a role as a Nazi sympathizer in Stanley Kramer's *Ship of Fools* (1965). His later film credits include *Voyage of the Damned* (1976), Billy Wilder's *Fedora* (1978), and Woody Allen's *A Midsummer Night's Sex Comedy* (1982).

Ferrer was big on Broadway, and he was a Big Deal in Hollywood—but maybe not big enough to satisfy him. He successfully navigated the crosscurrents of show business while maintaining his dignity and his sense of himself. Without "leading man looks," he still was a renowned protagonist on stage and in Hollywood films. In addition, he is notable for having a career in which he proved he could portray the widest possible range of characters—usually non-Latin ones. He has long been regarded as a gentleman and a dignified presence in Hollywood filmdom.

Multitalented José Ferrer (1912–1992) is pictured in his iconic
Oscar-winning portrayal in the title role of *Cyrano de Bergerac* (1950).

THE RING

UNITED ARTISTS, 1952 / DIRECTOR: KURT NEUMANN

The Ring is a drama dealing with the social and economic pressures in postwar Los Angeles that drive a Mexican American youth into the world of boxing. Though third billed, Lalo Rios is the star as Tommy Catanios. Tommy discovers his

father, Vidal (Martin Garralaga), lost his job at the same time the new living room furniture they ordered arrives at the house. It must be returned, but Tommy gave the old furniture to his clubhouse buddies and now is embarrassed to ask for it back. Feeling dejected, he visits his girlfriend Lucy, played by Rita Moreno in one of her early roles. Heading to the roller rink, the two realize they forgot the segregated rink was not open to them that day. They go to a bar instead, where two white men insult Tommy and make a remark about Lucy. A violent fistfight ensues, and Tommy has the upper hand, but he runs to avoid problems with the police. Talent scout and boxing manager Pete Ganusa (Gerald Mohr), who sees boxing potential in Tommy, picks the young man up. Tommy is initially suspicious of Pete's motives and knows his father would disapprove of his fighting, but finally agrees to Pete's offer to train him for a boxing career.

Pete gives him the Anglo name Tommy Kansas, and he proves himself a winner in his first low-level bouts. The money earned makes him the sole family breadwinner, to his father's disdain, but he wins the admiration of his little brother (Robert Altuna). After winning several fights, Tommy loses bouts as he encounters better fighters and refuses to listen to his trainer.

A near incident at a Beverly Hills diner with his friends, where they avoid arrest because a sympathetic police officer recognizes him as a prominent boxer, makes Tommy realize the importance of celebrity or, as his friends put it, "being somebody." He rededicates himself to boxing and assures Pete and Jerry that he will obey them without question. But as soon as he enters the ring, he pushes for a match with a seasoned opponent against the advice of his manager.

The Ring was progressive and far ahead

Lalo Rios as Tommy and Rita Moreno as Lucy are refused entry into the segregated skating rink.

its time in casting a Mexican American youth to play a Mexican American and in featuring a largely Latin cast. It was filmed on location in a multiethnic, predominantly Mexican American neighborhood of East Los Angeles, with a Jewish American enclave and pockets of Japanese Americans.

Though he made his film debut in *The Lawless* (1950), Rios's role as Tommy was ultimately the most prominent and memorable in his short career. After this film, his resume consisted of primarily small or bit parts, including an acid-throwing gang member in *Touch of Evil* (1958). The opportunities for leading roles for a distinctive Mestizo-looking actor were limited at the time.

In *The Ring*, Rios could be regarded as Hollywood's first Latino working-class rebel hero, as he expressed postwar concerns that developed into the Chicano (Mexican American) civil rights movement of the 1960s. His character is a progenitor of the teenage antihero that James Dean played in *Rebel Without a Cause*. Rios, who had no formal training, played the antihero naturally. In only her third film, Rita Moreno brought life to Lucy Gomez, the daughter of a more well-to-do family than the working-class Catanios. Martin Garralaga played the father, and the mother, Rosa, was played by Julia Montoya. Tommy's sister Helen was played by Lillian Moliere. Screen veteran Soledad Jiménez played the grandmother, and Joe Dominguez, a street vendor. Pepe Hern, Tony Martinez, Ernie Chavez, and Victor Millan round out the cast as Tommy's clubhouse friends.

HIGH NOON

With her oval face, piercing dark eyes, deep voice, and Mestiza beauty, Mexican actress Katy Jurado stood out from the rest of the female stars in Hollywood of her era. Jurado's role as Helen Ramirez in *High Noon* was an atypical

nuanced complex female Mexican character actually portrayed by a Mexican actress. She is at the center of the film, not a simple stereotype on the margins.

Jurado told the *New York Times* at the start of production, "I am very proud to make the picture because I look and act like a Mexican, not (an) imitation."[54]

Helen is the proprietress of the local saloon and has vested business interests in the town of Hadleyville. She is also the former lover of not only outlaw Frank Miller but also Marshal Will Kane (Gary Cooper). She has now taken up with Kane's young deputy, whom she dismisses for his immaturity and callowness.

On his wedding day to Quaker girl Amy Fowler (Grace Kelly) and last day as Marshal, Kane (Cooper) receives a telegram that Miller, an outlaw that he put away, has done his time and is en route on the noon train to exact

revenge. Kane is told to run, but he stays and calls upon the townspeople, who refuse to help him face down the outlaw and his gang. In desperation, Kane visits Helen, and she says in Spanish, "Un año sin verte," to which Kane replies "Si, lo se." which translates to English as "It's been a year since I've seen you," and Kane replies, "Yes, I know."

Ramirez is about to leave Hadleyville on the very train that is bringing Frank Miller to town. "I always hated being the only Mexican woman in Hadleyville," Ramirez confesses to Amy, referring to racial and moral indignities. There is a stark black-and-white contrast between the actresses, emphasized by wardrobe and photography: the elegant dark woman with a past and the wholesome Quaker dressed in white. The last shot of Ramirez in the film has her pensively looking out the window as the train pulls out of the station, leaving behind

her past and the imminent events, of which she is no longer a part and has no interest in the outcome.

"The femme assignment that has color and sex appeal is carried by Katy Jurado," declared *Variety* in its review of the film.[55] Jurado was nominated for a Golden Globe award but amazingly was not nominated for a Best Supporting Actress Oscar for her performance in *High Noon*. Two years later, she won a nomination for her performance as Senora Devereaux, the Mexican Apache wife of a cattle baron played by Spencer Tracy in *Broken Lance*. Even though her performance was good, she had little to do in this western about sibling rivalry and racial prejudice. The nomination seemed as if the Academy were trying to make up for not having nominated her previously. She balked at the idea of graying her hair to be more compatible with the middle-aged Tracy. It was thought she would look too young, but Jurado convinced the production team that Indigenous women's hair does not gray until well into old age.

Jurado was born Maria Christina Estela Mariela Jurado Garcia in Guadalajara, Mexico, and she made her Mexican film debut in 1943 in *No matarás*, in which she played a sultry femme fatale. She appeared in seventeen films over the next seven years. Besides acting, she worked as a journalist in Mexico City, covering the arts and bullfighting.

Katy Jurado as Helen Ramirez and Gary Cooper as Marshall Will Kane in a posed publicity photo..

Bullfighter and the Lady was Jurado's first Hollywood role, though the film was made entirely in Mexico. Director Budd Boetticher and producer/actor John Wayne spotted Jurado at a bullfight in Mexico City, not knowing that she was an actress, as she was there in her official capacity as a bullfight critic. Boetticher cast her opposite Gilbert Roland as the wife of an aging matador.

When she was brought to the attention of *High Noon* producer Stanley Kramer, who expressed an interest in casting her in the vital

role of Helen Ramirez, he asked Jurado to come to Los Angeles from Mexico for a screen test. Jurado refused and told him through her agent that if he had any doubts about her abilities and how she photographed, all he had to do was go to any Spanish-language movie house in Los Angeles and see her latest film. More crucial to the casting was that Kramer did not know she spoke almost no English. When he sent her the script, her good friend in Hollywood, the well-respected actor and director Antonio Moreno translated the screenplay into Spanish for her. When Kramer and director Zinnemann cast her, the actress stayed with Moreno, who coached her throughout filming. Though her English was extremely limited, she knew her lines perfectly and made herself understood by all.

Jurado followed with the westerns: *Arrowhead* (1953), in which she played a sultry Mexican Apache woman named Nita, who is torn between her love for a white man and her loyalty to her own people, and *San Antone* (1953), for which she was billed on the film's poster as "that *High Noon* girl."

Jurado also returned to Mexico to star opposite her real-life godfather, actor Pedro Armendáriz, in Luis Bunuel's acclaimed film *El bruto* (1953) as Paloma, an unfaithful wife. She won Mexico's equivalent to the Oscar, the Ariel Award, for her performance. In Mexican cinema, Jurado played a greater variety of nuanced, complex roles of women of all stations in life, but, in Hollywood, she was typecast exclusively

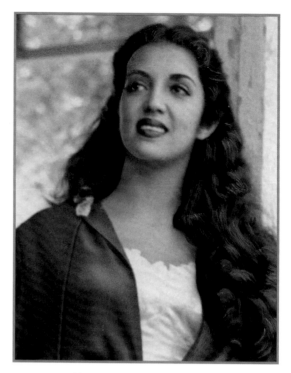

Katy Jurado as Helen Ramirez.

as a Native American or a Mexican woman largely in westerns.

In *Trial*, at MGM, opposite Glenn Ford, she played Mrs. Chavez, a Mexican American teenager's strong-willed but suffering mother. In Carol Reed's Parisian circus drama *Trapeze* (1956), she broke the usual typecasting in a contemporary role as Rosa, a circus performer and former girlfriend of star Burt Lancaster's aerialist. She also costarred with Anthony Quinn in the modestly budgeted western *Man from Del Rio* (1956).

In *The Badlanders* (1958), a character-driven western heist drama, Jurado again played a downtrodden Mexican woman with Alan Ladd and Ernest Borgnine. Borgnine, a Best Actor Oscar winner for *Marty* (1955), became smitten with Jurado during filming, and they married upon the

film's completion. The marriage lasted only a short time. Jurado later claimed their temperaments and his fits of jealousy doomed the marriage.

Jurado and Marlon Brando met when he was filming *Viva Zapata!* The romantic relationship they formed led to Brando casting her in the only film he directed and starred in: *One-Eyed Jacks* (1961). Jurado plays Maria Longworth, the Mexican American wife of Rio's (Brando) former outlaw partner Dan Longworth (Karl Malden), now the respectable sheriff of Monterey, California, against whom Rio has sworn revenge.

As she matured, Jurado transitioned into character roles. She played Eulalia Lewis, the cigar-smoking, domineering Mexican American mother of a judge in the 1920s New Mexico–set, racially charged legal drama *A Covenant with Death* (1967). The film had cinematic echoes to the Warner Bros. Paul Muni film *Bordertown* (1935). Jurado played Elvis Presley's Native American stepmother, Annie Whitecloud, in the abysmal, politically incorrect musical comedy *Stay Away, Joe* (1968). Despite this misstep, in a *Los Angeles Times* interview, she was quoted as saying, "I didn't take all the films that were offered, just those with dignity." She told the Associated Press she wouldn't play "shallow, American stereotypes of Mexicans."[56]

Jurado appeared in a memorable sequence in Sam Peckinpah's flawed western *Pat Garrett and Billy the Kid* (1973) as the shotgun-toting wife of mortally wounded Sheriff Baker (Slim Pickens). Jurado sits by the riverbank, anguished and crying, as Pickens faces his last sunset to the music of Bob Dylan's "Knockin' on Heaven's Door."

In 1981, she lost her only son, from an early marriage to actor Victor Velasquez, in a car accident. His death sent her into a depression and she stopped working for a time, but director John Huston lured her back to the screen with a role in *Under the Volcano* (1984), which was filming near her home in Cuernavaca, Mexico. As Doña Gregorio, Jurado has an essential scene with former British Consul Fermin, played by Albert Finney. Her last American film appearance was as a fortuneteller in Stephen Frears's modern western *The Hi-Lo Country* (1998). She died in 2002, at the age of seventy-eight.

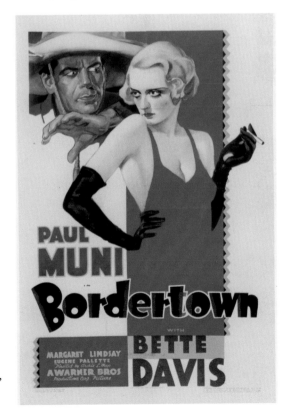

BLACKBOARD JUNGLE

MGM, 1955 / DIRECTOR: RICHARD BROOKS

*B*lackboard Jungle was the first major Hollywood studio film to introduce Spanish-speaking US citizens from the Caribbean island of Puerto Rico. The screen image of Puerto Rico had first been seen in *Mr. Moto on Danger Island* (1939), a

programmer about a Japanese American detective in which the island was maligned as a center of diamond and drug smuggling. More than seven hundred thousand Puerto Ricans arrived in New York City from 1945 to 1960, thus becoming a significant percentage of the New York City public school student population, as reflected in the movie. *Blackboard Jungle* also marks the first motion picture soundtrack to use the rock 'n' roll music of the youth generation of the 1950s, with the song "Rock Around the Clock," by Bill Haley & His Comets.

The film was a tremendous hit with teenagers and sparked controversy, with many conservatives critical of the movie for its unflattering depiction of US youth and the education system. Richard Dadier (Glenn Ford) is an army veteran hired as an English teacher in a New York City trade high school. In the

classroom, he deals with disrespectful, hard-edged working-class teenagers from diverse ethnic and racial backgrounds who give little thought to formal education.

In one notable scene, Dadier brings in a tape recorder and insists that Morales (played by Rafael Campos), a Puerto Rican who doesn't speak English fluently, be the first to try it. Dadier is hesitant, but Artie suggests Dadier doesn't like "spics." Morales fires back, calling him a "mick" in retaliation, prompting another student to throw a magazine at Morales.

Born in the Dominican Republic, Rafael Campos usually played and represented ethnic teenagers—Mexican, Puerto Rican, or Native American. His father was called to New York City in 1949 to fill an embassy post as consul general of the Dominican Republic when Campos was thirteen. The boy attended the city's High School of Performing Arts and

Rafael Campos as Puerto Rican student Pete Morales and Glenn Ford as high school teacher Mr. Dadier.

began appearing in plays. He was discovered by MGM casting director Al Altman in a Broadway play called *The Heavenly Express*. In a memo to producer Pandro S. Berman and director Richard Brooks, Altman stated of Campos, "Of Dominican origin but looks Puerto Rican with an accent that was good—a bit thick, possibly."

After *Blackboard Jungle*, Campos was cast again with Glenn Ford in *Trial* as a Mexican American boy wrongly accused of murdering a wealthy white girl in a southern California town. He followed with three films for Walt Disney. He also appeared opposite Marlon Brando in the western *The Appaloosa* (1966) with Miriam Colón and Emilio Fernández, and in the thriller *Lady in a Cage* (1964) with Olivia de Havilland. His last feature was *Fever Pitch* (1985), starring Ryan O'Neal. Campos passed away from stomach cancer at age forty-nine.

THE SEVEN YEAR ITCH

20TH CENTURY FOX, 1955, DIRECTOR: BILLY WILDER

Marilyn Monroe was devoted to a Mexican American designer. They came together most prominently in the frothy 1955 classic *The Seven Year Itch*, a movie that propelled Monroe to stratospheric cultural status, partly because of the

white dress that designer and costumer Bill Travilla created for the curvaceous Monroe.

A definitive entry in the canon of Marilyn Monroe, in this film a middle-aged New York publishing executive with a vivid imagination during a hot, steamy New York summer becomes infatuated with a bombshell wannabe actress who moves into the apartment upstairs. The film contains the iconic scene in which Monroe stands on a New York subway grating in midtown Manhattan wearing a halter-top, pleated, pure white dress as the updraft lifts and twirls her skirt. The image went global.

Oscar-winning costume designer William "Bill" Travilla, known professionally as Travilla, designed that distinctive dress and contributed to the creation of Monroe's signature look. He designed the wardrobe for eight films with Monroe and, on many occasions, for her personal use to wear at events. Travilla

emphasized Monroe's curves in his designs, such as the memorable pink gown in the musical number "Diamonds Are a Girl's Best Friend" from *Gentlemen Prefer Blondes*. He also designed the gold lamé dress from the same film, which at the time was considered risqué.

Travilla was born on Catalina Island, off the coast of California, and from an early age, he showed a talent for drawing. He studied design at Los Angeles's prestigious Chouinard Art Institute and Woodbury University. The designer began his motion picture career at Warner Bros. in 1941, on the recommendation of actress Ann Sheridan. He designed the costumes for her film *Nora Prentiss* (1947) and for *Flamingo Road* (1949), which starred Joan Crawford. Travilla won an Academy Award for Best Costume Design, Color, shared with Leah Rhodes and Marjorie Best, for *The Adventures of Don Juan* (1948), starring Errol Flynn. His stylish

costume design, though historically inaccurate, set the standard for future period adventure films.

He moved to 20th Century Fox in 1950.There he met Monroe and began working with the rising star. As Monroe became the studio's most important female star of the 1950s and a global sex symbol, Travilla literally fashioned an essential element of Marilyn's appearance and imagery that retains its influence today.

He designed the wardrobe for dozens of films and later, in the 1980s, worked in television, which brought him two Emmy Awards and four nominations. Although his designs are associated with Hollywood glamour, Travilla's talents in more than forty films ranged from such diverse genres as science fiction (*The Day the Earth Stood Still*, 1951), westerns (*The Tall Men*, 1955), and melodrama (*Valley of the Dolls*, 1967).

Travilla's favorite film was Elia Kazan's 1952 *Viva Zapata!* with Marlon Brando, Jean Peters, and Anthony Quinn. Travilla recalled his work on the film: "To give the costumes a peasant look . . . I was out in the streets beating the

clothes, wearing them down, and greasing them down, making body pads—giving an American girl a Mexican look." He continued, "There is a time when you can be a Pygmalion as a designer for movies because you are not only doing the clothes but developing the character they are playing."[57]

of a new hotel by oil tycoon Jett Rink, Juana and their baby are refused entry into the hall because of her ethnicity. The film's climax finds Bick and Leslie and Juana and the baby stopping at a roadside café where the owner scowls at seeing his mixed-race patrons. Moments later, Mexican workers enter the café and are ordered out by the owner. Bick intercedes on their behalf and gets involved in a vicious brawl with the café owner. He loses the fight but wins Leslie's respect.

The location for the exterior scenes was Marfa, Texas, where a facade of the main Benedict house was built. The Mexican village was filmed in the town of Valentine, forty miles to the east. In his insightful PBS documentary *Children of Giant* (2015), Hector Galan observed that "the film mirrored the real-life racism and discrimination against Mexican-Americans throughout the Southwest and in Marfa in which Mexicans were isolated in their own neighborhoods and kept apart from Anglo society. Everything was segregated, public accommodations, restaurants, housing, and schools."[60] As late as 2021 a chain-link fence at the cemetery in Marfa still divided the Mexican and whites-only sides.

Elsa Cárdenas, who played Juana, was a sixteen-year-old actress brought from Mexico to the United States for the film. Until then, she was not aware of the extent of American racism, particularly in Texas. To its credit, the film cast many Mexican American actors, including Victor Millan, Pilar Del Rey as Mrs.

Obregon, Felipe Turich as the head of the Mexican pueblo, Maurice Jara as Dr. Guerra, and Tina Menard as Lupe. The Los Angeles–based Menard had additional duties recruiting and hiring Mexican American extra players for the film both on location and back at the studio.

A tremendous hit and an outstanding production with stellar performances in a sweeping melodramatic adaptation of the novel, *Giant* won director George Stevens a Best Director Academy Award. Although the press visited the filming location during production and posted stories on the stars and the movie, they never commented on the racist policies prevalent in the county or in the film's storyline.

The movie's aspirations as a catalyst for social change were overshadowed by the untimely death of teen idol and antihero James Dean (fresh from his success in *East of Eden* and *Rebel Without a Cause*). Dean died in a car crash a few weeks after principal photography was completed and before *Giant*'s release. Though several prominent groups in Texas objected to the film's depiction of the dark side of Anglo-Mexican relationships in Texas and threatened boycotts, the film succeeded.

Although Stevens employed Marfa residents during the location shoot and the set was entirely open for residents to work and mingle without regard to race, ethnicity, or color, in accordance with town policies, Mexican residents who saw *Giant* in local movie houses had to sit in the segregated back of the theater or in the balcony.

Errol Flynn wearing the Oscar-winning wardrobe designed by Travilla for *The Adventures of Don Juan* (1949).

Travilla and his muse Marilyn Monroe in a wardrobe test photo.

A wardrobe test photo of Anthony Quinn in his authentic and well-worn Travilla-designed Mexican Revolution–era costume for his Best Supporting Actor Oscar–winning role in *Viva Zapata!* (1952).

THE TEN COMMANDMENTS

PARAMOUNT, 1956 / DIRECTOR: CECIL B. DEMILLE

*T*he *Ten Commandments* was pioneering director Cecil B. DeMille's final, most outstanding, and most popular cinematic achievement in a career that spanned the birth of the motion picture industry to the mid-twentieth century. The

biblical story of the Egyptian prince Moses who learns of his true heritage as a Hebrew and his divine mission to lead his people out of Egypt to freedom was a blockbuster motion picture that has endured as a film classic entertaining generations with yearly Easter airings on US television.

Francisco "Chico" Day was DeMille's first assistant director on *The Ten Commandments*. He helped guide the enormous production from location shooting in Egypt and the Sinai to Paramount in Hollywood. Chico orchestrated fourteen thousand costumed extras, rolling stock, and numerous local assistants to execute the massive and memorable sequence of the Israelites escaping from bondage in Egypt.

Chico recalled in an interview with this author, "On location in Egypt, we didn't hire just extras. We hired entire villages and tribes. DeMille made detailed sketches of what he

wanted the background action to be, and I hired local assistants with different colored caps and positioned them and showed them the specific action that I wanted out of each group they were in charge of." He further explained his duties: "I had to stage background action that would harmonize with what the director did with the principal players."[61]

Day was born Francisco Alonso in Ciudad Juarez, Mexico, the younger brother of actor Gilbert Roland. Day started as an extra player, but his keen knowledge of film production and the placement of background action led to a position as assistant director. He did such an excellent job in making a back lot set of a Mexican border town realistic to the last detail on *Hold Back the Dawn* (1941) that on a trip to Tijuana to secure authentic props and set dressings, to Chico's amusement, it was rumored among studio employees that he even

Assistant director Francisco "Chico" Day and the legendary director Cecil B. DeMille on the set of *The Ten Commandments* (1956).

brought back authentic local horse droppings. He endured much ribbing about his Mexican origins, but he was respected for his abilities.

Day worked at Paramount Pictures for thirty years on such films as *Shane* (1953), where he was the assistant on location in Jackson Hole, Wyoming, for George Stevens. Paramount also assigned him to guide star actors turned first-time directors—Anthony Quinn in *The Buccaneer* (1938) and Marlon Brando in his one directorial and starring effort, *One-Eyed Jacks*. Day later became a unit production manager on such international productions as *The Magnificent Seven* (1960), filmed in Mexico, and the Oscar-winning *Patton*, filmed in Spain and North Africa. Day was the first Mexican American member of the Directors Guild of America, which he joined in 1937.

AROUND THE WORLD IN 80 DAYS

UNITED ARTISTS, 1956 / DIRECTOR: MICHAEL ANDERSON

Mexican screen comedian Mario Moreno Reyes, better known as Cantinflas, was famous throughout Mexico, Spain, and Latin America for his wordplay, physical comedy, and social satire. Cantinflas made his motion picture debut in 1936

and starred in fifty-one films over his career. He established his own production company, which gave him complete artistic control and ownership of his movies, making him a multimillionaire. His frequent collaborator was Miguel Delgado, who directed him in thirty-three films from 1941 until his last, *El barrendero* (The streetsweeper), in 1982.

In 1954 impresario/showman/producer Michael Todd was mounting his film version of the Jules Verne novel *Around the World in 80 Days*, set in Victorian England, wherein Phileas Fogg wagers at the elite London Club that he can travel around the world in eighty days by steamship and railway. He is accompanied by his French valet Passepartout on a worldwide adventure to win the bet. Todd hit on the idea

of casting Cantinflas as Passepartout, knowing that his fame would add millions of dollars in revenue from Spanish-speaking markets.

Enjoying enormous popularity, Cantinflas had resisted offers from Hollywood, especially from RKO in the late 1940s, when it had vested interests in Mexico City's Churubusco Studios. But Todd convinced him of the artistic and economic potential of this spectacular English-language film. Even though the role is French, Cantinflas employed his natural Mexican accent and did not try to approximate a French accent. He essentially played his Cantinflas persona. Todd and director Michael Anderson made accommodations to the script to showcase his comic gifts to new audiences while not disappointing his existing fans. In the film, the

comedian hung from a hot air balloon, rode a turn-of-the-nineteenth-century high-wheeled bicycle through the streets of London, and traversed the top of a train while being chased by a horde of Native Americans in the Wild West. Not in the original script, an added stopover in Spain allowed Cantinflas to engage in a comic bullfight routine originating from his early days as an arena clown. He also participates in a wild flamenco dance with noted dance master José Greco. The movie introduced the concept of "cameos," in which well-known performers play bit parts. Among the movie's recognizable fifty cameo star appearances were Gilbert Roland and Cesar Romeo as Arab traders.

Around the World in 80 Days won five Academy Awards, including Best Picture of 1956. It is spectacular entertainment best appreciated on widescreen in a theater.

Cantinflas made another English-language Hollywood film, *Pepe* (1961), a musical comedy about a Mexican ranch hand who goes to Hollywood searching for his prized white stallion, previously sold to a struggling producer. The film interspersed musical numbers and episodic vignettes with star cameos. A highlight is a terrific dance number with Cantinflas and Debbie Reynolds to the classic tune "Tequila." Pepe is an innocent fish out of water, mistaken as simple-minded, often called Poncho in a condescending

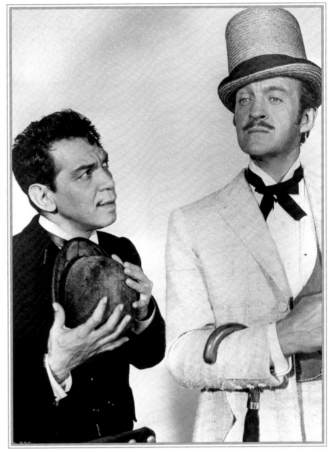

Mexican comedian Cantinflas as Passepartout and David Niven as Phileas Fogg in the Oscar-winning Best Picture.

manner by some stars he encounters along the way. *Pepe* plays like an expensively produced color television variety special of the '60s, stretched to three hours and fifteen minutes. It was not well received by critics or audiences. After the failure of this expensive extravaganza, the Mexican comedian never made another Hollywood movie.

The beloved comedian passed away in 1993, with legions of international fans and decades of entertainment to his credit.

THE BRAVE ONE

RKO, 1956 / DIRECTOR: IRVING RAPPER

*T*he Brave One, the story of a Mexican peasant boy, Leonardo, who tries to save his adopted pet bull Gitano (Gypsy) from certain death in the bullring, was honored with an Academy Award for Best Original Story for writer Robert Rich, who was

actually McCarthy-era blacklisted screenwriter Dalton Trumbo. It was filmed entirely on location in Mexico, according to studio records, at the cost of $723,000. Michel Ray—born Michel de Carvalho in 1944 in London, England, the son of a Brazilian diplomat and an English mother—played Leonardo. Michel had no aspirations to be an actor when a producer friend of the family needed a boy who could ski for a movie. He made his film debut in *The Divided Heart* (1954) based on a true-life event that was widely reported in the press about an orphaned child at the center of a court battle between his Holocaust survivor mother and his German adoptive parents. The movie's publicity led to him being cast in *The Brave One*.

Ray also had an important role in the western *The Tin Star* (1958), with Henry Fonda, and later played Farraj, the teenage Arab follower of T. E. Lawrence in *Lawrence of Arabia*. Shortly after that,

he abandoned acting and attended Harvard, where he majored in business. He became a member of the British Olympic ski team and competed in three Olympiads. De Carvalho is now a successful British financier and a controlling stockholder in the Heineken beer empire.

Rodolfo Hoyos Jr. played Leonardo's loving father, Rafael. He was a supporting character actor who appeared in many Hollywood westerns and TV shows from 1952 until he died in 1983. His film credits include *The Fighter* (1952), *Second Chance* (1953), *The First Texan*, *The Little Savage* (1959), and the title role of Pancho Villa in *Villa!* Born in Mexico City, Distrito Federal, Hoyos Jr. is the son of noted opera singer Rodolfo Hoyos Sr. He immigrated to the United States with his family and was exposed to Hollywood moviemaking at an early age, when his father appeared as an opera singer in the Marx brothers comedy *A Night at the Opera* (1935).

JAILHOUSE ROCK

MGM 1957 / DIRECTOR: RICHARD THORPE

Alex Romero was a dancer and choreographer at MGM Studios from the 1940s through the '50s. He choreographed the impressive "Jailhouse Rock" musical production number for the film of the same title. Romero knew traditional

choreography would not work for rock 'n' roll singer turned actor Elvis Presley in his third film. He asked Presley to demonstrate the hip-gyrating dance moves he performed on stage at his live concerts. Romero developed choreography incorporating Elvis's natural movements, and it worked out perfectly for the screen, backed by professional dancers in prison uniforms.

Alex's birth name was Alejandro Quiroga. He was the son of a Mexican general who was killed in the Mexican Revolution in 1913. His pregnant mother fled with the rest of his siblings and settled in San Antonio, Texas, where Alex was born. He joined a family vaudeville act as a dancer and changed his name to the easier to pronounce Romero. At seventeen, Alex went to Hollywood and joined Jack Coles's famed Columbia Pictures dance troupe. Romero was later hired as a staff

Alex Romero demonstrates his dance moves midair to actress Sandra Dee during rehearsals at MGM for *Until They Sail* (1957).

Elvis Presley in the iconic pose for the *Jailhouse Rock* musical number choreographed by Alex Romero.

assistant choreographer at MGM, where he worked on *American in Paris* (1964), *Seven Brides for Seven Brothers* (1954), and *On the Town* (1949). He was promoted to full-time choreographer at MGM in the late '40s, where he remained for twenty years, choreographing musical sequences in *Love Me or Leave Me* (1955) with Doris Day, *I'll Cry Tomorrow* (1955) with Susan Hayward, and *Tom Thumb* (1958) with Russ Tamblyn.

TOUCH OF EVIL

UNIVERSAL, 1958 / DIRECTOR: ORSON WELLES

Charlton Heston's strangely believable performance as a Mexican cop on the border with the United States is just one of the unusual but powerful elements in the Orson Welles–directed film noir *Touch of Evil*. In the film, a Mexican Federal

Narcotics agent, Mike Vargas (Heston), is investigating the border-town murder of a wealthy US businessman. This leads to danger for himself and his new bride, played by Janet Leigh.

Touch of Evil is a classic and the last studio film directed by Welles, who transformed a B movie and elevated it to bravura cinema. The film's final edit was taken away from Welles, and it was released in severely truncated form. Although the movie retained its visual power and Welles's vision in its condensed form, it left audiences perplexed and dissatisfied. In 1998, Universal issued a restored version more closely matching Welles's original edit, using a fifty-eight-page memo he sent to studio executives before the initial release. The film can best be appreciated in the restored version as closest to what Welles envisioned.

Touch of Evil deals with murder, corruption, duplicity, and racism in the fictional Mexican town of Los Robles, on the Mexican side of the border. That the protagonist of the film is a Mexican married to an Anglo-American woman was very progressive for its time and was a way for Welles to upend audience expectations, since in the original novel, *Badge of Evil*, the hero is Anglo. In the film, the American cop is the bad guy, not the Mexican Heston. He was in brown face and not ideally suited to play a Mexican, but he was the rising star the studio wanted for the film, and he strongly urged that his proposed costar, Welles, direct the movie.

After all, Heston was a dedicated actor. *Touch of Evil* touches on all the Mexican border stereotypes and Anglo-American fears about them through Janet Leigh's Suzie. As Welles wrote in his massive editorial notes to the studio, "she's American and he's Mexican. Their separation too is directly the result of a 'border incident,' in which the interest of the

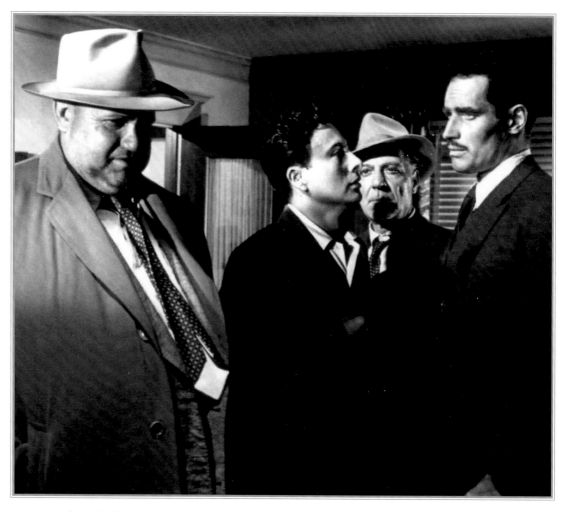

Orson Welles as Hank Quinlan, Victor Millan as murder suspect Sanchez, Joseph Calleia as Pete Menzies, and Charlton Heston as Mike Vargas in Orson Welles's *Touch of Evil.*

countries are in some conflict."

There is no beautiful, colorful, romantic Mexican backdrop for these newlyweds. Welles selected the seaside community of Venice, California, for the location, doubling for the Mexican border town, as it "looked convincingly run down and decayed," as Welles noted in his lengthy memo.

As the investigation into the car bombing that caused the murder unfolds, Sanchez (Victor Millan), a lowly shoe salesman, boyfriend of the wealthy victim's daughter, surfaces as the prime suspect. Soon police officers led by Quinlan and Vargas show up at Sanchez's stateside apartment to question him. As they go through his personal effects, Sanchez tries to explain to the authorities

in Spanish. "I don't speak Mexican," Quinlan retorts before slapping him. Vargas discovers Quinlan has planted evidence to frame Sanchez. Near the film's end, Vargas is told that Sanchez was guilty and had confessed to dynamiting the car.

Actor Victor Millan recalled in a 1994 interview, "I went to read for Orson Welles at Universal Studios. We went into rehearsal period, and it is a long scene. Orson wanted it in one take without any cuts. He had a disagreement with the studio because they wanted it with cuts, but he wanted it in one take. We rehearsed it in Welles's home in the Hollywood hills. So, he blocked the scene in his big living room with all the actors, and we rehearsed without the slap. After a couple of days of rehearsal, we were ready to shoot. I got used to him (Welles) not hitting me. Well, in the scene, Welles comes into the room and comes up to me and addresses me and says the lines, and then he slaps me. He really did slap me, and my teeth were rattled. I was worried about my jaw swelling up. I didn't want to do another take. I thought this had better be good, and it was good. We did it in one take!"[62]

Millan, whose real name was Joseph Brown, was born and raised in East Los Angeles and graduated from the University of California, Los Angeles. Among his many film credits are George Stevens's *Giant*, *The FBI Story* (1959) with James Stewart, *Walk the Proud Land* (1956) with Audie Murphy, and *Boulevard Nights* (1979) with Danny De La Paz and Richard Yniquez. Millan was a professor and dean of the Theatre Arts Department at Santa Monica College in California. Millan had a solid career as more than a yeoman actor, including his valuable participation in Welles's *Touch of Evil*—an indication that Latino/Latina artists were a significant part of the trajectory of Hollywood film evolution.

RIO BRAVO

WARNER BROS., 1959 / DIRECTOR: HOWARD HAWKS

*R*io Bravo is a high watermark in the legendary career of director Howard Hawks. It has influenced many modern-day filmmakers such as Quentin Tarantino and John Carpenter and was a major box-office hit for western film icon

John Wayne. Sheriff John T. Chance (Wayne), in his efforts to hold in jail the murderer brother of a powerful cattle baron and his hired guns, is aided by his band of misfits: a disabled old man, a drunk, a teenage gunfighter, and hotel owner Carlos Robante, played by the diminutive comedic character actor Pedro Gonzalez Gonzalez. Gonzalez Gonzalez makes an excellent comic foil for straight-shooting Wayne. He is far from the Mexican stereotype.

Robante's wife, Consuelo, is played by Estelita Rodriguez, a Cuban-born actress who was under contract at Republic Pictures and appeared in many westerns with Roy Rogers. Carlos and his wife, Consuelo, are presented as capable in *Rio Bravo*, and Carlos is not afraid to tote a gun. It is symbolic that the hotel owned by the Mexican couple is named the Alamo Hotel, after the site of the legendary 1836 battle in which the Mexican Army defeated the

Texas rebels. It is as if with this name, they are reclaiming the legal and moral right to be a part of this American community.

Gonzalez Gonzalez's successful career in motion pictures is more striking because he could neither read nor write English or Spanish. His wife read scripts aloud to him, and he memorized his lines. If changes were made to the script on set, his costars would help him. "I never learned to speak English too good, but the audiences liked it that way," remarked Gonzalez Gonzalez in a 1998 interview.[63]

He was born in Aguilares, Texas, as Ramiro Gonzalez Gonzalez, to a Mexican American trumpet-player father and a Spanish dancer mother who had the same last name. As is customary in Mexican culture, both the mother's and father's surnames are used. Thus, Gonzalez Gonzalez. At seven, he left school to join the family in a theatrical show touring

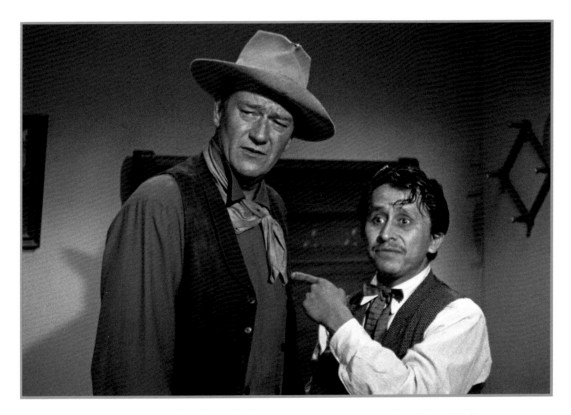

John Wayne as Sheriff John T. Chance and Pedro Gonzalez Gonzalez as hotel proprietor Carlos Robante in Howard Hawks's classic western.

Mexican communities in the Southwest during the Depression. He was drafted and served in the US Army in World War II.

His breakthrough to a national audience came with his hilarious appearance as a contestant on Groucho Marx's *You Bet Your Life* television program in 1953. He caught the attention of John Wayne, who was impressed with how Gonzalez Gonzalez matched wits with the formidable Marx. Wayne signed him to a contract with his Batjac Productions. After Gonzalez Gonzalez

was cast as a comedic shipboard radio operator in Wayne's hit film, *The High and the Mighty* (1954), the actor became a regular fixture in movies and television westerns of the '50s and '60s, appearing in *Strange Lady in Town* (1955), *The Sheepman* (1958) with Glenn Ford, *Hostile Guns* (1967), and *Support Your Local Sheriff* (1969) with James Garner.

A brother, Jose Gonzalez Gonzalez, virtually identical in look, would take Pedro's roles when he was not available. They were often mistaken for one another by producers.

THE PAWNBROKER

AMERICAN INTERNATIONAL PICTURES, 1964 / DIRECTOR SIDNEY LUMET

Though it is about a Jewish survivor of a Nazi concentration camp, *The Pawnbroker* equally features a talented Latin and African American supporting cast. Cinematographer Boris Kaufman captures a gritty and realistic look at the 1960s East

Harlem neighborhood known as El Barrio because of its predominantly Puerto Rican inhabitants surrounding the pawnshop's 116th Street and Park Avenue location, where much of the film takes place.

Sol Nazerman (Rod Steiger), the Holocaust survivor, runs a pawnshop in New York's Spanish Harlem used as a front by a local crime czar, Rodriguez (Brock Peters). Tortured by the pain of the past, he has emotionally detached himself from everyone around him. When his young Puerto Rican assistant, Jesus Ortiz (Jaime Sánchez), repeatedly tries to break through Sol's icy veneer, he is treated with disdain. Life is tough in this poverty-stricken neighborhood, where there are few options for upward mobility. Jesus aspires to run his own pawnshop and wants to learn the trade so that he and his girlfriend, a sex worker, can escape their dire circumstances. He implores Sol to teach him

about gold, but Sol rebuffs Jesus's interest with disdain. In anger Jesus plots a store robbery with some local thugs. It backfires tragically.

The film depicts the mixed-race background of Puerto Ricans as illustrated by Jesus, played by Puerto Rican actor Jaime Sánchez (*The Wild Bunch*, 1969; *David and Lisa*, 1962), and by his mother, portrayed by Cuban American actress Eusebia Cosme. Brock Peters plays Rodriguez, and Puerto Rican actor Juano Hernandez plays pawnshop patron Mr. Smith. Thelma Oliver plays Jesus's girlfriend. The film was lauded as the first mainstream Hollywood film to deal with the psychological aftermath of the Holocaust on survivors and for the tour de force acting of Rod Steiger, which earned him an Oscar nomination for Best Actor. The film editing provided three-second subliminal flashbacks, innovative for the time and influential on other filmmakers.

CHINATOWN

PARAMOUNT, 1974 / DIRECTOR: ROMAN POLANSKI

*C*hinatown was a celebrated, critically acclaimed film of the new Hollywood of the 1970s. It won an Academy Award for Robert Towne's superlative screenplay. Over a forty-year career, actor Perry Lopez is best known for his role as LAPD Lieutenant

Escobar in *Chinatown* and its sequel, *The Two Jakes* (1990), set ten years later in 1948, when Escobar is a wounded veteran.

The film follows private investigator Jake Gittes, played by Jack Nicholson, in 1937 Los Angeles. Believing the wife of the Los Angeles Department of Water and Power chief engineer has hired him to follow her husband, whom she suspects of adultery, Gittes shadows the engineer, uncovering corruption and violence in LA politics and among its powerbrokers.

During his investigation, Gittes, a former police officer, runs into his old Chinatown partner, Lou Escobar (Lopez), now an LAPD lieutenant. Escobar has been assigned to the murder investigation of engineer Hollis Mulwray and understands the far-reaching elements that are outside his control. He tries to impart that hard-learned lesson to Gittes when he tells him, "I'm out of Chinatown now."

At the crushing end of the film, the next-to-last line is spoken by Escobar to Gittes: "You never learn, do you, Jake?"

It was rare to find an educated, tough-talking Mexican American police officer in a period film of this type played by an authentic actor. In fact, it was rare to find a Mexican American police officer of any rank in 1930s Los Angeles. By comparison, the LAPD in 2022 is 45 percent Latinx.

Perry Lopez was born in New York City of Puerto Rican parents. Possessing dark good looks, physical presence, and acting ability, he was signed to a Warner Bros. contract in 1955. He quickly appeared in minor roles in such films as *Mister Roberts* (1955) and *Battle Cry*, and he was given the lead in a prison programmer, *The Steel Jungle* (1956). He also costarred with Tony Curtis and Yul Brynner in *Taras Bulba* (1962). Because of his longtime friendship with

Jack Nicholson as Jake Gittes and Perry Lopez as police Lt. Lou Escobar.

Charles Bronson, his last parts were in Bronson's *Death Wish 4: The Crackdown* (1987) and *Kinjite: Forbidden Subjects* (1989).

Noted cameraman John A. Alonzo was nominated for an Academy Award for Best Cinematography for his camera work on *Chinatown*. In an American Society of Cinematographers interview, he recalled director Roman Polanski said, " 'Johnny, please no diffusion on the lens; I don't want a Hollywood look,' so I borrowed an idea the great [cinematographer] Jimmy Wong Howe had told me about. I used Chinese tracing paper to shift the light and color so that it turned beige and gold. Roman liked it."[64]

Alonzo became part of the new wave of Hollywood filmmakers who emerged in the early 1970s. They drew inspiration from more realistic documentary-style production photography. Alonzo excelled in handheld techniques and evocative lighting that took advantage of both location and studio sets in

Oscar-nominated cinematographer
John Alonzo sets up a shot on the set.

with his family to Dallas. Alonzo found work at a local television station and hosted a children's television show with puppets, and he later moved to a station in Los Angeles. He secured employment as an actor, appearing as a bandito in *The Magnificent Seven* and on several TV shows. Fascinated by the art of cinematography, he pursued the craft and was hired as a cameraman on several National Geographic documentaries and David L. Wolper Productions. While working as an assistant on John Frankenheimer's *Seconds* (1966), he was recruited on the spot by cameraman James Wong Howe as a last-minute replacement for a camera operator who failed to report to work that day. Alonzo joined the International Alliance of Theatrical and Stage Employees Local 600 as a union cameraman. He soon found work as a cinematographer on his first feature, *Bloody Mama* (1970), for famed commercial filmmaker Roger Corman. Alonzo was an innovative cameraman who embraced the developing video digital technology and won praise for his work in the new format on the television films *World War II: When Lions Roared* (1994) and *Fail Safe* (2000), for which he won an Emmy award for cinematography. Alonzo died at the age of sixty-six in 2001.

a fast and efficient manner, which enhanced the director's vision. Among the best known of his fifty feature film credits as director of photography are *Lady Sings the Blues* (1972), *Sounder* (1972), *Norma Rae* (1979), *Farewell, My Lovely* (1975), and *Scarface* (1983).

Alonzo was born in Dallas, Texas, to Mexican migrant farm worker parents. He spent nine years in Guadalajara, Mexico, before returning

Postwar Social Problem Films and Emerging Stars

(1945–1965)

Beginning right after World War II, many Hollywood films reflected American societal concerns, including the raw reality of returning veterans, racial and ethnic inequities, and the evolving roles of women.

The adjustments of returning vets were the subject of Samuel Goldwyn's all-star *The Best Years of Our Lives* (1946), antisemitism was the subject of *Gentlemen's Agreement* (1947), and racism was the issue in *Pinky*, *Home of the Brave*, and *Intruder in the Dust* in 1949. In all the films except *Brave*, women play crucial and proactive parts in the storylines.

A more sympathetic view toward Native Americans was on display in *Broken Arrow* (1950), and several films followed that focused on relationships between white people and Native Americans. Contemporary themes of racial prejudice could also be placed in a western to distance itself for audience consumption from the realities of the present

Mexican Federal agent Pablo Rodriguez (Ricardo Montalban) goes undercover as an undocumented worker in order to expose a human-trafficking crime ring operating along the US/Mexico border in *Border Incident* (1949).

his sister, played by Esther Williams, wants to become a bullfighter. In a dance sequence with accomplished dancer Cyd Charisse and Williams, Ricardo caused such a sensation that MGM signed him to a seven-year contract. He could dance and sing with such incredible agility that audiences had no idea he had never danced professionally.

In *Neptune's Daughter* (1949), he and Williams introduced the Oscar-winning Best Song "Baby, It's Cold Outside." The two perform the song sitting on a couch, and when Williams tries to stand up, Montalban tugs her back down by the arm. Written by Frank Loesser in 1944, the song was controversial in its time for its suggestive lyrics. Still, it overcame that stigma and became a popular Christmas song, recorded through the years by various artists, from Dean Martin to most recently John Legend and Kelly Clarkson. In 1949, Montalban appeared on the cover of *Life*, which proclaimed him the "new romantic star" and signaled his mainstream acceptance by US audiences. While filming *Across the Wide Missouri* (1951) for director William Wellman opposite Clark Gable on location in the Colorado Rockies, Montalban suffered a severe injury. As Native American Iron Shirt, he rode a horse with only a blanket and bridle. A cannon fired from the valley below spooked the horse, and the animal ran off with the actor holding on for dear life until he was thrown. He fell on his back, and a rock punctured his spine, causing a slight hemorrhage. The injury left him in

Ricardo Montalban MGM portrait, circa 1947.

constant pain and with limited movement of one leg for many years after. Through medical treatment therapy, exercise, and sheer willpower, he regained the full use of his leg. In later years, the pain reappeared, and his movements were again compromised. Filmmakers covered his limitations with strategic camera angles and a stunt double for scenes that required running.

In his early MGM films, Montalban was cast as the archetypical Latin lover; he even starred as Brazilian Roberto Santos in a film called *Latin Lovers* (1953) with Lana Turner. The actor also turned in solid dramatic work as Pablo Rodriguez in *Border Incident*.

In *Right Cross* (1950), Montalban played Mexican boxer Johnny Ramirez opposite June

Allyson and Dick Powell. He also starred as Boston detective Pete Morales, in charge of a critical murder case, in the John Sturges directed film noir *Mystery Street* (1950). In *My Man and I* (1952), Montalban essayed the starring role of Chu Chu Ramirez, a Mexican immigrant farm laborer who becomes a naturalized US citizen and proudly carries with him a letter from the president of the United States. A local rancher cheats him, but his belief in his new country's values and sense of justice enable him to win in court and in love. John Fante and Jack Leonard wrote the original source story "Letter from the President," in which the protagonist was Filipino.

Although Oscar-nominated Shelley Winters received top billing, Montalban was the film's star.

MGM released Montalban from his contract in 1953, along with other MGM stars, as the studio system of contract players wound to a close during the decade. As a freelance star, Ricardo alternated between films and television dramas. He remarked that the variety of roles on television gave him "wings as an actor and freedom from the Latin Lover stereotype."[65] He starred in the Mexico City–filmed *A Life in the Balance* (1955), in which his character is falsely accused of murder while unbeknownst to him, his young son is in pursuit of the actual

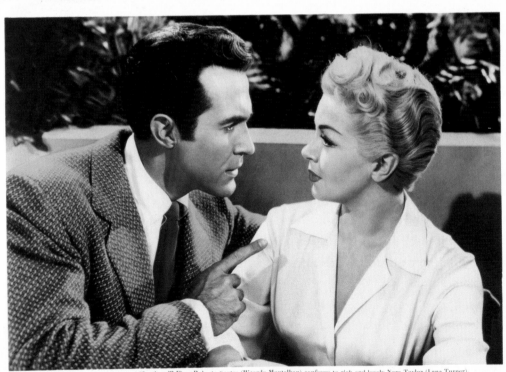

"I don't mind your millions . . . I like them!" Fiery Roberto Santos (Ricardo Montalban) confesses to rich and lovely Nora Taylor (Lana Turner).

"LATIN LOVERS"

M-G-M's Color by Technicolor

Copyright 1953 Loew's Incorporated Country of Origin U. S. A. Property of National Screen Service Corp. Licensed for display only in connection with the exhibition of this picture at your theatre. Must be returned immediately thereafter. 53 - 465

killer (played by Lee Marvin). In an unusual casting choice, Montalban played Nakamura, a Japanese Kabuki star attracted to Caucasian US Army general's daughter Eileen (Patricia Owens) in the Oscar-winning *Sayonara* (1957), a tale of prejudice and racism in postwar Japan also starring Marlon Brando. He played an Italian army officer in Hemingway's *Adventures of a Young Man* (1962) for director Martin Ritt and a French priest in the musical hit drama *The Singing Nun* (1966) opposite Debbie Reynolds.

His costarring role opposite Shirley MacLaine in Bob Fosse's film version of the musical *Sweet Charity* (1969), as Latin movie idol Vittorio Vidal, was a great personal success. "It was really a satire on the Latin Lover," recalled Montalban. "The circumstances that developed were quite hilarious."[66]

In John Ford's last western, the epic *Cheyenne Autumn*, Montalban played Native American Little Wolf alongside Gilbert Roland and Dolores del Rio. This was the only time the three worked together in major starring roles. "Ford was not at his best and in failing health, but he still retained his ability with photographic composition," Montalban said of the legendary director.[67]

Montalban encountered the modern science fiction film genre with his role as Armando, the circus owner who hides and raises the baby ape Caesar in two sequels to the seminal *Planet of the Apes* (1968): *Escape from the Planet of the Apes* (1971) and *Conquest of the Planet of the Apes* (1972).

When he suddenly lost work because of his activism on behalf of Latino/Latina performers in Hollywood (see page 202), Montalban went to Europe for a part as an Indian scout in the spaghetti western *The Deserter* (1971), and to Mexico to costar with John Wayne in *The Train Robbers* (1973).

In a 1970 *TV Guide* interview, Montalban remarked, "It's taken me a long time to reach this point, but it's paid off. I'm on the right track and ready to go. The best is yet [to come]. I'm closer now as an actor to being able to do the simplest things well. To arrive at the simplicity of truth—that is what is exquisitely difficult."[68]

During a theatrical tour stopover in Detroit, he was offered the opportunity to be a television spokesperson for a series of car commercials touting a new automobile, the Chrysler Cordoba. With its emphasis on Spanish elegance and style, the Cordoba fit Montalban's image. His now legendary acclaim of the interior's "Corinthian leather" made it one of the top-selling cars of the era.

These ads brought the actor renewed attention and interest from producer Aaron Spelling, who was searching for a lead actor for his proposed ABC television network series *Fantasy Island* (1978–1984). The network considered Orson Welles for the lead role but Spelling knew the temperamental actor would not commit to a series and rejected the idea. Spelling cast Montalban in the role he would become closely identified with, as the mysterious Mr. Roarke, host of Fantasy Island. With his diminutive assistant Tattoo (played by Hervé Villechaize), Roarke grants the

wishes of paid guests to the island paradise. The one-hour-episode series was one of television's highest-rated programs for most of its run.

When Montalban was offered the opportunity to reprise the role of Khan in the feature film *Star Trek II: The Wrath of Khan*, he remarked, "I had to rewatch the original show to reacquaint myself with the character, who had become so passionate and consumed with avenging his wife's death by getting Captain Kirk."[69] Montalban's performance as the powerfully menacing Khan was of Shakespearean magnitude, and he received some of the best notices of his career. Critic Christopher Null called Khan "the greatest role of Montalban's career,"[70] and *New Yorker* critic Pauline Kael wrote it was "The only validation he has ever had of his power to command the screen."[71]

Today, Montalban is also known as the wheelchair-using Grandpa Cortez in Robert Rodriguez's hit Spy Kids franchise. Because of a degenerative spinal disease aggravated by his previous injury and unsuccessful spinal surgery, Montalban used a wheelchair and was in constant pain in his later years. In *Spy Kids 3D* (2003), the magic of computer-generated imagery restored Montalban's ability to run and leap as a virtual-reality superhero confronting the Toymaker (played by Sylvester Stallone). Innovative wunderkind filmmaker Robert Rodriguez grew up watching Montalban in movies and on television and sought him out especially for the role.

Among his many awards, Montalban earned

Ricardo Montalban in his memorable role as Khan in *Star Trek II: The Wrath of Khan* (1982).

an Emmy for his role as a Native American chief in the TV western miniseries *How the West Was Won* (1976), and he was nominated for a Tony Award for Best Actor in the Broadway musical *Jamaica* (1957), opposite Lena Horne. He was given a Screen Actors Guild Lifetime Achievement Award in 1994 for his service to the union.

The actor married Georgiana Young, a model and half sister of actress Loretta Young, and they had four children. Montalban continued acting on screen and doing voice work for animated programs until shortly before his passing in 2009. His impact is still widely felt; the Ricardo Montalban Theatre in Hollywood is the only legitimate theater in the United States named after a Latin performer.

ANTHONY QUINN

Tall, ruggedly handsome, barrel-chested Anthony Quinn was perhaps the most important American Latino star of his generation. His memorable portrayal of characters of many ethnicities in more than two hundred motion pictures during a

seven-decade career made him recognizable to moviegoers worldwide.

Quinn was a two-time Oscar winner for Best Supporting Actor for his roles as Eufemio, the drunken and undisciplined older brother of Mexican revolutionary Emiliano Zapata (Marlon Brando) in Elia Kazan's *Viva Zapata!* and for his portrayal of artist Paul Gauguin in Vincente Minnelli's *Lust for Life*, opposite Kirk Douglas as Vincent van Gogh.

Quinn's larger-than-life portrayals represented the downtrodden underdog in earthy, masculine, and strong nonwhite screen personas. Whether Greek, Chinese, Mexican, Native American, or Arab, his characters transcended race and ethnicity, imbuing his performances with universal humanity that audiences identified with—so much so that many nations claimed him as their own, though his origins lie in Mexico.

The humanity and sensitivity evident in Quinn's performances were forged early, as he was born and raised during times of upheaval and human struggle in his native Mexico and in the United States. He didn't start out to be an actor, but he learned his craft and brought something unique to Hollywood and world cinema.

Anthony Rudolpho Quaxaca Quinn was born in a railroad boxcar somewhere in Chihuahua, Mexico, during the Mexican Revolution in 1915. His parents, Frank Quinn, an Irish Mexican, and Manuela Quaxaca, an Indigenous Mexican, fought for Pancho Villa. Quinn's paternal grandfather was an Irish immigrant who became a railroad worker in the American West. He later went to Mexico to work the railroad expansion during the presidency of Porfirio Díaz.

To escape the ravages of the warring factions of the revolution, the Quinns moved to El Paso, Texas, before making their way to Los Angeles. Frank found work at the old Selig studios in the camera department, but he died unexpectedly

in a car accident at twenty-nine when Anthony was eleven. The devastating loss forced young Quinn to help support his mother, sister, and grandmother.

He demonstrated talent in drawing and sketching and met famed architect Frank Lloyd Wright. Wright became a father figure to Quinn and took a personal interest in the young man's welfare. Wright noticed Quinn had a speech problem and sent him to a doctor who corrected a physical impediment. Quinn then took elocution lessons upon Wright's recommendation. When Quinn was offered employment as an actor, Wright urged him to pursue the opportunity.

He appeared in several stage productions and soon landed a nonspeaking part as a convict who is knifed in the back in the film *Parole!* (1936). But Quinn's big-screen break came when he was cast as a Cheyenne Indian in Cecil B. DeMille's *The Plainsman* (1936), with Gary Cooper. He later vowed that he won the interview by claiming he was a member of the Blackfoot tribe. "A Mexican boy couldn't be anything else but an Indian. They would say to me, 'Hey, you're an Indian,' so I played Indians," remarked the actor.[72] "I saw racial discrimination all around me, but I refused to acknowledge it. Mexicans were treated as second-class citizens, and it created a tremendous conflict in me," recalled Quinn of his youth.[73]

Quinn ended up with a Paramount Pictures contract, and he received his on-the-job training playing swarthy villains, gangsters, Native Americans, and Pacific Islanders. As he later

Anthony Quinn is Alexis Zorba, the earthy, larger-than-life Greek peasant in *Zorba the Greek* (1964).

explained, "The bad guy or the villain as you call him, has a point of view and more than likely believes his actions are right." This insight brought subtlety and sensitivity to otherwise stereotyped characters.[74]

He appeared in three B movies for Paramount with Chinese American actress Anna May Wong. His other notable early film credits include *Union Pacific* (1939), *The Buccaneer* (1938), *Waikiki Wedding* (1937), *Swing High, Swing Low* (1937), and *The Ghost Breakers* (1940).

The young aspiring actor met and married the dark-complexioned Katherine DeMille, adopted daughter of Cecil B. DeMille. "He saw me as some kind of Indian and thought

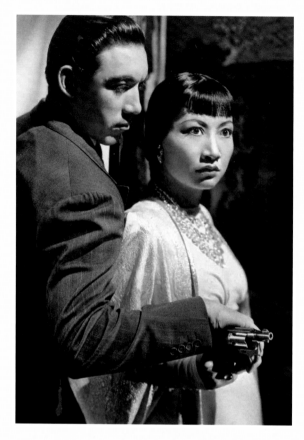

Anthony Quinn and Anna May Wong
in *Dangerous to Know* (1938).

He was able to find solace or temporary refuge from grief in a steady stream of film portrayals. Quinn was the bullfighter Manolo, a rival to star Tyrone Power's Juan Gallardo in *Blood and Sand* (1941). He played Chief Crazy Horse opposite Errol Flynn's George Custer in Raoul Walsh's western *They Died with Their Boots On* (1941), a Mexican lynching victim in *The Ox-Bow Incident*, a Chinese warlord in *China Sky* (1945) with Randolph Scott, and Chief Yellow Hand in *Buffalo Bill* (1944) with Joel McCrea. He portrayed a Filipino freedom fighter in *Back to Bataan* and a South American mining engineer in *Tycoon* (1947), both with John Wayne.

In 1947, Quinn left Hollywood for the New York stage, where he studied at the famed Actors Studio. Director Elia Kazan offered him the part of Stanley Kowalski, the role that made Marlon Brando a star, in the road company of *A Streetcar Named Desire*. Quinn essayed the role and made it his own, later following Brando in the role on Broadway.

In 1951 he returned to movies as the manager of a gored toreador afraid to return to the arena in Robert Rossen's *The Brave Bulls*, which was shot in Mexico. "The supporting cast was entirely Mexican, and I was thrilled to be in such company," he recalled. "After so many years as the token Latin on the set, I found tremendous security in numbers. For the first time, I belonged."[77]

Despite winning the Academy Award for

me and his daughter were a good match," said the actor.[75] He and Katherine suffered a tragic loss when their three-year-old son Christopher accidentally drowned after wandering away from his home and falling into a neighbor's garden pool. It was decades before Quinn could openly talk about his grief and told an interviewer it reminded him of a line from *Zorba the Greek* (1964) reflecting on the character's own loss. "I had to dance. Everyone thought I had gone mad, but if I had not danced, I would have surely gone mad."[76]

Viva Zapata!, he continued to be cast in the usual secondary ethnic character parts: a Portuguese sailor in *The World in His Arms* (1952), a Madagascan pirate in *Against All Flags* (1952), a Seminole chief in *Seminole* (1953), and a Javanese despot in *East of Sumatra* (1953). On the night of his Oscar win, he was on location in Mexico playing second fiddle to his friend Gary Cooper (who also won an Oscar that night as Best Actor for *High Noon*) in a derivative melodrama *Blowing Wild* (1953).

With no change in sight, Quinn left for Italy in search of better acting opportunities. In an attempt to broaden its international appeal, neorealist Italian cinema was making lucrative deals for Hollywood talent. "What could I play? They only think of me as a Mexican, an Indian, or a Mafia Don," remarked the actor about his decision.[78] Things did not bode well initially when he played a supporting role in *Ulysses* (1954), but he had the promising lead in *Attila* (1954). Good fortune soon presented itself, but Quinn did not realize it.

Italian neorealist filmmaker Federico Fellini was planning a film called *La Strada* (1954) to star his wife Giulietta Masina, who was doing a movie in Rome, *Angels of Darkness* (1954), with Quinn. Fellini met the actor and thought Quinn had the strong masculinity necessary for the character of the brutish circus strongman Zampano and offered him the role. Quinn later remembered, "I thought he was a little bit crazy, and I told him I wasn't interested in the picture, something about a strongman and a half-wit girl, but he kept hounding me."[79] Quinn's fellow actors urged him to take the role and told to watch Fellini's *I vitelloni* (1953). Upon seeing the film, he signed on to play Zampano.

La Strada began shooting in October 1953, with Quinn alternating frequently between two filming locations, as he was also shooting *Attila*. The circus strongman Zampano (Quinn) buys a naive peasant girl, Gelsomina (Masina), from her impoverished mother. The two travel through war-ravaged Italy, performing for poverty-stricken locals. Zampano is cruel and abusive to trusting, childlike Gelsomina, who has grown to love him. They join a larger circus, where Zampano encounters an old rival, the acrobat artist known as the Fool (Richard Basehart). The Fool helps Gelsomina but incurs Zampano's jealousy and wrath, to a tragic outcome. Quinn's heartbreaking scene at the end when he collapses on a bleak and windswept beach is unforgettable and earned him international acclaim.

Premiering at the Venice International Film Festival in 1954, *La Strada* won the Silver Lion Award and went on to win more than fifty international honors, catapulting Fellini to the top echelons of world cinema. It became the first film to win an Academy Award in the new Best Foreign Language category in 1956. In his *New York Times* review, A. H. Weiler wrote, "Anthony Quinn is excellent as the growling monosyllabic and apparently ruthless strongman, but his character is sensitively developed so that his innate loneliness shows through the chinks of his rough exterior."[80]

Quinn's performance established him as

a leading international actor and star. "My life really started all over again when I did *La Strada*. I think it really convinced people I was an actor."[81] He received a second Best Supporting Actor Oscar for his intense portrayal as artist Paul Gauguin in Vincente Minnelli's *Lust for Life*. What followed was a rich period of leading roles. He starred in two westerns, *The Ride Back* (1957) and *Man from Del Rio*, and received an Academy Award nomination for Best Actor as an Italian rancher who marries the immigrant sister (Anna Magnani) of his deceased wife in *Wild Is the Wind* (1957), directed by George Cukor. The in-demand actor followed with another two westerns, *Warlock* (1959), with Henry Fonda, and *Last Train from Gun Hill* (1959), opposite Kirk Douglas.

Quinn turned to directing in 1957, when his ailing father-in-law, Cecil B. DeMille, was unable to remake his 1938 film *The Buccaneer*, in which Quinn had a minor role. Quinn's direction suffered under the weight of an expensive and outdated script supervised by DeMille. The film was a box-office dud.

Returning to acting, he took on a romantic lead role as Rick Valente in *The Black Orchid* (1958), directed by Martin Ritt. Valente is a widower who falls in love with a mob widow played by recently transplanted Italian actress Sophia Loren. Quinn played a Greek resistance fighter in the all-star international hit war adventure *The Guns of Navarone* (1961), in which he shared the screen equally with Gregory Peck and David Niven. He followed this with the critical role as a Bedouin

Giulietta Masini as Gelsomina and Anthony Quinn as the brutish strongman Zampano in Fellini's *La Strada/The Road* (1954).

chieftain in David Lean's Academy Award–winning classic *Lawrence of Arabia*.

The actor returned to Italy to star in the biblical epic *Barabbas* (1961). Back in New York, he memorably essayed the role of Mountain Rivera, a battered champion boxer who has seen better days, in *Requiem for a Heavyweight* (1962).

In 1964, he took on his most recognizable role, Alexis Zorba, the earthy, life-affirming peasant in *Zorba the Greek*. The modest black-and-white film was to be made on location on the Greek island of Crete but was underfunded to the tune of $200,000. In a desperate effort to

save the production, Quinn called his old friend and boss Darryl F. Zanuck, head of 20th Century Fox, and asked for $700,000 to entirely finance the film. Zanuck wired the money the next day, in exchange for the distribution rights.

Anthony Quinn (far right) as the Bedouin leader in *Lawrence of Arabia* (1962), with Peter O'Toole and Omar Sharif.

Zorba the Greek, directed by Michael Cacoyannis from a 1946 novel by Nico Kazantzakis, is the story of Basil (Alan Bates), a reserved young Englishman who meets Zorba, a wily Greek man with a zest for life, on a ferry to Crete. When Zorba learns Basil hopes to settle on land and reopen a mine, he offers to help and tutor him in the ways of life. The film was a worldwide hit, and Zorba became synonymous with the larger-than-life Quinn. It is commonly thought that he won an Academy Award as Best Actor for his signature role, but he didn't. He received a nomination but lost to Rex Harrison as Professor Higgins in *My Fair Lady* (1964).

Quinn's Oscar nomination was a springboard to challenging lead roles in several notable films, including an outlaw disguised as a priest who defends a town against marauding Indians in *Guns for San Sebastian* (1968), a Russian pope in *The Shoes of the Fisherman* (1968), a bumbling Italian mayor who hides the town's wine from

invading Nazis in *The Secret of Santa Vittoria* (1969), a Greek multimillionaire based on real-life Aristotle Onassis in *The Greek Tycoon* (1978), and an Arab freedom fighter in *Lion of the Desert* (1980).

Quinn's last prominent role was as Tiburon Mendez, a Mexican underworld powerbroker whose young American friend Cochran, played by Kevin Costner, falls in love with Mendez's young wife in Tony Scott's *Revenge* (1990).

"Out of all the pictures I've done," Quinn candidly admitted, "I've only worked with what I consider five or six great directors. I've had the joy of working with Kazan, Minnelli, Cukor, and Fellini, who is one of the geniuses, and David Lean."[82] Acting and writing were not Quinn's only achievements. He was a recognized painter and sculptor. Among his last film credits are *A Walk in the Clouds* (1995) and John Hughes's *Only the Lonely*. He died in 2001.

RITA MORENO

The legendary Moreno is one of the most honored women in the entertainment industry. The Puerto Rican actress has the distinction of being an EGOT winner, a performer who has won all four of the most prestigious awards in show business:

an Oscar, a Tony, two Emmys, and a Grammy.

Moreno won an Academy Award in 1962 as Best Supporting Actress for her role as Anita in the film *West Side Story*. On television, she won two Emmy awards for Best Supporting Actress. One was for a guest appearance on the television series *The Rockford Files* (1978), and the other was for best individual performance in a variety or music program (*The Muppet Show*, 1977). Her Broadway stage role as Googie Gomez in Terrence McNally's *The Ritz* (1975) won her a Tony Award as Best Featured Actress. The Grammy was awarded in the category of Best Album for Children for *The Electric Company* album based on the popular PBS TV series.

The consummate performer, multitalented Moreno, with her vitality, powerful personality, and passion, has blazed an upward career trajectory with resiliency in the face of professional and personal downturns. Moreno's passionate eight-year relationship with

superstar Marlon Brando began in 1954 and ended after she became pregnant with his child, had a botched abortion, and attempted suicide. Her life stabilized with her 1962 marriage to Leonard Gordon, a cardiologist who was not aware she was an actress when they first met. They had one daughter, Fernanda, in 1967.

Born Rosa Maria Dolores Alverio in Humacao, Puerto Rico, Rita's earliest memories are of performing for her family. At age six, she moved with her single mother to New York, where she took music and dance lessons. She loved movies and, of all the people on the screen, she aspired to be like luminous teenage actress Elizabeth Taylor. Performing at parties and in clubs at a young age, Rita made her Broadway stage debut at thirteen in the play *Skydrift* (1945), starring Eli Wallach.

Her singing and dancing got her to the attention of Louis B. Mayer, who, during a visit to New York, signed her to an MGM contract.

Moreno and her mom moved to Hollywood six months later. At the studio's suggestion, she changed her last name to that of her stepfather, Moreno.

The wonderland of the MGM studios soon felt like a restricted playground in which she could play only infrequently and was, more often than not, relegated to watching from the bench. She hoped to be another Elizabeth Taylor but instead found herself in bit or minor roles in a succession of films, as a Polynesian, Native American, or generic Latina, often with makeup to darken her skin. "You needed to work and hoped, despite stereotypes, you could show ability as an actress," remarked the actress in 1994.[83]

Billed in the credits as Rosita Moreno, she made her film debut on loan from MGM in a B movie, *So Young, So Bad* (1950), as an emotionally unstable inmate in a girl's correctional facility. In her first MGM film, *The Toast of New Orleans* (1950), she played a Cajun gypsy opposite operatic singing star Mario Lanza. In her next movie, *Pagan Love Song* (1950), with Howard Keel and Esther Williams, she played a Polynesian native.

The closest Moreno got to feeling like a genuine star in those early days was her role as screen siren Zelda Zanders in the classic *Singin' in the Rain*. Moreno was dressed in a glamorous 1920s outfit, walking the red carpet at a recreated fictitious film premiere at the legendary Grauman's Chinese Theatre, with a throng of adoring fans and press photographers. This was a brief fantasy moment, and the role

Rita Moreno in a 1950 MGM studio portrait photo.

was no more than a glorified extra part, but she got to observe MGM dancer-choreographer Gene Kelly at work.

In her last movie under contract at MGM, *Latin Lovers*, she was a Brazilian girl who dances briefly with star Ricardo Montalban. In 1952, after two years with the studio, her contract was dropped. "I was shattered [A]t twenty, I was through. I couldn't go back to New York. I was ashamed," she said in an interview with the author. "So I stayed on in Hollywood and did what every other actor did to survive. I worked in B movies and did TV shows. I played all

Portrait of Rita Moreno as wannabe showbiz bathhouse performer Googie Gomez in *The Ritz* (1976).

Gary Cooper and Richard Widmark, *Seven Cities of Gold* (1955) with Anthony Quinn and Richard Egan, and the Oscar-winning musical *The King and I* (1956) with Yul Brynner.

The role of the Siamese girl Tuptim in *The King and I* was not challenging for Moreno, but it offered the opportunity to work with noted choreographer Jerome Robbins in the "Cabin of Uncle Thomas" sequence. It proved a fortunate collaboration, as he would remember her talents later. With music by Leonard Bernstein and lyrics by Stephen Sondheim, *West Side Story* in 1957 became a groundbreaking Broadway musical stage hit, thanks in part to Robbins's choreography. When the rights were purchased by the Mirisch brothers and United Artists planned a film adaptation, Robbins was hired as co-director of the big-budget production. He sought her for the role of Anita, the Puerto Rican girlfriend of the Sharks' leader, Bernardo.

As she explained to the author, "It was not easy to find a young girl in Hollywood who was an equally good dancer, actress, and singer as well as fitting the character requirements as I did with Anita." She further explained, "Anita was the very first Hispanic character I had ever played who had dignity, a sense of self-respect, and was loving. I tested several times, and they saw just about every actress in Hollywood before I was

those parts the same way—barefoot with my nostrils flaring."[84]

A chance encounter led to her being featured on the cover of *Life* magazine in March 1954, after a photographer for the prestigious magazine spotted her working on the set of a failed TV pilot. She was quickly signed as a contract player with 20th Century Fox, but it was more of the same. She played mainly Native Americans, Mexican dancers, and handmaidens in major motion pictures opposite stars. Some of these films included *Garden of Evil* (1954) with

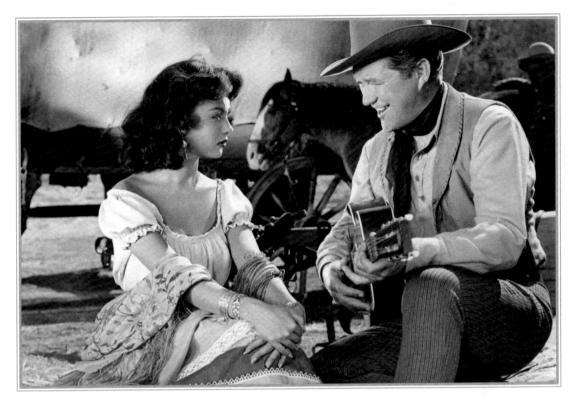

Rita Moreno as a señorita and Dennis Morgan in *Cattle Town* (1952).

chosen shortly before production was to begin."[85]

While zeroing in on Moreno as Anita, the producers had not cast the pivotal role of Maria, Anita's younger sister, who falls in love with Tony, former leader of the rival gang, the Jets. The studio would not proceed with the film until a recognizable star was secured for the role. Natalie Wood, an experienced film actress who began her career as a child star and was coming into her own, was cast as Maria.

Moreno couldn't understand why the production applied dark makeup to the cast members playing Puerto Ricans, including Greek American George Chakiris and her. She explained the different skin tones in the multiracial Puerto Rican community, but the makeup artists would hear nothing of it. That was the Hollywood mindset of the time. Latinos and Latinas were supposed to be dark skinned to clearly differentiate them from white characters.

Robbins was a master choreographer and perfectionist. He put Moreno and all the actors and dancers through their paces in rehearsals and throughout the film shoot with codirector Robert Wise.

Moreno was nominated for an Academy Award in the Best Supporting Actress category and did not expect to win, even though she had won a Golden Globe award. She was shocked and totally unprepared when her name was announced. She made her way to the stage, was handed her Oscar at the podium by actor Rock

Hudson, and gave one of the shortest acceptance speeches in Oscar history. *West Side Story* won ten Oscars, including Best Picture of 1961, and it remains a beloved and enduring classic motion picture.

When an actor wins an Oscar, it usually brings on better and broader acting opportunities. Not so in Moreno's case. "After winning the Oscar, I did not work for seven years because all I was offered were more of the same, what I call Rosita, Pepita type roles," said Moreno to the author.[86] The Oscar-winning actress refused to accept parts she considered limited or demeaning, so she chose not to work in films. Instead, Moreno appeared in several New York and London stage productions in roles that challenged her and expanded her artistic range. She starred, for example, in pioneering African American playwright Lorraine Hansberry's Broadway play *The Sign in Sidney Brustein's Window* (1964). Moreno also kept busy as one of the Hollywood stars who took part in the historic Civil Rights March on Washington in 1963, allowing her to witness the stirring words of Rev. Martin Luther

Rita Moreno as Valentina in Speilberg's *West Side Story* is a dynamic link between generations of Latinx performers.

King Jr. at the Lincoln Memorial.

Moreno returned to the screen when Marlon Brando asked her to be in *The Night of the Following Day* (1969). She went on to appear with Jack Nicholson in Mike Nichols's *Carnal Knowledge* (1971). Moreno recreated her Tony award-winning role as showbiz wannabe Googie Gomez in the film version of Terrence McNally's *The Ritz*, and she starred in the romantic comedy *The Four Seasons* (1981) with Alan Alda.

More recently, Moreno received acclaim for playing Catholic nun Sister Peter Marie in the HBO prison drama *Oz* (1997–2003), and she costarred as Grandmother Lydia in Norman Lear's reimagining of his past hit TV series *One Day at a Time* (2017–2020) with a contemporary Cuban American family. The Netflix series was produced by Gloria Calderon Kellett and featured an all-Latinx cast headed by Justina Machado.

Moreno's life and seventy-plus-year career have come full circle with her role in Steven Spielberg's *West Side Story* (2021) remake, in which she also is credited as an executive producer. Moreno played Valentina, a newly conceived character, who is the widow of the original film's Doc, the kindly man who ran the corner store where Anita is assaulted. In

Rita Moreno and George Chakiris proudly hold their Academy Awards for *West Side Story* at the Oscars ceremony in March 1962.

her capacity as executive producer, she assisted Spielberg in correcting the Puerto Rican cultural inaccuracies of the original film.

In a Q&A on the American Masters website, Moreno reflected on her Oscar-winning role: "Anita had intelligence, dignity, and strength and I love that she is inspiring a whole new generation of Hispanic performers all these years later."[87]

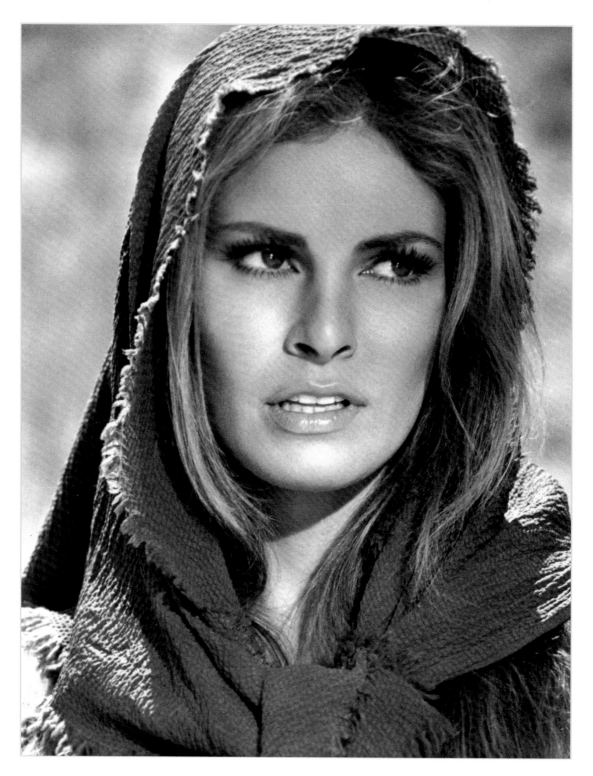

Raquel Welch as the Mexican Indigenous rebel fighter Sarita in *100 Rifles* (1969).

RAQUEL WELCH

The voluptuous Bolivian-rooted Raquel Welch was the last Hollywood studio-manufactured sex symbol of the late '60s and early '70s. Her image replaced those of the late blonde bombshells Marilyn Monroe and Jayne Mansfield. With her

famous figure and stunning looks, Raquel captured the imagination of moviegoers the world over.

Her first significant film role was in the landmark 1966 science fiction film *Fantastic Voyage*, in which she created a sensation with her skintight diving outfit in the role of scientist Cora Peterson. She and her colleagues are miniaturized and injected into a dying scientist's bloodstream to save his life.

A fantastic voyage, indeed. Signed to a contract by 20th Century Fox, Welch was loaned out to the British Hammer Films, which specialized in horror movies, for her breakthrough role in *One Million Years B.C.* (1966). Theater audiences overlooked the absurdity of humans living among dinosaurs and just sat back and enjoyed the show. As curvaceous blonde cavegirl Loana, sporting a fur bikini, she stole the show from the stop-motion animation prehistoric creatures. "Both

films made a huge difference in my career," she acknowledged in a 2019 interview. "Overnight, I found myself in demand."[88]

A publicity photo of Raquel from the movie, in her fur bikini displaying her soon-to-be-famous figure ran in magazines. She became the best-selling personality pinup, second only to the Farrah Fawcett poster of the late 1970s. In 1969, *Time* magazine proclaimed Raquel "the nation's number one sex symbol."

Born in 1940 as Jo Raquel Tejada in Chicago, Illinois, her parents were Armando Tejada, a Bolivia-born engineer, and Josephine Sarah Hall, who could trace her ancestry back to the *Mayflower*. The family moved to San Diego when Raquel was two years old and settled in the seaside community of La Jolla. Raquel studied ballet from the age of seven until seventeen, when her instructor told her that she did not have the body for ballet.

The aspiring nineteen-year-old actress told

the *Los Angeles Times* in 1959, when she played the title role in *Ramona* in the annual theatrical pageant in Southern California, "I am a Latin type, and suppose in movies I was to be cast and typed? I have more serious expectations. In fact, I like Greek drama most of all."[89] In an attempt to avoid being typecast, the actress took her former husbands' last name, and thus Raquel Welch was created.

"My family was very conservative, and I had a traditional upbringing. I was not brought up to be a sex symbol, not in my nature to be one," she said in an interview many years later. "The whole sex symbol thing is part of what I do as an actress. It's kind of a character I play. It's part of me, but not the whole me."[90]

She made her film debut in a bit part as a college student in the Elvis Presley film *Roustabout* (1964) and played another small role as a bordello girl in *A House Is Not a Home* (1964). Soon she landed a screen test at 20th Century Fox and was signed to a contract where she was loaned out to several overseas productions, the first of which was the London-based *One Million Years B.C.*

In Italy Welch made *The Biggest Bundle of Them All* (1968), a heist drama with Robert Wagner and Edward G. Robinson, for MGM. That was followed by the Italian production *Shoot Loud, Louder*, in which she was cast opposite Italian heartthrob Marcello Mastroianni. Soon afterward she starred in the superspy title role of *Fathom* (1967) for her home

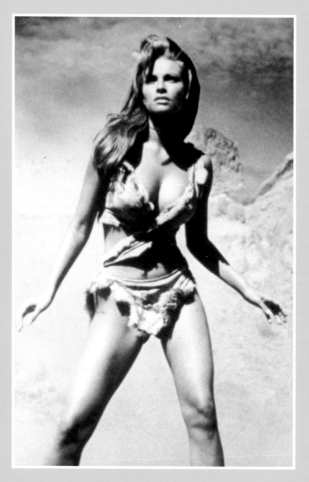

Raquel Welch stars in the famous fur bikini photo seen 'round the world in *One Million Years B.C.* (1966).

studio in Spain. She played the temptress Lillian Lust, one of the seven deadly sins, in the comedy *Bedazzled* (1967), starring Peter Cook and Dudley Moore, and directed by Stanley Donen.

Although she played a variety of roles, Welch did not totally escape being typecast as a Latina. In *100 Rifles* (1969), she played Sarita, a half-Mexican, half-Yaqui freedom fighter. An action western, the film is remembered as the first major Hollywood motion picture to feature a sex scene between an African

American star (football icon turned actor Jim Brown) and supposedly white star (Welch). The film also contains a memorable scene where the beautiful Sarita single-handedly stops a train. She distracts a passing trainload of federal soldiers by taking a nearly nude shower under a railroad water tower for a surprise rebel attack. That certainly topped Claudette Colbert's leg-revealing maneuver to hail a ride forty years earlier in *It Happened One Night*.

Raquel played Miami Beach socialite Kim Forrest, starring opposite Frank Sinatra, in *Lady in Cement* (1968), a lighthearted detective drama and sequel to Sinatra's hit *Tony Rome* (1967). Arguably her most challenging role was as a transgender woman in the critical and box-office disaster *Myra Breckinridge* (1970), a film based on a novel by celebrated writer Gore Vidal featuring a cast of screen luminaries, including the legendary Mae West and actor/director John Huston. Years after its release, the film has become a cheeky cult favorite.

Along with her new husband, manager turned producer, Patrick Curtis, she produced the film *Hannie Caulder* (1971), a western highlighting a gender role reversal. Welch plays a frontier woman turned gunfighter out for revenge. Continuing her hands-on approach to her projects, she produced and starred in *Kansas City Bomber* (1972). It was an earnest attempt at a serious leading role, in a contemporary character study about single mother K. C. Carr (Welch), who tries to make a living in competitive women's roller derby. She proved adept at light comedy with her role as the klutzy Constance in the Richard Lester comedy *The Three Musketeers* (1973) and its sequel *The Four Musketeers* (1974) opposite Oliver Reed, Richard Chamberlain, and Michael York. Welch stood up for herself and defied the Hollywood powers that be when she was unfairly and abruptly fired from a starring role in an MGM production of *Cannery Row* (1982). The producers alleged lateness on set and unreasonable behavior.

Welch filed a "breach of contract" lawsuit against the studio in 1981. It took six years but was eventually decided in her favor by a jury trial in 1986 and after various studio appeals in 1988. She proved in court that the producers used her name to get financing but actually wanted a younger popular actress of the moment, Deborah Winger, to star. However, the negative publicity surrounding the legal battle tarnished her reputation and effectively brought her film career to a standstill for many years. She told the press at the time of her favorable jury verdict against the MGM studio, "I think what this shows is that it's important to stand up for your rights, and I hope that women in and out of Hollywood stand up for their rights when they feel they've been wronged."[91] Raquel Welch combined her fame, glamour, intelligence, and talent with entrepreneurial business sense. As film offers evaporated, she survived to become a fitness and beauty guru, as well as a headliner for Broadway shows and in concert venues.

She reconnected with her Latin heritage with her role in the comedy *Tortilla Soup* (2001).

Raquel Welch and Eugenio Derbez in the comedy *How to Be a Latin Lover* (2018).

The film is essentially a Latin version of the widely admired film *Eat Drink Man Woman* (1994) directed by Ang Lee. She costarred as Hortensia, a sexy grandmother with designs on retired chef Martin Naranjo, played by award-winning film, stage, and television actor Hector Elizondo (*The Taking of Pelham One Two Three* [1974], *Pretty Woman* [1990], *Princess Diaries* [2001]). It is ironic that Raquel Welch had few opportunities to draw on her Hispanic heritage in film roles. There have been relatively few juicy parts written for Latinas playing Latina characters. So it's a delight to see her in a role as a modern American Latina of a certain age who is desirable, wily, and witty.

In 2002, Raquel traveled for the first time to Santa Cruz, Bolivia, her father's hometown, from which he immigrated to the United States in the 1930s. In her memoir *Beyond the Cleavage*, Welch wrote, "Dad seemed indifferent to his heritage. This made me feel like there was something wrong with being from Bolivia, a

Third-World country."[92] She later recalled in an interview, "He wanted to spare us some of the difficulty he faced."[93] Her father, Armando, never spoke Spanish at home. This is not unusual in immigrant families. Parents want their children to succeed in the United States and sometimes emphasize English at the expense of Spanish, even around the household. Many Latinx performers relate personal stories of this dichotomy. Late in her career Welch costarred opposite famous Mexican comedian Eugenio Derbez in the hit film comedy *How to Be a Latin Lover* (2018). She remains an enduring role model, an empowered woman, and a Latina Hollywood star who helped pave the way for others.

Just a few years prior to Welch's prominence, several Latina actresses of a new postwar generation made their presence felt in Hollywood in the first years of the sixties. Cuban-born dancer, actress, and sex symbol Chelo Alonso made a name for herself in popular Italian "sword and sandal" movies that made their way to the States. Her screen dancing combined Afro-Cuban rhythms with burlesque "bump and grind" in such films *Goliath and the Barbarians* (1959) with Steve Reeves and *Queen of the Tartars* (1960).

California-born blonde ingénue Yvette Mimieux, of French and Mexican parentage, slipped under Hollywood's ethnic radar. She was put under contract at MGM and appeared in such films as the science fiction classic *The Time Machine* (1960) and *Where the Boys Are*

(1960). Multiethnic New York–born BarBara Luna's career in stage, film, and television spans more than seventy years. She began as a child actress on Broadway in 1949. As a young adult, Luna costarred as a blind island girl in the motion picture *The Devil at Four O'clock* (1961) with Spencer Tracy and Frank Sinatra and played the older sister of a Mexican street urchin in *Dime with a Halo* (1963) and a flamenco dancer in Stanley Kramer's all-star drama *Ship of Fools.*

Chelo Alonso, Cuban dancer/actress/sex symbol of Italian sword and sandal films in *Sign of the Gladiator* (1959).

Turbulent Times: The '60s and '70s

The Latino and Latina performers of the '60s and '70s necessarily reflected their times, both in their personal lives and in the characters they portrayed. Hollywood filmmakers, after all, do not function in a vacuum. Movie themes revealed, or at least hinted at, a nascent feminist consciousness and a growing sense of political activism. In society—and in Hollywood films—it was a gradual cultural process that swelled from the end of the Second World War to the protests against the war in Vietnam. Latino and Latina Hollywood artists and performers played a significant role in that evolution, asserting themselves in all their varying cultural and ethnic agency.

The aftermath of World War II eventually led to the beginning of the civil rights movement in earnest. Black soldiers had put their lives on the line for their country, yet segregation in the Deep South was still the order of the day. Simultaneously, in the Southwest Latino soldiers returning from the war bristled at the racism they encountered.

Like their African American brethren, they had risked their lives for their country and were angered at the hostile homecoming they faced. They were denied the very rights and liberties they fought to preserve for all Americans.

Returning veterans of Latino descent faced discrimination in employment, as well as segregation which limited where they could

A. Martinez as Cimarron and John Wayne in The Cowboys (1972).

BarBara Luna as Juanita in *Dime with a Halo* (1963).

exclusionary practices. After extensive meetings with the Justice Department, the entertainment labor unions offered, in response, a minority training program that was a halfhearted attempt at enhancing entry-level employment for minorities. It provided access to union membership but would terminate the employment of minority personnel before they met the thirty-day union qualification period. Compliance was rarely monitored, and in the end, only a few participants became union members with gainful employment. Because of this thinly veiled racism, tensions and resentment ran high among the union members and the new minority hires. At one point, the militant Mexican American group Justicia made a bomb threat to one of the Hollywood studios.

The reclaiming of Latin identity spawned a new generation of artists, dramatists, actors, and directors who used their talents to explore new narratives of pride in their backgrounds as part of the American experience. Forms of self-expression manifested through periodicals, street art, and visual communication (art, film, photography). Murals popped up in barrios all across the country.

in scenes depicting hundreds of bloodthirsty Mexicans shot by gringo gunmen.

Besides negative images, there were discriminatory union hiring practices that excluded African Americans, Latinos, and other minorities, as well as women from film crews. The Equal Employment Opportunity Commission held hearings in 1969 and after its investigations announced its findings that the historically protectionist and biased film industry unions engaged in discriminatory

Rita Moreno in her 1961 Oscar-winning Best Supporting Actress role of Anita in West Side Story.

Centros culturales (cultural centers) formed along with grassroots theater groups. Young Los Angeles filmmaker Jesús Treviño wrote and directed *Raíces de sangre* (Roots of blood, 2002), the first Mexican Chicano production that told the story of Mexican workers in the factories along the US southern border. The bilingual film used both Mexican and US Latino/Latina actors. San Diego–based Isaac Artenstein wrote and directed *Break of Dawn* (1988), about the remarkable life of Pedro J. Gonzalez, a pioneering Mexican radio personality who achieved success in California in the 1920s and '30s.

Latinos, Latinas, and Hispanics were largely absent from movie screens in the '60s and '70s except in traditional roles in westerns, most significantly Jaime Sánchez as Angel in *The Wild Bunch*. Among others beginning to make names for themselves were A. Martinez as Cimarron in *The Cowboys* (1972), Mexican leading man Jorge Rivero opposite John Wayne in *Rio Lobo* (1970), and Pepe Serna and Victoria Racimo in *Red Sky at Morning* (1971), a coming-of-age-story complicated by racial tensions between Anglos and Mexican Americans.

English actor Peter Ustinov, in brown face, starred as a Mexican general in the contemporary comedy *Viva Max* (1969), leading a group of soldiers into Texas to retake the Alamo. In his second feature film as the star, director, and cowriter, Woody Allen made a spoof of contemporary Castro-like revolutionaries, military dictators, and banana republics called *Bananas* (1971). Egyptian

international star Omar Sharif (*Lawrence of Arabia, Doctor Zhivago*, 1965) looked right in his incarnation of the iconic Argentine revolutionary Ernesto "Che" Guevara in *Che!* (1969), but the film's screenplay and matter-of-fact presentation in episodic flashbacks fell short of a compelling dramatization.

The pristine panorama of the mythic Old West turned into the contemporary blighted urban slum exteriors. The Old West bandidos transformed into urban drug dealers, gang members, and bank robbers in contemporary police thrillers, and the señoritas became drug-addicted streetwalkers or suffering *mamacitas*. The righteous lone cowboy hero became the lone rogue cop of Clint Eastwood's *Dirty Harry* (1971) or the vigilante Paul Kersey played by Charles Bronson in *Death Wish* (1974). Further examples of films in this decade-long trend were *The French Connection* (1971), *Badge 373* (1973), *Serpico* (1973), *The New Centurions* (1972), and *Fort Apache, the Bronx* (1981).

Badge 373 drew the ire of the New York Puerto Rican Action Coalition for its negative portrayals, distorting community activist groups like the Young Lords, and misrepresenting the Puerto Rican independence movement.

The New Centurions starred George C. Scott as a veteran LAPD patrol cop. He teaches a rookie (Stacy Keach) the ropes of police work in a crime-filled area of Los Angeles populated by one-dimensional minorities. This teacher/pupil scenario proved a convenient trope for *Colors* (1988), with Robert Duvall and Sean Penn

Martin Sheen as Walker, an American journalist, and Ben Kingsley as Mahatma Gandhi in the Oscar-winning Best Picture *Gandhi* (1982)

policing warring gang factions, and *Training Day* (2001), with Denzel Washington and Ethan Hawke, in which the veteran officer is now African American, instructing the white rookie on the perils of the street. Although it predates *Colors* by eight years, *Fort Apache, the Bronx* substitutes East Los Angeles for New York's impoverished, crime-ridden South Bronx. A coalition of Black and Puerto Rican South Bronx community groups protested the film's negative depictions and the lack of positive minority characters. Murphy, the veteran cop played by Paul Newman, has a romance with a Puerto Rican nurse played by Rachel Ticotin, who turns out to be a heroin addict and dies of an overdose.

In the October 16, 1978, cover story on Hispanic Americans, *Time* magazine declared that they would soon become the largest minority group, with nineteen million people. A decade later, *Time* again proclaimed the "decade of the Hispanic" in its July 11, 1988, cover story on Latin influence on American popular culture, politics, and the economy. The cover featured the face of Oscar-nominated Best Actor Edward James Olmos (for *Stand and Deliver*, 1988). "Even though we were there and doing it, the art or the artist was not being recognized or looked at in any way, then we broke through, and it started in the theater and then motion pictures and television," recalled Olmos in an interview.[94]

MARTIN SHEEN

In his 2019 Youngstown University commencement address, Martin Sheen told the graduating class, "I have been an actor all my life and have no conscious memory of not being one."[96] The actor/activist was born Ramon Estevez in Dayton, Ohio,

to immigrant parents: Spanish-born father Francisco Estevez and Irish mother, Mary Ann Phelan. His mother died when he was eleven, and he started working as a caddie at a golf club to help with the family expenses while attending high school.

At seventeen, he took off to New York to pursue a career as an actor with money from a parish priest who believed in him. However, casting directors were confused when fair-skinned, blue-eyed Ramon Estevez came in for an audition. They expected a short, dusky Puerto Rican. There were virtually no roles for Latinos and a bias against them in the theater. The actor never changed his legal name but fashioned the stage name of Martin Sheen after CBS casting director Robert Dale Martin and New York Catholic Bishop Fulton J. Sheen, and roles started to come his way.

He made his film debut as a young hoodlum in the terrifying New York subway drama *The*

Incident (1967). He won acclaim, and a Tony nomination, as a returning young veteran in the Broadway play *The Subject Was Roses* (1964), and he reprised the role in the film. In 1973, he starred as the teenage serial killer Charlie Starkweather in *Badlands*, opposite Sissy Spacek, the first film by celebrated filmmaker Terrence Malick. He was on a roll.

Sheen's stardom skyrocketed when director Francis Ford Coppola picked him for the epic film *Apocalypse Now* (1979). He plays Captain Willard, sent upriver to Cambodia during the Vietnam War to find and assassinate renegade Green Beret, Colonel Kurtz, played by Marlon Brando. Sheen headed a cast of some of the finest actors of his generation, among them Robert Duvall, Harrison Ford, Dennis Hopper, and Laurence Fishburne. Trouble plagued *Apocalypse Now* throughout the challenging sixteen-month shoot on location in the Philippine jungle. Sheen suffered a heart attack

Martin Sheen strikes a crucifixion pose in Terrence Mallick's *Badlands* (1973).

that nearly derailed the production. In an alcohol-fueled scene, the actor broke a mirror with his bare hand, which bled profusely, but the sequence made it into the film as it was shot.

"I was drinking heavily," he recalled in an interview. "I was confused about who I was and why I was here. I was doing this humongous film that had so much riding on it. I had gotten very low. I didn't feel any sense of control or self-worth."[97]

Upon his return to California, Sheen concentrated his on his family and continued with an acting career that took on a broader international scope because of the publicity and acclaim surrounding *Apocalypse Now*. He

followed with a part as a journalist in the Oscar-winning *Gandhi* (1982) and a starring role in John Schlesinger's *The Believers* (1987). Sheen portrayed Confederate Civil War general Robert E. Lee in *Gettysburg*, and in Oliver Stone's *Wall Street* (1987), he delivered a powerful performance opposite one of his sons, Charlie Sheen.

Sheen has alternated between films and television throughout his career. He is best known to television viewers as president of the United States Joshua Bartlett for seven seasons of the acclaimed drama *The West Wing*. All three of Martin's sons followed him into careers in entertainment, and two established themselves as stars in their own right.

His eldest, Emilio Estevez, born in New York City in 1962, chose to work under his family name to distance himself from his famous father and forge his own career. Estevez made his film debut in *Tex* (1982) and was cast as the character Two Bit in Francis Ford Coppola's film adaptation of S. E. Hinton's coming-of-age story *The Outsiders* (1983). Estevez was part of a young cast that included future stars Tom Cruise, Rob Lowe, Matt Dillon, Patrick Swayze, and C. Thomas Howell. He landed a starring role in the cult film *Repo Man* (1984), followed by *The Breakfast Club* (1985), *St. Elmo's Fire* (1985), and *The Mighty Ducks* (1992). He starred as outlaw Billy the Kid in the western *Young Guns* (1988) and its sequel, *Young Guns II* (1990), with his brother Charlie Sheen and up-and-coming stars Kiefer Sutherland and Lou Diamond Phillips.

Marlon Brando as Colonel Kurtz and Martin Sheen as Captain Willard in *Apocalypse Now* (1979).

Estevez began writing and directing independent films in 1996 with *The War at Home*. He directed the critically acclaimed ensemble drama *Bobby* (2006), about a disparate group of people on the night of Bobby Kennedy's assassination. His most recent directing credits include *The Way* (2010) and *The Public* (2018).

Carlos Irwin Estevez, better known as Charlie Sheen, launched to stardom with his role in Oliver Stone's Vietnam war drama *Platoon* (1986) much like his father did ten years earlier in *Apocalypse Now*. In *Platoon*, Sheen played Chris Taylor, director Stone's surrogate, in this personal tale of a college dropout who enlists in the army, goes to Vietnam, and becomes disillusioned by his actions in the war. *Platoon* garnered critical acclaim and won Oscars, including Best Picture. Sheen starred as baseball player Ricky "Wild Thing" Vaughn in *Major League* (1989) and Aramis in the 1993 version of *The Three Musketeers*.

Charlie's life has warranted media attention for controversial public behavior involving drug use, sexual liaisons, and an HIV-positive diagnosis. Still he has achieved tremendous success, including for his starring role on the popular, long-running television comedy *Two and a Half Men* (2003–2011).

SONIA BRAGA

The Brazilian actress and sex symbol captivated International and American moviegoers with the Brazilian Portuguese-language sex comedy *Doña Flor and Her Two Husbands* in 1976, directed by Bruno Barreto. Braga enthralled moviegoers as a

woman with two lovers: her ghostly ex-husband and her living husband. Braga's revealing on-screen sex scenes were empowering, frank, and fun. She followed with several more hit films.

Newsweek magazine's Jack Kroll, in Cannes in 1981, wrote, "This festival revealed the most life-enhancing movie star in the world to be Brazil's Sonia Braga, a woman of blazing beauty and energy who combines comic verve with courageous explicitness."[98]

Sonia Braga from *Moon over Parador* (1988).

In 1985, she portrayed the title character and two other roles in the Academy Award–winning film by Hector Babenco, *Kiss of the Spider Woman*. The English-language film is about two political prisoners in a South American country. They have nothing in common but, while sharing a cell, discover shared truths in their humanity. It stars Raul Julia as the intellectual political prisoner Valentin and William Hurt, who won the Oscar for Best Actor for his role as Molina, criminalized for being gay. Braga is the captivating Spider Woman, French chanteuse Leni Lamaison, in Molina's dreamlike movie within the movie, and Valentin's girlfriend.

Braga first came to work in Hollywood when actor/director Robert Redford selected her for the crucial role of Ruby Archuleta, the community's political voice, in *The Milagro Beanfield War*. Since then, the actress has alternated her acting appearances in films and television between Hollywood and her native Brazil.

RAUL JULIA

J ulia should also have been nominated for Best Actor for his performance in *Kiss of the Spider Woman*, as he and Hurt were equally talented, played off each other, and shared most of the screen time, their portrayals dependent on one another. Julia was

one of the most respected and acclaimed actors, but his accolades came primarily on Broadway. He surpassed and transcended Latin stereotypes and played many leading characters, serving as a role model for a generation of aspiring performers.

The famed Puerto Rican–born actor worked in a handful of films but never found the right breakthrough role for his talents until he played the larger-than-life, outrageously charming Gomez Addams in the hit films *The Addams Family* (1991) and its sequel, *Addams Family Values* (1993).

Julia was diagnosed with stomach cancer in 1991, and his condition was not revealed publicly, but his drastic weight loss and gaunt appearance indicated something was amiss. While battling the disease he continued to work. He died in 1994 at age fifty-four, before his screen potential was fully realized.

Julia and Braga worked together on three films and were close friends. They appeared together in the South American comedy *Moon over Parador* (1988) with Richard Dreyfuss and in the Clint Eastwood crime thriller *The Rookie* (1990). Braga played Carvalho, an anthropologist, in the 1994 HBO biopic *The Burning Season*, in which Julia starred as the murdered Brazilian environmental activist Chico Mendes.

William Hurt, director Héctor Babenco, and Raul Julia discuss a scene on the set of *Kiss of the Spider Woman*.

MARIA CONCHITA ALONSO

Born in Cuba, Alonso immigrated with her family to Venezuela, where she was raised. She began her career there as a beauty queen, singer, and actress. Alonso made her Hollywood film debut in 1984 alongside Robin Williams in *Moscow on the*

Hudson. She played Lucia Lombardo, an Italian immigrant salesgirl who helps a defecting Russian stay in America. Critic Pauline Kael wrote in her review, "Mazursky's instinct was really working for him when he paired Robin Williams with Maria Conchita Alonso, a Venezuelan beauty who's an unselfconscious cut up, like the young Sophia Loren."[99] The comedy-drama about hopes, dreams, and the harsh realities of the immigrant experience in America connected with audiences and was a big hit.

Hollywood's vague ethnic parameters allowed Alonso a number of diverse costarring roles in such films as the sci-fi *The Running Man* (1987) opposite Arnold Schwarzenegger, *Colors* with Sean Penn and Robert Duvall, and *Predator 2* (1990) opposite Ruben Blades and Danny Glover. Her long career extends to recent credits such as the Spanish-language comedy *¡He matado mi marrido!* (I killed my husband! [2019]).

Robin Williams and Maria Conchita Alonso in *Moscow on the Hudson* (1984).

IRENE CARA

The multitalented Oscar winner starred as Coco Hernandez in the original MGM Alan Parker–directed *Fame*. The gritty New York–set 1980 musical drama centers on the lives of aspiring performers who attend the High School of Music and

Art. Coco is a triple threat drama, music, and dance major who is so focused on her career that she is oblivious to the world around her. The film brilliantly conveys the hopes, dreams, disappointments, and anguish of talented young artists in New York City. It touched a nerve among youth worldwide and became a tremendous success. Cara sang the film's theme, which won an Academy Award for Best Song. The soundtrack went platinum, selling over one million copies. Cara won her own Academy Award in 1984 for singing and cowriting the Best Song, "What a Feeling," for the movie *Flashdance* (1983), which she did not appear in.

Cara was born Irene Cara Escalera in New York, of Cuban and Puerto Rican parents. A professional child actress, she appeared in Broadway stage shows before making her film debut in Warner Bros.' *Sparkle* (1976). The veteran performer has been absent from movie screens and makes her home in Florida, where she has concentrated on her musical pursuits.

Irene Cara as Coco Hernandez in the musical drama *Fame*.

RUBÉN BLADES

Rubén Blades is better known as a renowned singer, song-writer, producer of salsa and Latin music, but he is also a highly regarded actor, with more than fifty film and television credits. He appeared in *Hands of Stone* (2016) with Robert De Niro

and Edgar Ramirez, Robert Redford's *The Milagro Beanfield War* (1988), *The Two Jakes* with Jack Nicholson, Spike Lee's *Mo' Better Blues* (1990), and Robert Rodriguez's *Once Upon a Time in Mexico* (2003) He has received three Emmy Award nominations for his work on television. He played Danny Alvarez for six seasons on the television series *Fear the Walking Dead*.

Born in Panama City in 1948, Blades left for New York because of a political problem his father encountered with Panamanian dictator Manuel Noriega. Blades emerged as one of the major innovators of salsa music in New York in the late '70s. He made his lead acting debut as salsa singer Rudy Veloz in Leon Ichaso's independent film *Crossover Dream* (1985), and his Hollywood debut in the Richard Pryor comedy *Critical Condition* (1987).

Ruben Blades as Sheriff Bernabe Montoya in *The Milagro Beanfield War*.

Authentic Voices: Hollywood Reimagines Latinos

The work of Nosotros and its supporters helped guide Hollywood in its portrayal of Latino and Hispanic reality and created opportunities for Latin artists.

The last two decades of the twentieth century brought a variety of motion pictures made by non-Latino Hollywood filmmakers dealing with immigration, urban youth gangs, and political instability in Central America—and US response to that instability.

The immigration issue was the focus of such films as *Border Line* (1980) and *The Border* (1982). Several depicted urban gang issues, including *The Warriors* (1979), *Boulevard Nights*, *Walk Proud* (1979), and *Blood In, Blood Out* (1993). The political chaos in Central America was the focus of Hollywood releases such as *Under Fire* (1983), *Salvador* (1986), and *Romero* (1989). These projects employed numerous Hollywood Latino and Latina actors, including Enrique Castillo, Alma Martinez, Danny De La Paz, Tony Plana, Sal Lopez, and Trinidad Silva. *The Milagro Beanfield War*, directed by Robert Redford, featured a predominantly Latin cast,

Esai Morales as Bob Morales and Lou Diamond Phillips as Ritchie Valens in *La Bamba* (1987).

including Rubén Blades, Julie Carmen, Chick Vennera, Mike Gomez, and Sonia Braga. The western spoof *Three Amigos!* (1986), in which three silent movie stars are mistakenly recruited to save a Mexican village from marauding bandidos, featured a largely Latino supporting cast, including Alfonso Arau, Loyda Ramos, Dyana Ortelli, and Patrice Martinez.

Brian De Palma's iconic *Scarface* (1983) starred Al Pacino as ruthless Cuban immigrant turned drug kingpin Tony Montana and featured Stephen Bauer as Manny, Miriam Colón as Mama Montana, and Pepe Serna as Angel, a Cuban refugee who winds up at the wrong end of a chainsaw during a drug deal gone bad. De Palma's follow-up, *Carlito's Way* (1993) (based on the novel by Edwin Torres), also starred Al Pacino (as Puerto Rican Carlos Brigante) and provided roles for many Latino actors, including Ángel Salazar, John Leguizamo, and Luis Guzmán.

Elpidia Carrillo costarred in the science fiction film *Predator* (1987) with Arnold Schwarzenegger, having previously made her debut costarring opposite Jack Nicholson in *The Border*. *I Like It like That* (1994), directed by Darnell Martin from her original script starring Luna Lauren Velez, Jon Seda, and Rita Moreno, centered on an Afro-Latino woman and her family relationships in the South Bronx.

The Christmas Holiday themed *Nothing Like the Holidays* (2008) in which a Latinx family gathers for a Christmas reunion in Chicago was written by Rick Najera and featured a largely Latinx cast. *McFarland USA* (2015), starring Kevin Costner, used the white savior trope but was sensitively directed by Niki Caro. The story is about a predominantly Mexican American farmworker community in Central California and its high school cross country team. Their fish-out-of-water coach leads them to a championship. These films provided showcases for Latinx talent but the roles were largely subordinate or secondary characters in Latin-centered stories. Only in a few instances were Latinx at the center of and creative behind the scenes forces in their own stories. Beginning in the 1980s and 1990s, Latin artists and filmmakers entered an explosive, groundbreaking creative period from *Zoot Suit* in 1981 to 2002's *Real Women Have Curves*— in which they gained access to Hollywood's production system. They brought to screens new narratives with complex, nuanced lead Latin characters at the center of their own stories, played by Latin performers. These filmmakers offered a unique perspective, creating new self-identifying screen representations that moviegoers were receptive to experiencing.

LUIS VALDEZ

An American playwright, filmmaker, and actor, founder of El Teatro Campesino, Valdez was born in Delano, California, in 1940, to Mexican farmworkers. Valdez had an early brush with Hollywood moviemaking when his father worked

as an extra driving a wagon in the Oklahoma land rush sequence of the Oscar-winning western *Cimarron* (1931), filmed near Bakersfield, California. The family moved from harvest to harvest in the Central Valley of California until settling in San Jose. Young Luis showed an early interest in theater by putting on puppet shows at school and at home.

At San Jose State University, he studied drama. He began writing plays that focused on the Mexican American experience. Valdez confronted racism and injustice in his writing, establishing new narratives about Chicano cultural identity, infused with Mexican mythological elements. His play, *Zoot Suit*, written in 1978, was a blend of fact and fiction in 1940s Los Angeles, based on unjust accusations against a group of Mexican Americans in the Sleepy Lagoon murder trial (1942) and the Zoot Suit Riots between Mexican Americans, US servicemen, and the police in 1943. Zoot suits

were exaggerated, colorful, and oversized, a style popularized stateside by Mexican American and African American youth during World War II. In consideration of wartime rationing of fabric, the zoot suit was often seen as a sign of un-American defiance that fueled racial tension.

The play was a long-running hit in Los Angeles, and Valdez became the first Chicano playwright to have his work make it to Broadway. But the play did not translate for a New York audience unfamiliar with West Coast subculture, and it closed after five weeks. In Los Angeles, with the assistance of Universal Studios production executive Sean Daniel, Valdez secured a minimal budget to film the stage play at the Aquarius Theatre in Hollywood with the original cast. Thus, Valdez became the first Mexican American to direct and write a major Hollywood studio film. The production was shot in fourteen days on a $2.5 million budget. Imaginatively and

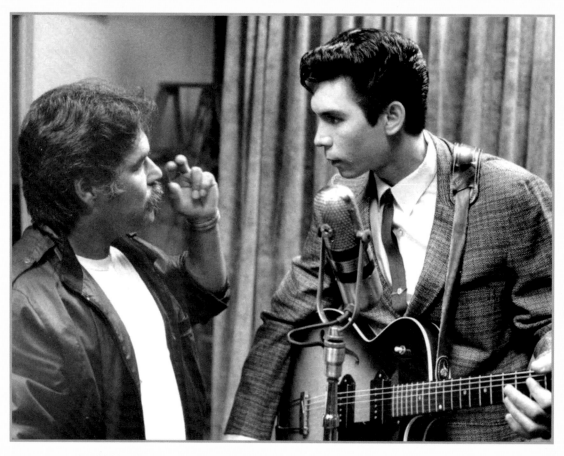

Luis Valdez directs Lou Diamond Phillips as Ritchie Valens in a scene from *La Bamba*.

creatively shot in 35mm with multiple camera set-ups, the film preserves the integrity of the play while capably utilizing technical skills. This evocative work showcased an ensemble of Latino actors whose careers were launched with this film, most notably Edward James Olmos as the ultimate zoot suiter, El Pachuco. A mythical character who controls time and space, El Pachuco struts defiantly across the stage, commenting on the events as they occur and challenging the protagonists. The film captured the youthful vibrancy and energy of a new American narrative. In an interview, Valdez said, "It's incumbent on all writers and people who tell stories of America to reexamine the idea of American representation acknowledges the Latino presence and redefine what it is to be an American, and we can do that through the arts."[100] The film stands as a permanent document of the stage play and is widely available on video and streaming platforms. *Zoot Suit*, the theater production and the film, has stood the test of time.

While making the film version of *Zoot Suit*,

Valdez, with his brother Daniel, began looking into the life of Chicano rock-and-roll legend Ritchie Valens. In 1959, Valens had a meteoric rise as a recording star. He generated three chart-topping hits in a very brief, eight-month, career. His life ended at age seventeen in a single-engine plane crash along with fellow rockers Buddy Holly and the Big Bopper. Valens quickly faded into obscurity. Little was known about his origins, but it was thought that he was perhaps Italian American, like many teen idols of the period, such as Frankie Avalon.

Ritchie Valens turned out to be a Mexican American, born Ricardo Valenzuela in Pacoima, California, in 1941. After Ritchie's death, the family withdrew from public view and moved to Watsonville, California, only sixteen miles from Valdez's home in San Juan Bautista. Valdez and his brother located surviving family members, who opened up to them. Valdez secured the rights and turned their story into *La Bamba* (1987), a musical biopic of family bonding, sibling rivalry, and the pursuit of the ultimate American Dream. It's a story that everyone can relate to: the dream of making it as a rock star. Only this time, he infused the biopic with familial and cultural details from his own Mexican American background. "There were so many elements in the script that had come from my own direct experience," recalled Valdez.[101] The director told a class of American Film Institute students in Los Angeles: "Rock-and-roll grew out of the guts of America. The struggling working class and oppressed racial minorities put their stamp on it when it was not the big deal it is today. They had to sing because they had nothing else, and I'm talking about Elvis as I am about Little Richard, Fats Domino, and Ritchie Valens."[102]

Valdez cast an unknown Filipino American actor, Lou Diamond Phillips, from Dallas, Texas, as Valens. Esai Morales (*Bad Boys*, 1983), who played Ritchie's older half brother, Bob, gave a complex character performance. He reflected on his work in the film for NBC News Latino: "I realized I had a lot more in common with Bob that resonated. I, too, grew up without the presence of my biological father, and I've always felt like an overlooked talent." Morales continued, "I think that explains a lot of the pain of Bob's character—it's always about Ritchie."[103]

La Bamba became a top US box-office draw to the tune of $55 million. The cover of the title song "La Bamba" on the soundtrack by Los Lobos became a number-one-selling worldwide hit recording.

Despite the film's success, Valdez never directed another major theatrical feature. A white filmmaker with comparable success could expect to make several follow-ups. Valdez commented, "There was a great deal of difficulty in trying to get new projects that I wanted to do. They offered me things I didn't want to do, and so I decided not to because I had other options."[104] Known as the father of Chicano theater and film, Valdez received the National Medal of Arts from President Barack Obama in 2016.

EDWARD JAMES OLMOS

The Oscar-nominated actor/activist consciously assumed his celebrity to uplift the Mexican American community through his art. Edward James Olmos made himself accessible to the community at large. The actor chose his roles with the

utmost care, refusing lucrative offers when parts were demeaning and stereotypical.

Olmos was born in the East Los Angeles Boyle Heights neighborhood in 1947 to Pedro Olmos, a Mexican immigrant, and Eleanor Romo, a Mexican American. His parents divorced when he was young. In high school, Olmos aspired to be a professional baseball player. He later started his own rock band, Eddie James and the Pacific Ocean, which played at famed Sunset Strip clubs.

Pursuing an acting career, he scored occasional minor roles on popular series such as *Kojak* (1973–1978) and *Hawaii Five-O* (1968–1980) and started a furniture-moving business for additional income to support his family.

One day, while in downtown Los Angeles waiting to audition, he was asked to read for a new play by Luis Valdez called *Zoot Suit*. He immediately recognized and related to the authentic character and language of the play,

and he won the coveted role of El Pachuco. Together with Valdez, he made the role his own and captivated theater audiences with his portrayal. The performance launched his career.

He literally burst onto the entertainment stage as the time-bending, ultimate zoot suiter, El Pachuco, in the 1978 stage production, which earned him a Tony Award nomination as Best Featured Actor. The American Theatre Wing cited El Pachuco "as one of three original American characters of lasting influence on the American Stage [the other two were Marlon Brando's Stanley Kowalski in Tennessee Williams's *A Streetcar Named Desire* and Lee J. Cobb's Willy Loman in Arthur Miller's *Death of a Salesman*]."

Olmos's screen career took off when he was cast in the horror-thriller *Wolfen* (1981) as a Native American, opposite Albert Finney. Olmos would not accept the role until the producers interviewed the appropriate Native American talent and Native American groups

approved him in the part.

Olmos portrayed mixed-race police officer Gaff in Ridley Scott's classic science fiction adventure *Blade Runner* (1982), starring Harrison Ford. He developed his character from the original script with Scott's approval and added layers of backstory to make him more three-dimensional. Gaff has a memorable exit line in his final scene: "It's too bad she won't live, but then again, who does?" Olmos added the unscripted line on the set, and it was left in the final cut. Now considered groundbreaking science fiction, *Blade Runner* received mixed reviews and only modest box-office success. It took several decades, release on video, and revival screenings to gain its classic status.

When it came time to produce the film adaptation of the play *Zoot Suit* for Universal, Olmos recreated his role of El Pachuco.

Producer Moctesuma Esparza brought Olmos a screenplay, *The Ballad of Gregorio Cortez*, and asked him to star in and produce the film, based on an actual 1901 incident in Gonzales, Texas, that immortalized the local hero in a Mexican "corrido," a populist folk song. The actor realized this would be the first time that a real-life American hero of Mexican descent would be depicted on screen. Gregorio Cortez was a Spanish-speaking rancher in Texas who

Edward James Olmos with his real-life counterpart, high school calculus teacher Jaime Escalante, between takes on *Stand and Deliver* (1988). Olmos was nominated for an Academy Award for the role.

misunderstood a sheriff's questions in English about a stolen horse, and shot and killed him in in defense of his brother. Cortez goes on the run in one of the largest manhunts in Texas history, fueled by racist political hysteria. Olmos chose longtime mentor Robert M. Young to direct and celebrated cameraman Reynaldo Villalobos (*Urban Cowboy* [1980]) as cinematographer. Olmos met Young when he had a minor role as a street drunk in his film about a Mexican immigrant, *Alambrista!* (1977).

Cortez is not a fearless lone hero; he is a human being afraid for his life who uses his horsemanship and cunning across treacherous terrain to evade capture. The elusive Cortez faces exhaustion and hunger and, with virtually no dialogue, Olmos expresses his raw human emotions. The overwhelming forces overtake and apprehend him. He becomes a folk hero to the Mexican population but is vilified by

the Anglo lawmen as a vicious outlaw until the simple truth comes to light in a courthouse. *The Ballad of Gregorio Cortez* is a unique film in documentary style, portraying a new narrative.

Stand and Deliver was cowritten and directed by Cuban American Ramón Menéndez and produced and cowritten by Tom Musca. Its basis was the true story of calculus teacher Jaime Escalante and his fourteen students at Garfield High School in East Los Angeles.

Since its release, *Stand and Deliver* has become one of the most widely seen movies of any made in the United States through all media platforms, but also because it has been showcased in middle schools and high schools across the country as an inspirational and motivational teaching tool. It follows a Bolivian immigrant who teaches math to a diverse group of underachieving, inner-city high school students. He helps them excel at a college entrance exam, and the authorities question their grades because of racial bias. The students decide to retake the exam to prove their abilities. Olmos gives a multifaceted performance as Escalante, and it earned him an Oscar nomination as Best Actor. Fresh-faced unknowns and nonprofessionals were cast as the students, which brought authenticity to the film. Among them was *La Bamba*'s Lou Diamond Phillips in his second film role.

Made for American Playhouse under executive Lindsay Law for the Public Broadcasting System, Warner Bros. acquired *Stand and Deliver* for theatrical release in a first-of-its-kind deal. Though

it was a modest box-office success when initially released, Olmos received unanimous critical praise for his work in the film. Warner Bros. at first did not actively pursue an awards-season Oscar campaign for him. Instead they pushed for the Clint Eastwood-directed biopic *Bird* (1988), so Olmos mounted his own campaign with the limited resources available to him. Once he earned the nomination and *Bird* was overlooked, the studio transferred its full support to Olmos.

In her review for the *Washington Post* Rita Kempley wrote, "Edward James Olmos' dynamic performance as workaholic saint Jaime Escalante drives the movie."[105] Janet Maslin, *New York Times* film critic, wrote, "A math teacher to root for."[106] *People* magazine said, "As Jaime Escalante, the teacher who inspired the unlikely math prodigies, Olmos provides plenty to stand up and cheer about."[107]

The Oscar nomination allowed Olmos to direct and star in his long-gestating dream project: *American Me* (1992), an unproduced script written by Floyd Mutrux in 1973 about a young Mexican American man who, even though incarcerated, heads a vast crime network from prison. Various studios optioned the screenplay with the idea of casting Al Pacino, but the project languished. The original script was written in the vein of a traditional Hollywood prison drama with a bigger-than-life, charismatic central character. Olmos learned of the script when he had a bit part in Mutrux's film *Aloha, Bobby and Rose*. Twenty years later, with his star ascending, the clout

Jennifer Lopez as Selena

of his Oscar nomination, and an Emmy Award for playing Lieutenant Castillo on the popular television series *Miami Vice* (1984–1989), Olmos produced, directed, and starred in *American Me* for Universal Pictures. He envisioned a gritty, realistic, and cautionary tale of Mexican American gang life and incarceration.

American Me was filmed on location in East Los Angeles and at Folsom State Prison. Olmos again called upon his mentor Robert M. Young to assist in the production, and signed on Reynaldo Villalobos as cinematographer. The bleak, unromanticized prison drama was poorly received by critics and audiences but remains an unflinching look at the impact of ethnic, racial, cultural, and generational trauma in the American penal system.

Olmos followed with a role as the eldest Sanchez son, Paco, an aspiring writer, and narrator of Gregory Nava's multigenerational *My Family / Mi Familia* (1995). He memorably played Abraham Quintanilla, the father and manager of the slain Tejano singer in Gregory Nava's hit musical-drama *Selena*, starring Jennifer Lopez in the title role that launched her career. Years later, he reprised his role of Gaff in *Blade Runner 2049* (2017).

He juggled film work with television as one of the first Chicanos in science fiction as Admiral William Adama in the cable series *Battlestar Galactica* (2004–2009). Olmos continued with his directing career, including HBO's *Walkout* and the independent feature *The Devil Has a Name* (2019). He stepped into the role of Felipe Reyes in the FX drama series *Mayans M.C.* in 2018.

GREGORY NAVA

Oscar-nominated writer, director, and producer Gregory Nava was born in San Diego, California, of Mexican Basque heritage. Nava found himself constantly going back and forth between San Diego and Tijuana, Mexico, because his family

lived on both sides of the border. This bicultural, binational upbringing gave him a unique insight that would become the foundation of his life's work in US cinema.

He attended film school at UCLA, where he completed his bachelor's degree. He took a position as a film teacher at Moorpark College while completing his master of fine arts. Together with his then-wife, Anna Thomas, he cowrote and directed the independently produced film *El Norte* (1983), the story of two Indigenous Guatemalan teenage siblings, Enrique and Rosa. They leave their war-torn country and make the perilous journey to cross the US border seeking a better life. Nava, with a small crew including cinematographer James Glennon, producer Anna Thomas, and actors Zaide Silvia Gutiérrez and David Villalpando, traveled to remote locations in the Mayan highlands of Chiapas, Mexico, that resembled Guatemala to give the film authenticity. The movie faced numerous

production obstacles and challenges. At one point, local thugs held the negatives hostage, but ransom was paid and the negatives returned undamaged. The film was completed in and around San Diego and Los Angeles.

El Norte opened in art houses to unanimous critical acclaim. It was one of the first films to portray a contemporary Central American immigrant journey from their point of view, and it resonated with the Latino experience. Nava and Thomas received an Academy Award nomination for Best Original Screenplay and a Writers Guild nomination. The nomination brought them the full attention of Hollywood and resulted in a major theatrical feature for Columbia Pictures, *A Time of Destiny* (1988), starring William Hurt, which focused on Nava's Basque background.

He directed and cowrote with Thomas the multigenerational saga *My Family / Mi Familia* that centered on three generations of the Mexican American Sanchez family in East Los

Poster art for *My Family/ Mi Familia*,
directed by Gregory Nava (1995).

Angeles from the 1920s to the 1980s. The saga
begins with young Jose Sanchez (Jacob Vargas)
walking away from his tiny village in Mexico
and encompasses his arrival in the States and
his marriage to Maria (Jennifer Lopez). She is
deported after an immigration raid, and the
film follows her perilous journey alone with her
newborn back to Los Angeles. Her young son's
death at the hands of racist police is witnessed
by a younger sibling and marks him for the rest
of his life. One daughter embraces traditional
family values and marries, but the other
becomes a nun and later leaves her religious
order to become an activist lawyer. The Sanchez

family is affected by the past traumas but
still reaffirms life, family, and the immigrant
experience.

The movie showcased the most talented,
well-known, and up-and-coming Latino and
Latina actors of the time: Jimmy Smits, Edward
James Olmos, Esai Morales, Jennifer Lopez (in
her first big-screen role), Jacob Vargas, Lupe
Ontiveros, Elpidia Carrillo, Constance Marie,
Maria Canals, Jenny Gago, Eduardo López
Rojas, and Enrique Castillo. It was executive
produced by Francis Ford Coppola, who saw
similarities with his own family background as
the grandson of Italian immigrants. Coppola
respected and supported Nava's filmic vision.
Filmmaker Nancy De Los Santos was an
associate producer. Ken Diaz and Mark Sanchez
received an Oscar nomination for Best Makeup
for their work on the film.

Nava followed with what has become his best-
known and most popular film, *Selena*, the story
of rising Mexican American songstress Selena
Quintanilla-Perez, from Corpus Christi, Texas.
She was just shy of her twenty-fifth birthday and
about to cross over to mainstream success when
her fan club president murdered her. Nava at first
was ambivalent about taking on the project when
it was offered to him by producers Moctesuma
Esparza and Bob Katz. However, while walking,
he came upon two little Mexican American
girls wearing T-shirts with Selena's image. He
asked why they loved her, and they replied,
"because she looks like us." That was the key
for the writer/director to move forward with the

Cast photo, *My Family / Mi Familia. Top*: Constance Marie, Elpidia Carrillo, Jimmy Smits, Lupe Ontiveros, Enrique Castillo *Bottom*: Edward James Olmos, Jenny Gago, Eduardo Lopez Rojas

film. He remembered, "Our young people do not see themselves on screen and to give them such a bright light in a family drama about a young woman who fought for her own voice, making something positive out of a tragedy."[108]

Selena was one of the few instances in which a film biography was made close to the actual events or person being depicted. Selena died in March 1995. The film went into production in September 1996 and was released in March 1997. Although there were battles with the studio over casting, as they wanted a bankable non-Latina in the title role, Nava made the film he wanted to make. After a nationwide search, he found his Selena in Jennifer Lopez, providing her with the role that catapulted her to superstardom. Edward James

Olmos played Selena's father, Abraham Quintanilla, and Constance Marie played her mother, Marcella. The cast also featured Jon Seda and Jacob Vargas. Filmed on location in San Antonio, Poteet, and Corpus Christi in 1996, it was an immediate hit with Latin audiences.

Nava told the Corpus Christi *Caller-Times* just before the film's release, "Telling the story of Selena's life was a challenge and a privilege, but I wish I hadn't had to make this film. I wish I were making a movie with Selena, not about her."[109]

Nava reunited with Jennifer Lopez, by then a big name, in 2006 for *Bordertown*, a contemporary crime thriller, written and directed by Nava and based on actual incidents. It starred Lopez as an American journalist who investigates the disappearance and murder of a Mexican woman in the border city of Juarez, Mexico. The independent production also starred Antonio Banderas as a Mexican journalist. Even with this winning star combination, the film was a disappointment. *Bordertown* ran into problems with a fledgling production company, which resulted in loan defaults and lawsuits. It saw a limited overseas release with poor audience reaction and box office, ultimately resulting in a video-only US release.

Since that time, Nava has been actively involved as a governor of the Academy of Motion Picture Arts and Sciences and has several film projects in development.

LEON ICHASO

The Cuban American director Leon Ichaso has been referred to as "the poet of Latin New York" since most of his independent film work centers on fully realized Latino characters and Latino life in the city rarely represented in Hollywood films.

Woody Allen has made more than twenty-five films about New York. Not one has included a Latino or Latina principal player or considered the city's significant Puerto Rican, Cuban, and Dominican population in any meaningful way. Historically, Latinos have had little to no presence in New York–set Hollywood films, and if they are seen, it is in bit parts among the city's poor, as service workers, drug addicts, or criminals. A Cuban political refugee himself, Ichaso is also known for his insightful depiction of their experience in the United States. He was born in Havana, Cuba, in 1948 and was influenced by his father, a pioneer in the Cuban radio and television industry. His mother was a radio journalist and program host. The senior Ichaso believed in the revolution and stayed in Cuba. Leon's mother detested Castro and his regime, so she took him and his sister and fled to Mexico in 1962, and made their way to the United States. His father later

became disenchanted with the revolution and joined them in New York. Leon found work in advertising and commercial production in New York City. He even did a stint on NBC's *Saturday Night Live*.

With the money earned from producing Spanish-language commercials for Goya Foods, he financed his first independent film, *El super* (1979), based on an off-Broadway play by Ivan Acosta. The Spanish-language film centers on a Cuban immigrant building superintendent in New York City. His next film, *Crossover Dreams* (1985), starred singer turned actor Rubén Blades as an aspiring salsa singer in New York. *Pinero* (2001) is the story of New York–based, drug-addled Puerto Rican poet and playwright, Miguel Pinero. Starring Benjamin Bratt, it featured a host of New York actors, including Rita Moreno, Nelson Vasquez, Jaime Sánchez, Talisa Soto, and Mandy Patinkin. *Bitter Sugar* (1996) was a contemporary story directed by

Ichaso about a disillusioned Cuban on the Communist island. He also directed *Sugar Hill* (1993), about two African American brothers in the Harlem drug trade, starring Wesley Snipes.

El cantante (The singer, 2006) focused on the rise and fall of the legendary Puerto Rican salsa singer Héctor Lavoe from his arrival in New York to his early death from drug use and HIV/AIDS. Puerto Rican singer/actor Marc Anthony was a perfect choice for the starring role, as he resembled the late singer and had the vocal capabilities to project his musical charisma. Lavoe's wife, Puchi, was played by Anthony's then-wife, Jennifer Lopez. The modestly budgeted film celebrated Lavoe and his music, but the movie's realistic gritty portrayal of a drug-induced downfall and a weak script with a downer ending did not serve the stellar talents involved, and it failed to engage a large audience. Ichaso has also directed episodic television and cable movies while developing other feature length projects.

Marc Anthony as legendary Puerto Rican salsa singer Héctor Lavoe, Bernard Hernandez as his son Tito, and Jennifer Lopez as Puchi, in Leon Ichaso's *El cantante* (2006).

JOSEPH B. VASQUEZ

Vasquez, born in the South Bronx, won the 1991 Sundance Film Festival Screenwriting Award for his low-budget dramedy *Hangin' with the Homeboys* (1991), a nuanced story of a diverse group of Black and Puerto Rican friends on a night

out in New York City. It was based on Vasquez's friends and experiences growing up. *Homeboys* starred several promising young actors, including the multitalented Tony award–winning John Leguizamo as Johnny, a nerdy lovesick supermarket clerk. The Colombian-born, New York–raised performer made his film debut in 1989's *Casualties of War* and won accolades in such diverse films as *To Wong Foo, Thanks for Everything! Julie Newmar* (1995), *Carlito's Way, Romeo + Juliet* (1996), *Summer of Sam* (1999), *Moulin Rouge* (2001), *Empire* (2002), and *John Wick* (2014).

Vinny, whose real name is Fernando (Nestor Serrano), is a Puerto Rican who adopted an Italian American wise-guy womanizing personality. Willie (Doug E. Doug) blames all his problems on being Black, and Tom (Mario Joyner) is a telemarketer who wants to be an actor.

Vasquez made two low-budget films, *Street Wars* and *The Bronx War (1991)*. They caught the attention of New Line Cinema, which was looking for talent to exploit the growing young, inner-city Black and Latino/Latina audiences.

The son of a Puerto Rican father and African American mother who suffered from substance abuse disorder, Vasquez was raised by his grandmother. He started making home movies with a Super 8mm camera given to him by a relative. Vasquez died from HIV/AIDS in 1995 at thirty-three.

Director Franc Reyes, also a Puerto Rican New Yorker, carried on Vasquez's urban drama tradition with his films *Empire*, with Leguizamo; *Illegal Tender* (2007); and *The Ministers* (2009).

RICHARD "CHEECH" MARIN

Marin was born in South Central Los Angeles, the son of a Los Angeles policeman, and raised in the San Fernando Valley. Cheech was part of the successful drug counterculture comedy duo Cheech and Chong with Tommy Chong. They had

unprecedented success in comedy recordings, nightclubs, and films such as *Up in Smoke* (1978). Cheech ventured out on his own and wrote, directed, and starred in *Born in East L.A.* (1987), a comedy about Rudy Robles, a US citizen of Mexican descent. He is picked up mistakenly in an immigration raid and deported to Mexico. Because he left his wallet at home, Rudy has no way of proving who he is. Zealous immigration agents deport him to Mexico, and he has to find a way back across the border. Based on a real-life incident and originally a video spoof of the Bruce Springsteen song "Born in the U.S.A.," the film still resonates with audiences today and, in some ways, is more relevant than ever. His parody of the Neil Diamond song "Coming to America," in which Rudy gathers hundreds of undocumented aliens to cross into the United States at a predetermined place and time, overwhelming and overrunning the ill-prepared

US Border Patrol, is an eerie foreshadowing of more recent events on the southern border.

Cheech Marin is the star, writer, and director of *Born in East L.A.*

ROSIE PEREZ

Perez was nominated for the Best Supporting Actress Oscar in 1994 for her performance as Carla Rodrigo in Peter Weir's *Fearless* (1993). Carla is an airline crash survivor who lost her newborn in the catastrophe. The tragedy unexpectedly bonds

her with another survivor, Max, played by Jeff Bridges. The actress also earned awards from the New York and Los Angeles film critics groups.

Perez was born to Puerto Rican parents in Brooklyn, New York, and made her auspicious film debut in Spike Lee's *Do the Right Thing* (1989). With her unique multiracial look and high-pitched Brooklyn Puerto Rican accent, she created a memorable characterization as Tina, Mookie's (Lee) girlfriend. Lee wanted to show the intimate social interactions between African Americans and Puerto Ricans in Brooklyn by casting Perez, a dancer he met at a party. Next followed a role as Gloria Clemente in Ron Shelton's sports comedy *White Men Can't Jump* (1992) with Wesley Snipes and Woody Harrelson. Gloria was initially written by Shelton as a white southern woman, but Perez made the character her own with the writer/director's approval. Her Gloria dominates the last third of the film.

Refining her image as an activist and outspoken cultural presence in the more recent past, Perez co-hosted *The View* in 2014 and 2015, worked on the Broadway stage, and supports several charitable organizations.

Oscar-nominated actress Rosie Perez in 2019.

PATRICIA CARDOSO

The Colombian-born film director is known for the 2002 landmark HBO film adaptation of Josefina Lopez's stage play *Real Women Have Curves*, starring Lupe Ontiveros and eighteen-year-old America Ferrera in her film debut. The powerful,

heartwarming motion picture is a coming-of-age story representing a mother-daughter relationship in the context of the cultural and societal expectations placed on Latinas. One of the film's highlights is a scene in which the Latina factory workers take their blouses off because of the stifling heat and are empowered with self-acceptance and body positivity by Ferrera as Ana. It was a revelation never before seen on screen in mainstream Hollywood motion pictures. Cardoso told the *Los Angeles Times*, "I was aware that Latinx people were not portrayed in our full experience."[110]

Eighteen-year-old Ana (America Ferrera) is in conflict with her mother, Carmen (Lupe Ontiveros), in Real Women Have Curves.

PATRICIA RIGGEN

The Guadalajara-born director made her Hollywood break-through with *Bajo la Misma Luna / Under the Same Moon* (2007), about a Mexican boy's lone journey to America to reunite with his immigrant mother. She followed with *The 33*

(2015), starring Antonio Banderas, based on the true story of the trapped Chilean miners and

their rescue, and *Miracles from Heaven* (2016), starring Jennifer Garner.

Director Patricia Riggen made her mark at Sundance
with *Under the Same Moon*.

ROBERT RODRIGUEZ

Rodriguez is a groundbreaking Texas-born filmmaker and the most important, successful, and influential Latinx director working in Hollywood as of this writing. His celebrated independent film *El Mariachi* (1992) was made for $7,000,

money he was paid as the subject of a clinical drug trial. It brought the filmmaker to the attention of Hollywood. Fiercely independent, consummately creative, and determined to do things his way, he set up a production facility in Austin, Texas, called Troublemaker Studios. He found kindred spirits in up-and-coming filmmakers Quentin Tarantino and Allison Anders.

Rodriguez's career spans the innovative film hits *Desperado* (1995), *Once upon a Time in Mexico* (2003), *Sin City* (2005), *From Dusk till Dawn* (1996), the Spy Kids franchise (2001–2011), *Machete* (2010), and *Alita: Battle Angel* (2019). He has been instrumental in furthering the careers of such Latinx talent as Antonio Banderas, Salma Hayek, Cheech Marin, Michelle Rodriguez, Jessica Alba, and Alexa Vega. With character actor Danny Trejo in the title role of *Machete* (2010) and its sequel *Machete*

Antonio Banderas and Salma Hayek in Robert Rodriguez's *Desperado*.

Total Filmmaker Robert Rodriguez.

Kills (2013), Rodriguez created the first Latinx action movie hero. Trejo's Machete resonated with Latinx audiences, many of whom identified with his fight for justice in defense of immigrants and the underdog in society. Rodriguez profoundly changed the image of Latinx in Hollywood and found a winning formula of original stories featuring relatable Latinx characters, full of imaginative plotlines and stylistic action. As Rodriquez stated, "You don't have to be British to like James Bond and his adventures."[111] Though it is evident that the Cortez family in the Spy Kids franchise is Latinx, that is not the point of the story or of their existence, though it is very much a part of their characters. Rodriguez has collaborated with James Cameron, Robert De Niro, and Sylvester Stallone, to name just a few who have been drawn to work with the innovative filmmaker.

Latina Protest and Empowerment

Until recent decades, there had been few leading role opportunities for Latin actresses in Hollywood theatrical features. When available, often a white woman in brown face was cast in the role, most notably, Jennifer Jones as the hypersexualized Pearl Chavez in *Duel in the Sun* (1946), the Nordic Ingrid Bergman as the passionate Spanish rebel Maria in *For Whom the Bell Tolls*, and Natalie Wood as the virginal Puerto Rican Maria in *West Side Story* (1961). In the decade leading to the new century in such films as *House of the Spirits* (1993), based on Isabel Allende's novel set in Chile, the principal leading roles were cast with non-Latin Meryl Streep and Glenn Close. *The Perez Family* (1995), about Cuban refugees in Miami, starred Italian American actress Marisa Tomei. As recent as 2001's *A Beautiful Mind*, in an instance of "whitewashing" or "erasure," John Nash's Salvadoran-born MIT-graduate wife Alicia Esther Lopez-Harrison de Larda was portrayed as an all-American girl. Actress Jennifer Connelly won the Best Supporting Actress Oscar for the role opposite Russell Crowe.

In 1992, writer/director Luis Valdez (*La Bamba*) announced he would produce and direct a film from a script cowritten with

Jennifer Jones in brown face as Pearl Chavez in *Duel in the Sun* (1946).

his wife, Lupe Trujillo Valdez, based on the life of Mexican artist and feminist icon Frida Kahlo and her turbulent relationship with her husband, famed Mexican muralist Diego Rivera. *Frida and Diego* was to be a coproduction with New Line Cinema and the Mexican government film producing arm, IMCINE (Instituto Mexicano de Cinematografía).

Actress Laura San Giacomo, of Italian descent and known for her star turn in Steven Soderbergh's Oscar-nominated *Sex, Lies, and Videotape* (1989), was cast as Frida opposite Raul Julia as Diego Rivera. Casting a non-Latina as Frida outraged a group of actresses and artists from the Latino/Latina Hollywood community. They formed an ad hoc committee to publicly denounce such discriminatory Hollywood casting practices with a press conference on August 6, 1992, at the Beverly Hilton Hotel. About a hundred actresses and their supporters attended dressed in traditional Mexican embroidered blouses and ruffled skirts, with their hair up in buns, in homage to Frida Kahlo's iconic style.

According to *Variety* several speakers at the press conference emphasized they were not targeting Luis Valdez or San Giacomo.[112] Their issue was with the practice of denying Hispanics the opportunity to compete for these roles when Latino and Latina actors were denied the chance to audition for and be cast in parts where ethnicity was not a factor.

In an *LA Times Calendar* story, Valdez said the casting of Giacomo was meant to appease New Line Cinema with an established (though relatively unknown) actress, which was necessary because of the difficulty in green lighting movies about Latinos in Hollywood.[113] However, Valdez's own hit film, *La Bamba*, starred the unknown Lou Diamond Phillips, making the argument moot.

It was a self-fulfilling prophecy: there are no bankable Latino/Latina leading stars, but no Latino/Latina actors are given the opportunity to become bankable. Sylvester Stallone with his Italian surname and Arnold Schwarzenegger with his Austrian accent were unknowns with foreign names until the Oscar-winning *Rocky* (1976) and the sci-fi hit *The Terminator* (1984) made them stars. The producers who purchased the *Rocky* script from Stallone wanted to cast a known star in the lead, but Stallone held out for the role. If the public can learn to pronounce Stallone or Schwarzenegger, they can just as well learn Benicio Del Toro, Eva Longoria, and Ana De Armas. Producers took a chance on them, and audiences responded to the films and the stars.

Agent Margarita Martinez, who managed several Latin actors, said that the problem of their underrepresentation in the entertainment industry "is far greater than any one studio or production company." Two days earlier, New Line Cinema announced that the $10 million *Frida and Diego* was no longer "financially viable." The agreement with the Mexican government had not been signed. It was taking much longer than anticipated, and there were play-or-pay deals dependent upon starting production dates that would soon come due. Even though other financing was sought, it never materialized, and the film was never made.

But the reputation and legend of Frida Kahlo continued to grow to almost cult status in the next decade, during which two young Latina stars rose to prominence in Hollywood, Mexican Lebanese Salma Hayek and Puerto Rican Jennifer Lopez. They both recognized the dramatic possibilities in Kahlo's story.

In 1992, beautiful telenovela star Salma Hayek moved to Los Angeles to pursue greater career opportunities and slowly made a name for herself aligning with new directors, including Allison Anders (*Gas Food Lodging*), who cast Hayek in a small role in her first Hollywood film (*Mi Vida Loca*, 1993).

Despite studio opposition to her casting, on the insistence of director Robert Rodriguez, she scored as action heroine Carolina opposite Antonio Banderas in *Desperado*. She then moved on to a stunning appearance opposite George Clooney and Quentin Tarantino in *From Dusk till Dawn* (1996), also directed by Rodriguez, as Satanica, the sexy Aztec snake dancer. She also starred in the romantic comedy *Fools Rush In* (1997).

Hayek had long wanted to star in and produce a biopic on Frida Kahlo. Even though a highly regarded 1987 Spanish-language Mexican film, *Frida*, starring Mexican actress Ofelia Medina, had been made, it was little

Actresses dressed as the iconic Frida Kahlo protest in front of the Beverly Hills offices of New Line Cinema on August 6, 1992.

Salma Hayek as Mexican artist Frida Kahlo, a role that won her a
Best Actress Oscar nomination for the film *Frida*.

seen outside Mexico. Hayek wanted to reach a broader audience with an English-language film highlighting Latin talent.

After numerous deals fell through, with the help of her Mexican connections and the support of successful independent producers and distributor Miramax Films, Hayek produced *Frida* (2002) and played the title role, with respected actor Alfred Molina as Diego. Hayek engaged Broadway visionary Julie Taymor as director and enlisted several Hollywood friends to work on the film, including Antonio Banderas, Edward Norton, and Ashley Judd.

Valdez, in the meantime, had hired producer

Francis Ford Coppola and Jennifer Lopez for his film version, now called *The Two Fridas*, but scheduling conflicts and two competing films on the same subject proved too much for Hollywood. With Hayek's *Frida* already starting production in Mexico City and Lopez dropping out, Valdez's projected production halted again.

Despite production obstacles, many caused by Miramax head Harvey Weinstein, *Frida* was completed and won critical acclaim and financial success. Hayek received an Academy Award nomination in the Best Actress category, the first Latina to be nominated. The film also won Beatrice de Alba an Oscar for Best Makeup.

The promise of the *Frida* protest in 1992 was fulfilled ten years later. It marked the beginning of an era of Latina empowerment and representation that has gone far beyond performers, to include content creators, too. The action shattered barriers and served as a landmark for Latin women in non-stereotypical, nuanced leading roles and secured the box-office bankability of Latina performers as recognized A-list talent.

But there were still unseen barriers. Colombian actress Catalina Sandino Moreno was nominated for a Best Actress Oscar for the title role in the independent film *Maria Full of Grace* (2007). Even though she won this recognition, she continued to be offered stereotypical Latina roles. Mexican actress Adriana Barraza won an Academy Award as Best Supporting Actress in 2007 for her portrayal of a nanny in *Babel* (2006),

yet she has not been able to land mainstream roles in American films and again appeared as an impoverished Mexican woman in *Rambo IV* opposite Stallone. Previously, Argentine Norma Aleandro was honored with an Oscar nomination as Best Supporting Actress for her role as the caretaker of a disabled Mexican-Jewish woman in *Gaby* (1987), but she has been unable to cross over into Hollywood. French Argentinian Berenice Bejo was nominated as Best Supporting Actress for *The Artist* (2011), and before her, Brazilian Fernanda Montenegro won a Best Actress nomination for *Central Station* (1998). Most recently, Kenyan Mexican Lupita Nyong'o won an Academy Award as Best Supporting Actress for *12 Years a Slave* in 2014, but she is viewed as African American and has yet to play an Afro-Latina.

With no prior acting experience, Oaxacan Yalitzah Aparicio became the first Indigenous Mexican woman to receive an Academy Award nomination, in her first film outing, as Best Actress, for her role as Cleo, the live-in domestic worker in Alfonso Cuaron's Oscar-winning *Roma* (2018). Also nominated for *Roma* in the Best Supporting Actress category was Mexican Marina de Tavira. Both these actresses have faced obstacles furthering their screen work in Hollywood because of the extreme limitations posed by ethnic, racial, and cultural representational screen opportunities for foreign actors in current Hollywood productions.

JENNIFER LOPEZ

J Lo is an internationally recognized superstar and an American pop icon. She is a multi-platinum recording artist who brings together Latin, pop, and hip-hop music. She has graced magazine covers the world over and is renowned for her

beauty and glamour. The triple-threat talent and savvy businesswoman is a role model for young women, especially Latinas.

Lopez was born and raised in the South Bronx in New York, the daughter of Puerto Rican parents. She began her professional career as a Fly Girl dancing on the popular comedy-variety TV series *In Living Color* (1990–1994). Lopez made her film debut as the young Maria in Gregory Nava's *My Family/Mi Familia*. Her star-making role came two years later in the title role of *Selena*, as the late, legendary Tejana singer. Since then, she has been on a nonstop upward trajectory, starring in more than thirty feature films, including *Out of Sight* (1998) opposite George Clooney, *Blood and Wine* (1996) with Jack Nicholson, and *An Unfinished Life* (2005), costarring Robert Redford and Morgan Freeman. Lopez starred in and produced such hit films as *Maid in Manhattan* (2002), a fairy tale romance about a Puerto Rican single mother

who works as a maid at a posh hotel; *The Wedding Planner* (2001), in which she played an Italian American; and *Hustlers* (2019), for which she received excellent critical notices as Ramona, a New York City stripper who turns the tables on her wealthy strip club patrons.

Jennifer Lopez became the first Latinx actress paid one million dollars for a movie role for her star-making turn in *Selena*.

CAMERON DIAZ

Diaz was born in San Diego, California, of a Cuban American father, Emilio Diaz, and an Italian, German, and Native American mother, Billie Diaz, in 1972. Her paternal family came to Tampa, Florida, at the turn of the twentieth century

and worked in the cigar-rolling industry. The tall, blonde, blue-eyed Latina began her career as a model and graced the cover of *Seventeen*. She made her striking film debut with no previous acting experience opposite rubber-faced comedian Jim Carrey in the hit supernatural fantasy comedy *The Mask* (1994). She followed with the hits *My Best Friend's Wedding* opposite Julia Roberts (1997), the Farrelly brothers' gross-out comedy, *There's Something About Mary* (1998), and the blockbuster *Charlie's Angels* (2000). She turned in challenging dramatic work in such films as *Being John Malkovich* (1999), *Things You Can Tell by Looking at Her* (2000), and *Vanilla Sky* (2001) with Tom Cruise. She announced her retirement from screen acting in 2018 to concentrate on her marriage and daughter.

Cameron Diaz and Jim Carrey in *The Mask* (1994).

ZOE SALDANA

Saldana starred in one of the most successful films of all time, James Cameron's *Avatar* (2009), as the indigenous Neytiri, and as Gamora in Marvel's *Guardians of the Galaxy* (2014). Before that, she was familiar to audiences as Nyota Uhura, from the

revamped *Star Trek* (2009) film series, and starred in the action film *Colombiana* (2011). Zoe was born in Passaic, New Jersey, in 1973, the daughter of a Dominican father and a Puerto Rican mother. She was raised in Queens, New York, and the Dominican Republic. Returning to New York at seventeen, she joined the Faces Theater Group and the New York Youth Theatre, which led to her being signed by a talent agency. Her early film work includes *Crossroads* (2002) with Britney Spears and *Drumline* (2002) with Nick Cannon.

Zoe Saldana is a science fiction fan favorite, having starred as Neytiri in *Avatar* and *Avatar II* and as Gamora in the Marvel film franchise *Guardians of the Galaxy*, as well as portraying Lt. Uhura in the *Star Trek* film series reboots that began in 2009.

MICHELLE RODRIGUEZ

B orn in San Antonio, Texas, to Dominican and Puerto Rican parents, Rodriguez is best known for her role as Letty Ortiz, the tough, independent girlfriend of Vin Diesel's Dom Toretto in the worldwide hit film franchise *The Fast and the Furious*

(2001–2021). In most of her screen portrayals, Rodriguez has epitomized the attractive, tough, streetwise woman of color. She made her film debut in the critically acclaimed *Girlfight* (2000). Among her other film credits are *Avatar*, *Resident Evil* (2002), *Blue Crush* (2002), *Machete* (2010), and *Widows* (2018).

Michelle Rodriguez stars as Letty Ortiz opposite Vin Diesel's Dominic Toretto in the most ethnically diverse film franchise, *The Fast and the Furious*.

PENÉLOPE CRUZ

Born Penélope Cruz Sanchez in Madrid, Spain, in 1974, she is the first Hispanic actress to win an Academy Award as Best Supporting Actress. She was honored for her portrayal of the tempestuous artist Maria Elena in Woody Allen's Spain-set

comedy *Vicky Cristina Barcelona* (2008). Cruz married her costar, Spanish actor Javier Bardem, in 2010. She was nominated the following year for her role as Ada Albanese in the musical *Nine*, making her only the third actress to be nominated in the same category she won the previous year. Internationally recognized Spanish filmmaker Pedro Almodóvar's *Volver* (2006) provided Cruz with a meaty role as Raimunda, a working-class Spanish woman who is married to an abusive man and will do anything to protect her daughter. Hailed by critics for her work in the film, the actress was nominated for an Academy Award in the Best Actress category.

The Larsen on Film website writes in its review, "Penélope Cruz gives a complicated, peerless performance in Pedro Almodóvar's *Volver*, and she looks like a classic screen goddess doing it."[114] Her screen collaboration with Almodóvar began with *Carne tremula / Live Flesh* (1997), and she received acclaim twenty-five years later for her performance in his *Parallel Mothers* (2021) that led to yet another Academy Award nomination as Best Actress.

Cruz came to the attention of Hollywood at age seventeen in the Oscar-winning 1992 Best Foreign Language Film *Belle Epoch*, as Luz, the lustful youngest of a trio of sisters. Hollywood was unsure of what to do with the Spanish-accented actress. At first, Cruz was typecast as an all-purpose Mexican señorita, even though she was Spanish, in two high-profile modern westerns opposite Hollywood leading men: *All the Pretty Horses* (1998) with Matt Damon and *The Hi-Lo Country* with Woody Harrelson. She played a beautiful Greek peasant in the romantic drama *Captain Corelli's Mandolin* (2001), with Nicolas Cage and Christian Bale. Curiously, all three films found her at the center of a love triangle. Cruz worked opposite Tom Cruise in *Vanilla Sky*, an English-language version of the Spanish film *Abre los ojos / Open*

Penélope Cruz in her Oscar-winning role in *Vicky Cristina Barcelona* (2008).

Your Eyes (1997), in which she starred. The actress costarred opposite Johnny Depp as a drug smuggler's wife in *Blow* (2001).

Cruz, Hayek, Lopez, Saldana, Rodriguez, Diaz, and more, in collaboration with a new generation of leading men—Andy Garcia, Jimmy Smits, Antonio Banderas, Benicio Del Toro, Javier Bardem, and Demián Bichir—have opened doors for subsequent generations of Latinx performers.

A Contemporary Class of Leading Men

A generation of Latin leading men, such as Jimmy Smits, Andy Garcia, Antonio Banderas, Benicio Del Toro, Javier Bardem, and Demián Bichir, are standing on the shoulders of past performers. They are projecting a twenty-first-century modern American Latino identity that sheds most of the old cultural tropes. Traditional roles have been frequently one dimensional, but the new identity represents positive and empowering images that evolve with the growth of the artist.

Movie audiences relate to the subtle strength and vulnerability of this new generation of actors who are educated Americans of Latino descent in modern American society—a society that integrates their talents and portrayals. In many respects they stand above many other leading men on screen. Audiences identify with them not as some kind of cultural stereotype but as multilayered compelling characters.

They are film stars who define a new cinematic image and representation.

Andy Garcia as Vincent Mancini in *The Godfather, Part III*, which earned him a Best Supporting Actor Oscar nomination.

JIMMY SMITS

J immy Smits brings dignity, strength, and charisma to his diverse portrayals on the big screen, television, and stage. He was born in Brooklyn, New York, in 1955 to a Puerto Rican mother and a father from Dutch Surinam. Smits played

businessman Kevin Rosario, Nina's (Leslie Grace) overprotective father in Lin-Manuel Miranda's film adaptation of his award-winning stage musical *In the Heights* (2021), directed by Jon M. Chu.

Smits made his film debut as local drug lord Julio Gonzales in Peter Hyams's buddy comedy *Running Scared* (1986), with Billy Crystal and Gregory Hines. He costarred as Santeria-possessed Detective Tom Lopez in John Schlesinger's *The Believers*, opposite Martin Sheen. He starred as Mexican Revolutionary General Tomas Arroyo in the epic western *Old Gringo* (1989), opposite Hollywood legends Gregory Peck and Jane Fonda. He portrayed the traumatized Jimmy Sanchez in the critically

acclaimed *My Family/Mi Familia*, for which he received an Independent Spirit Award nomination. Smits is best known to sci-fi audiences as Bail Organa, father of Princess Leia I in George Lucas's *Star Wars: Episode II: Attack of the Clones* (2002), *Star Wars: Episode III: Revenge of the Sith* (2005), and *Rogue One* (2016). His other film credits include *Fires Within* (1991) and Carlos Avila's *Price of Glory* (2000).

Smits received an Emmy award for his work as lawyer Victor Sifuentes on the long-running series *L.A. Law* (1986–1992) and was nominated for his portrayal of Bobby Simone on *NYPD Blue* (1994–2004). He was honored with a star on the Hollywood Walk of Fame in 2021.

ANDY GARCIA

W hen the actor was five years old, Garcia fled Castro's Communist Cuba with his family to a new life in Miami, Florida. Garcia has impressed audiences with his eye-catching good looks and sophisticated demeanor in many film acting

roles, and he has expanded his talents as a director and producer. He was nominated for the Best Supporting Actor Oscar for his portrayal of Vincent Mancini, the illegitimate son of the slain Sonny Corleone, in Francis Ford Coppola's *The Godfather: Part III* (1990) opposite Al Pacino. His breakout role in Brian De Palma's *The Untouchables* (1987) as a police officer turned federal agent opposite Sean Connery and Kevin Costner led to Ridley Scott's *Black Rain* (1989), with Michael Douglas, and *Internal Affairs* (1990), opposite Richard Gere. He starred with Meg Ryan in the popular tearjerker *When a Man Loves a Woman* (1992).

The actor formed his own production company, CineSon, in 1991. He made his directorial debut with the acclaimed documentary *Cachao . . . como su ritmo no hay dos*, about the life of Cuban music legend Israel Cachao Lopez. Garcia directed, produced, and starred in *The Lost City* (2005), about pre-Castro Havana featuring Dustin Hoffman and Bill Murray.

He gave a noteworthy performance as District Attorney Casey in Sidney Lumet's *Night Falls on Manhattan* (1996). Garcia also joined George Clooney, Brad Pitt, Julia Roberts, and Matt Damon in the remake of the hit ensemble heist drama *Ocean's Eleven* (2001) and its two sequels as casino owner Terry Benedict. In 2018, he starred in two mature on-screen romances opposite Diane Keaton, as Mitch, the airline pilot she falls in love with in *Book Club* (2018), and as hotel manager Fernando Cienfuegos, who is reunited with an old flame played by the iconic Cher in *Mamma Mia! Here We Go Again* (2018).

ANTONIO BANDERAS

anderas began his career in Spanish cinema with Pedro Almodóvar in 1980. Several collaborations with the director over the years resulted in Banderas receiving an Academy Award nomination and the Best Actor prize at the Cannes Film Festival

for Almodóvar's *Pain and Glory* (2019). Banderas is also well known as the first Hispanic actor to embody the dashing swashbuckling fictional masked hero of old California, Zorro, in two hit films, *The Mask of Zorro* (1998) and *The Legend of Zorro* (2005).

The Spanish-born actor and screen heartthrob first caught the attention of the American public when pop superstar Madonna, who was a fan, featured him in a brief segment of her groundbreaking documentary *Truth or Dare* (1991).

He soon made his Hollywood film debut, in a costarring role as the younger Cuban brother in *The Mambo Kings* (1992), with Armand Assante. He could not speak English at the time but learned his lines phonetically and required a translator on set so the director could give him direction. He soon was seen in such films as *Philadelphia* (1993), with Tom Hanks, and the film adaptation of the worldwide hit Broadway musical *Evita* (1996), starring Madonna, in

which he played Che, a fictionalized incarnation of legendary Argentine doctor turned Cuban revolutionary Ernesto "Che" Guevara. Banderas became an action star with his role of El Mariachi in Robert Rodriguez's *Desperado* and *Once upon a Time in Mexico*. He also portrayed the head of the Cortez family in the hit Spy Kids film franchise, also for Rodriguez.

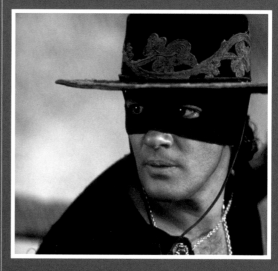

Antonio Banderas was the first Hispanic actor to portray El Zorro, one of the few enduring fictional Latin screen heroes.

BENICIO DEL TORO

The intense, chameleon-like Puerto Rican actor was awarded a Best Supporting Actor Oscar for his multilayered, predominantly Spanish-speaking portrayal of Javier Rodriguez, a conflicted Mexican police officer, in Steven Soderbergh's

Oscar-winning *Traffic* (2000). He was nominated again in the Best Supporting Actor category three years later, for *21 Grams* (2003). Del Toro and Soderbergh collaborated on the long-gestating *Che* (2008), based on the life of Che Guevara, which won Del Toro a Best Actor award at the Cannes Film Festival.

The son of two Puerto Rican lawyers, Del Toro moved with his family to Pennsylvania and, after high school, attended the University of San Diego for a short time before moving to New York to study acting with the legendary acting guru Stella Adler. With his small part as Dario at age twenty-one, he became the youngest Bond henchman in *License to Kill* (1989), his first film. He then portrayed the mysterious Alejandro, a Mexican prosecutor turned avenger in Denis Villeneuve's *Sicario* (2015) and its sequel, *Sicario 2: Day of the Soldado* (2018).

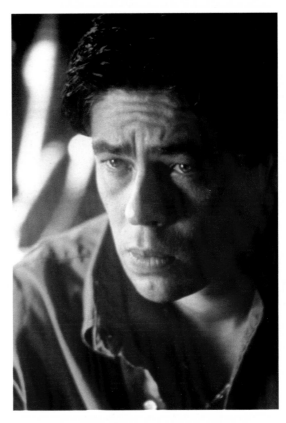

Best Supporting Actor Oscar-winner Benicio Del Toro in *Traffic* (2000).

JAVIER BARDEM

orn in 1969 in Las Palmas de las Canarias, Spain, Bardem hails from a theatrical family long involved in the Spanish film industry. His mother was a well-known actress, and Bardem himself was a major star in his native country before being

recognized by Hollywood. Bardem seriously considered acting as a career when he watched Robert De Niro in *Raging Bull* (1980) on television for the first time.

Years later, in Hollywood, Bardem received an Academy Award nomination for Best Actor in a Leading Role for his portrayal of Cuban poet Reinaldo Arenas in *Before Night Falls* (2000), and the Spanish-language *Biutiful* (2010), directed by Mexican filmmaker Alejandro Gutierrez Iñárritu. Bardem won an Academy Award as Best Supporting Actor for his blood-chilling performance as the psychopathic killer Anton Chigurh in the Coen brothers' *No Country for Old Men* (2007). Bardem costarred with future wife, Penélope Cruz, in Woody Allen's *Vicky Cristina Barcelona* and played the archvillain Raoul Silva, in *Skyfall*, opposite Daniel Craig's superspy James Bond.

Bardem was nominated for an Academy Award for Best actor in 2021 for his portrayal of

the pioneering Cuban-born American television icon Desi Arnaz in the film *Being the Ricardos*.

Javier Bardem in his Best Supporting Actor Oscar-winning role as Anton Chigurh in *No Country for Old Men* (2007).

DEMIÁN BICHIR

The Mexican actor earned an Academy Award nomination as Best Actor for his moving portrayal of Carlos Galindo, an undocumented Mexican immigrant, in Chris Weitz's *A Better Life* (2011).

Weitz is the grandson of pioneering Mexican actress Lupita Tovar and talent agent/producer Paul Kohner. His mother is Academy Award–nominated Best Supporting Actress Susan Kohner (*Imitation of Life*, 1959). Chris and his brother Paul produced the teen comedy *American Pie* (1999), and both were nominated for an Oscar for Best Adapted Screenplay for the film *About a Boy* (2002).

Bichir is from a prominent theatrical family in Mexico and worked primarily in Mexican films and television until the Oscar nomination facilitated a Hollywood and international film acting career.

Demián Bichir, Oscar–nominated Best Actor as an undocumented Mexican immigrant Carlos Galindo in *A Better Life.*

New Visions: Looking Toward the Future

In the second decade of the twenty-first century, Latinx in Hollywood are gaining ever-increasing representation, recognition, and participation in US cinema, with creative control over their narratives in new depictions that have greater cultural significance in global cinema. Latinx writers, directors, and producers acknowledge that the Hispanic and Latinx community has come a long way. But there is still a long way to go.

There have been notable successes. For example, songwriters Robert Lopez and Kristen Anderson Lopez (a married couple) have won two Academy Awards. Their collaboration was rewarded with Oscars for Best Original Song in 2018 for "Remember Me," from Pixar's hit animated movie celebrating Mexican cultural traditions, *Coco* (2017), and before that, for "Let It Go," from the animated feature *Frozen* (2013).

Latinx cinematographers have been recognized for their significant work. Mexican cameraman Emmanuel Lubezki won three consecutive cinematography Oscars, and Guillermo Navarro's photography of *Pan's Labyrinth* won him an Oscar in 2007. Cinematographer Rodrigo Prieto shot the Oscar-winning *Argo* (2012) for Ben Affleck and Martin Scorsese's *The Wolf of Wall Street* (2013).

Ana de Armas as Paloma in *No Time to Die* (2021).

The 2021 Latinx Oscar nominees: Javier Bardem as television icon Desi Arnaz in *Being the Ricardos*, Penélope Cruz as Best Actress for *Parallel Mothers*, Ariana Debose as Anita in *West Side Story*, and director Guillermo del Toro for *Nightmare Alley*.

Filmmakers hailing from Mexico have achieved startling success and influence in Hollywood in recent years, winning several major Academy Awards from 2014 to 2019. It could be said that they dominated the Academy Awards in that period.

Three directors: Guillermo del Toro, Alfonso Cuarón, and Alejandro Gonzalez Iñárritu, known affectionately in the industry as "the Three Amigos," have won a combined eleven Oscars. They represent a new generation of filmmakers born in Mexico City and influenced by Hollywood and global cinema. Their innovative, visionary approach to storytelling created a fresh filmmaking aesthetic.

Iñarritu's influential movies include the international-incident-focused *Babel* (2006) with Brad Pitt and Sandra Bullock; the single-take, continuous illusion of an aging actor's comeback in the Oscar-winning Best Picture *Birdman* (2014), with Michael Keaton;

and the revisionist Oscar-winning western, *The Revenant* (2015), with Leonardo DiCaprio. Iñarritu's breakthrough Mexican film *Amores perros* (2000), about how lives literally and metaphorically collide in contemporary Mexico City, brought him to the attention of Hollywood and influenced the Oscar-winning *Crash*.

Alfonso Cuáron's 2013 big budget science fiction film *Gravity*, with Sandra Bullock and George Clooney, won him the Best Director Academy Award. Cuáron won three Oscars, including Best Director, Best Cinematography, and Best Foreign Language film for his semi-autobiographical film about his Mexico City youth in the '90s, *Roma*. His success at the Oscars that year was a landmark achievement. Although already working in Hollywood since *The Little Princess* (1995), Cuaron made his mark with the Mexico City–set teenage road comedy *Y tu mama tambien* (2001) that also launched Mexican actors Gael García Bernal and Diego

Luna to international stardom.

Guillermo del Toro has established a respected reputation as a fantasy, horror, and action director with such films as *Cronos* (1993), *Mimic* (1997), *Hellboy* (2004), and *Pacific Rim* (2013). His Cold War fish-man romance, *The Shape of Water* won four Oscars. The film was strongly influenced by his childhood memories of the film *Creature from the Black Lagoon*. He garnered worldwide recognition with *Pan's Labyrinth*, a mystical story set against the iron-fisted reality of the Spanish Civil War, which earned three Oscars.

Eugenio Derbez was already famous in Mexico as a comedian, writer, producer, and director before he made his way to Hollywood. His comedy *Instructions Not Included* (2013) became the highest-grossing Spanish-language film in the United States. His Hollywood crossover success followed with two English-language comedies, *How to Be a Latin Lover* and *Overboard* (2018). Derbez expanded his talents with a dramatic role as Bernardo Villalobos, a music teacher to a teenager who is the only nondeaf member of her family in the 2021 Oscar-winning Best Picture *Coda*.

The recent Mexican influence in Hollywood can be traced to 1987's *Gaby: A True Story*, directed by Luis Mandoki, that led to his directing such films as *White Palace* (1990), with Susan Sarandon, and *Message in a Bottle* (1999), with Kevin Costner and Paul Newman.

The unprecedented international success of actor/director Alfonso Arau's independent

Oscar Isaac in *Star Wars: The Force Awakens* (2015).

feature *Like Water for Chocolate* (1992), noted for its visualization of magic realism, made it possible for him to direct *A Walk in the Clouds*, starring Keanu Reeves.

Oscar Isaac, a Latino, is one of the most versatile and sought-after leading actors in films today. Born in Guatemala and raised in Miami, Isaac achieved stardom as resistance fighter pilot Poe Dameron in the Star Wars trilogy of 2015–2019. He followed that achievement with such vehicles a Denis Villeneuve's *Dune* and Paul Schrader's *The Card Counter* in 2021.

Multitalented *Hamilton* juggernaut Lin-Manuel Miranda is a Pulitzer Prize– and Tony Award–winning New York–born Puerto Rican actor, songwriter, producer, and director. He costarred as Jack the lamplighter in *Mary Poppins Returns* (2018), wrote an Oscar-nominated song for the animated feature *Moana*

Best Supporting Actress Oscar winner Ariana De Bose as Anita dances in the "America" musical number in *West Side Story* (2021)

(2016), and brought the film version of his and Quiara Alegría Hudes Tony Award–winning Best Musical *In the Heights* (2021) to the screen, directed by Jon Chu (*Crazy Rich Asians* [2018]). The film featured a predominantly Latinx cast, starring Anthony Ramos in a breakthrough role as Usnavi, plus Melissa Barrera, Leslie Sykes, Olga Merediz, Dascha Polanco, Dafne Ruben Vega, Corey Hawkins, and Jimmy Smits. Miranda made his feature film directorial debut with *tick, tick … BOOM!* (2021) for Netflix and Ron Howard and Brian Glazer's Imagine Entertainment. It stars Andrew Garfield, M. J. Rodriquez, and Vanessa Hudgens in the autobiographical musical story of the late Jonathan Larson, creator of the long-running Broadway show *Rent*.

Miranda was also Oscar-nominated for his musical contributions to Disney–Pixar's Oscar-winning Best Animated feature Encanto (2021). Set in a magical South America, it is the story of the Madrigal family and their daughter, Mirabel. The film features an authentic and diverse level of representation of Colombian culture, which has generally been ignored by Hollywood except in negative screen depictions as a center of drug-cartel violence. The animated characters were brought to life by the voice talents of an all-Latinx cast, led by Wilmer Valderrama, whose mother is Colombian, Colombian-born John Lequizamo,

and Stephanie Beatriz, along with Yvette Merino as a producer and featuring the music of Germaine Franco. The hit film *Encanto* and its *Billboard* number-one-selling soundtrack brought Latin culture to the forefront of American pop culture in much the same way as the animated Oscar-winning Mexico-set Coco had in 2017.

A widely anticipated cinema achievement in 2021 was the Steven Spielberg version of the venerable *West Side Story*. At a preview screening at the Directors Guild of America Theater, Spielberg told the assembled audience, "The original film is an enduring, all-time film classic, while this version of *West Side Story* is for today."[115] Spielberg's *West Side Story*, a musical film reimagining of the classic 1957 stage play and 1961 film, showcases a predominantly Latinx cast, including Rachel Zegler, of Colombian descent, as Maria, David Alvarez as Bernardo, Ariana DeBose as Anita, Josh Andres Rivera as Chino, Ana Isabelle as Rosalia, and, of course, a meaningful role by Rita Moreno as Valentina, the widow of the drugstore owner Doc, who dispenses advice and guidance to the young people. The filmmakers succeeded in depicting a nuanced, authentic view of the Puerto Rican/Nuyorican cultural experience of the 1950s. DeBose, an openly queer Afro-Puerto Rican woman won an Academy Award as Best Supporting Actress (2021) for her vibrant portrayal of Anita, the same role and category Rita Moreno won sixty years earlier.

Cuban American actress Ana de Armas had a breakout role in *Knives Out* (2019) before scoring

Lin-Manuel Miranda, lyricist, composer, actor, director, and Tony- and Pulitzer Prize–winner of stage, film, television. and animation.

a top role as CIA agent Paloma, opposite Daniel Craig as James Bond 007, in *No Time to Die* (2021).

Salma Hayek entered the Marvel Cinematic Universe as the team leader and healer Ajak in *Eternals* (2021), directed by Academy Award winner Chloe Zhao. The film breaks ground with diversity in gender, age, and physical challenges with its multicultural superhero representations. Hayek is one of the few Latinx stars to portray a Marvel superhero. Her character is a maternal figure, initially conceived as a man. In 2021 Hayek startled some fans with her portrayal of fortune teller Pina Auriemma who helps plot a murder in the film *House of Gucci*, a vehicle for Lady Gaga directed by Ridley Scott. Hayek deliberately put on weight for the role to obtain a softer presence.

Afro-Latino director Reinaldo Marcus Green is the son of an African American father and Puerto Rican mother. He was born in the Bronx and graduated from NYU's Tisch School of the Arts. Green won critical acclaim for his second feature film, *King Richard* (2021), starring Will Smith in his Best Actor Oscar–winning role as Richard Williams, the determined father who struggles to see his daughters Serena and Venus triumph in the world of competitive tennis.

Andy Garcia heads a largely Latinx cast in a new version of *Father of the Bride* (2022). This time a Cuban American father is at the center of a family getting ready for their daughter's wedding. The original hit comedy starred Spencer Tracy in 1950, and the second version in 1991 starring Steve Martin was also a hit and spawned a sequel. Actress, producer, and director Eva Longoria (*The Sentinel* [2006] and *Dora and the Lost City of Gold* [2019]), a native of Corpus Christi, Texas, made her feature film directorial debut with *Flamin' Hot* (2022), the story of Mexican American Richard Montanez, the self-proclaimed inventor of the Flamin' Hot Cheetos brand who rose from janitor to corporate executive.

Newcomer Xolo Madriidueña is set to star in Warner Bros and DC Comics first Latin super hero film *The Blue Beetle* (2023) in which he plays Jaime Reyes, a Mexican American teen from El Paso, Texas, who is accidentally fused with an alien beetle that gives him extraordinary powers. The film is directed by Angel Manuel Soto.

Michael Peña, a Mexican American actor born and raised in Chicago by immigrant

Chilean-born actor Pedro Pascal (*Wonder Woman 1984* [2020], Disney's *The Mandalorian* [2019], Netflix's *Narcos* [2015]) plays Javi Gutierrez opposite Nicolas Cage in *The Unbearable Weight of Massive Talent* (2022).

parents, is one of the busiest Latinx actors in cinema. He had significant roles in the Oscar-winning films *Million Dollar Baby* and *Crash*, and went on to costar in *End of Watch* (2012), the first Latino/Anglo cop buddy film, and *Fury* (2014). The actor portrayed the late labor leader Cesar Chavez in *Chavez* (2014). He is most recognized for his costarring role as IT expert Luis in *Ant Man* (2015) and its sequel, *Ant Man and the Wasp* (2018). Peña was also part of a significant achievement in 2019: he headed an all-Latino cast in the warmhearted *Dora and the Lost City of Gold*, a family film that was the product of empowered Latino creativity. He also starred in the feature reboot of *Fantasy Island* (2019). Peña told NBC News, "The opportunities I have right now are better than when I started acting. And it feels good to be part of a generation that's making some changes."[116]

Michael Peña in many respects is the artistic beneficiary of the decades-long trajectory created by a constellation of Latino and Latina actors, writers, directors, producers, and craftspeople—and those who supported them—in the Hollywood film industry. He has worked diligently on his craft, and he was gifted with talent, no doubt, and luck. But, unmistakably, he benefited from the work of predecessors who opened doors of opportunity. He has been able to play a variety of roles—emancipated from the shackles of typecasting. Peña acknowledges that his success is built upon those that laid the groundwork for today's artists.

Hollywood motion pictures today such as The Fast and the Furious franchise, *Black Panther, Shang Chi, Dora and the Lost City of Gold, In the Heights*, and *West Side Story* are more inclusive than ever, moving further toward reflecting the diverse multiethnic population of the United States and the world, providing new cultural perspectives. Disparate cultures, religion, and languages can be affirmed in a film marketplace that is allowing for broader storytelling that tries to correct past stereotypes and misrepresentations.

The Latinx community is a vital part of the ongoing process of screen representations in shaping how the community sees, defines, and identifies itself. In addition such changes have an impact on the global community. And these changes are sure to become more profound as technology evolves and most assuredly affects Hollywood movies. Digital technology is making stories told with moving images more accessible—both in the production and distribution of product.

The global rise of streaming services, cable, social media, and broadcast platforms is shifting the Hollywood business model and creating a massive demand for content, thus allowing for new narratives and new opportunities for Latinx creative talent in bringing to the screen previously underrepresented characters and stories.

Linda Yvette Chavez, cocreator with Marvin Lemus of Netflix's Latinx dramedy *Gentefied*, which originated as a web series, summed up the accomplishments of Latinx talent: "We may never see how deep the work goes or how far it reaches, what seeds we planted for change in the world, but we do the work anyway—whether it was a face rarely if ever seen on screen, a director of color not often seen on set, a department head not often given the chance to lead, or a writer empowered and given their first credit.... Those seeds blossomed and reached millions around the world."[117]

Latinx artists both in front of and behind the cameras are committed to creating entertaining, compelling stories, unforgettable characters, and indelible images of humanity that will bring a greater understanding of the society and the world we live in. They have a long history in the evolving art of motion pictures since its inception and are taking a more prominent place in the present and future of Hollywood and the world's cinematic landscape.

Notes

CHAPTER 1: LATIN AND HISPANIC FILM ORIGINS: HOW IT ALL BEGAN

1. Marilyn Ann Moss. *Raoul Walsh: The True Adventures of Hollywood's Legendary Director* (Lexington: University Press of Kentucky, 2012), pp. 82, 83.

CHAPTER 2: MATINEE IDOLS, LATIN LOVERS, AND DANCING SENORITAS

2. Louis B. Mayer [*Los Angeles Times*] Dec 14, 1924, from the Academy Margaret Herrick Library, Los Angeles, CA.

3. James Kotsilibas-Davis and Myrna Loy, *Myrna Loy: Being and Becoming* (Donald I. Fine, Arbor House, New York, 1988).

4. George Pratt Eastman House audio interview with Ramon Novarro, 1958.

5. Roland interview, *TV Guide*, November 22, 1975.

6. Roland interview with author

7. *Ibid.*

8. *Ibid.*

9. *Ibid.*

10. *Ibid.*

11. Mordaunt Hall [*New York Times*], *Ramona* Film Review, May 15,1928.

12. San Francisco International Film Festival, Dolores del Rio in person tribute remarks October 11, 1981.

13. Dolores del Rio as quoted in *More Fabulous Faces*: Larry Carr, Doubleday, Garden City, NY, 1979, p. 32. Hollywood Dream Factory: [*La Opinion*] Spanish Language Newspaper, Los Angeles, January 23, 1929. Translated by author from Spanish.

14. Pinterest, Old Hollywood Happiness.

15. Bob Thomas [Associated Press] interview, 1960, with Dolores del Rio on set of *Flaming Star*.

16. Edwin Schallert [*Los Angeles Times*], *Gaucho* film review, November 7, 1927.

17. Frank Nugent, Playing at Teatro Hispano. La Zandunga film review [*New York Times*] May 14, 1938.

18. La Zandunga, [*El Universal*] Mexico City, Lupe Velez Press interview March 18, 1938, translated from Spanish by author.

19. William McKinley [*Cinematic Insane Blog*] November 26, 2012.

20. Kristy A. Rawson, A Trans-American Dream: Lupe Velez and the Performance of Transculturation; Doctorate, University of Michigan, 2012.

21. Michelle Vogel, *Lupe Velez: The Life and Career of Hollywood's Mexican Spitfire* (McFarland Press, 2012).

22. Peter J. Oppenheimer, Rita Hayworth: Still Beautiful [*Family Weekly*], March 1, 1964.

23. *Hollywood Reporter, Blood and Sand* Review, Dec. 31, 1940.

24. John Howard Reid, Hollywood Gold: Films of the Forties and Fifties, Lulu.com, 2005, p. 231.

25. Fred Astaire, *Steps in Time: An Autobiography* (Harper & Brothers, New York 1959).

26. Peter Ford, *Glenn Ford: A Life* (Don Jose) (University of Wisconsin Press, 2011).

27. *Variety, Miss Sadie Thompson* Film Review 1954.

28. John Hallowell [*New York Times*], Rita Hayworth interview, October 25, 1970.

29. Howard Thompson [*New York Times*], *Money Trap* film review, May 5, 1966.

CHAPTER 3: TUTTI FRUTTI HATS AND GOOD NEIGHBORS: HOLLYWOOD GOES LATIN FOR WORLD WAR II

30. [*The Times of London*] Miranda interview, April 24, 1948.

31. [*New York Press Telegram*], Miranda New York arrival press remarks. May 18, 1939.

32. That Night in Rio, *Variety* review, December 31,1940.

33. Cesar Romero "reflection" interview with author, 1992.

34. Romero interview with author, 1992.

35. *Ibid.*

36. *Variety*, *Captain from Castille*, film review 1947.

37. Romero interview with author 1992.

38. Bosley Crowther [*New York Times*], *Oceans 11* film review, August 11, 1960.

39. Bruce Bigelow [*Associated Press*], "Said Romero" in a June 22, 1989, interview.

40. Romero interview with author, 1992.

41. Montez, Maria, "Getting to Hollywood: a career within itself" [*Atlanta Journal-Constitution*], September 19, 1944.

42. Jerry Mason, Fair and sultry Maria Montez has changed in the last year [*Los Angeles Times*], March 12, 1944, F15.

43. Douglas McClelland, Forties Film Talk (McFarland, Jefferson, North Carolina), p. 134.

44. [*New York Times*], film review *A Song to Remember*, January 26, 1945.

45. Xavier Cugat Obituary [*Los Angeles Times*], October 28, 1990, Cugat quoted from a 1960 interview.

46. *Ibid.*

47. *Ibid.*

48. Edwin Schallert, Lina Romay: Former singer looks forward to screen acting career [*Los Angeles Times*], December 23, 1945.

49. Lina Romay obituary [*Los Angeles Times*], December 20, 2010.

50. Steven Jay Rubin, *The Complete James Bond Movie Encyclopedia* (McGraw-Hill, New York, 1995),Terrence Young interview, *From Russia with Love*.

CHAPTER 4: PRESENT AND ACCOUNTED FOR: HOLLYWOOD FILM CLASSICS

51. Marcel Delgado interview conducted August 16, 1970, with Jim Lane, posted in Cinedrome website May 16, 2010.

52. Montalban interview with author.

53. Bosley Crowther [*New York Times*], film review, *The Treasure of the Sierra Madre*, January 24, 1948.

54. [*New York Times*], July 6, 2002 [Associated Press], Katy Jurado 78, Mexican Star who appeared in *High Noon*, section A, p. 14 "Jurado told reporter in 1952".

55. *Variety, High Noon* film, review April 29, 1952.

56. [*Los Angeles Times*] quoted her as saying in her obituary [*Associated Press*] "I didn't take shallow, American stereotypes of Mexicans."

57. Travilla as quoted in GlamAmor Website by film and fashion historian Kimberly Truhler, interview with Kimberley Ashley, Travilla biographer, December 3, 2013.

58. Henry Ginsberg interview on *Giant* [Condo News], Palm Beach, Florida, 1973.

59. Victor Millan interview, 1994 interview with author.

60. Hector Galan, Children of Giant, Texas Public Radio interview Tom Michael, Marfa's Mexican Americans remember *Giant* and Texas segregation, April 24, 2015.

61. Francisco "Chico" Day interview with author, 1985.

62. Victor Millan interview with author *Touch of Evil* 1994.

63. *Rio Bravo* interview Pedro Gonzalez Gonzalez with author, 1993.

64. John A. Alonzo quote cited in Internet Encyclopedia of Cinematography and Cinematographers.

CHAPTER 5: POSTWAR SOCIAL
PROBLEM FILMS AND EMERGING STARS (1945–1965)

65. *TV Guide* interview January 24–30, 1970, pp. 10–12.

66. Interview with author 1981, 1995.

67. Interview with author 1981, 1995.

68. *TV Guide* interview January 24–30, 1970, pp. 10–12.

69. Interview with author 1981, 1995.

70. Christopher Null, *Star Trek: The Wrath of Khan* FilmCritic.com July 28, 2002.

71. Pauline Kael [*New Yorker*] *Star Trek: Wrath of Khan,* film review, June 7, 1982.

72. Anthony Quinn interview with author, 1981, 1985.

73. *Ibid.*

74. *Ibid.*

75. *Ibid.*

76. *Ibid.*

77. *Ibid.*

78. *Ibid.*

79. *Ibid.*

80. A. H. Weiler, La Strada [*New York Times*], film review, July 1, 1956.

81. Anthony Quinn interview with author, 1981, 1985.

82. *Ibid.*

83. Rita Moreno interview with author 1995, 2000.

84. *Ibid.*

85. *Ibid.*

86. *Ibid.*

87. Rita Moreno Q&A, Her career from Puerto Rico to Hollywood, Elisa Lichtenbaum, September 10, 2021, American Masters PBS website, Rita Moreno: Just a Girl who decided to go for it.

88. Brian Miller, KSN.com, June 27, 2015

89. [*Los Angeles Times*] Ramona Pageant 1959, quote as Raquel Tejada.

90. Raquel Welch, *Raquel: Beyond the Cleavage,* Weinstein Books, 2010 N.Y., pp. 38–40.

91. [*Associated Press*], Raquel Welch wins 10.8 million Judgment, June 24, 1986.

92. Raquel Welch, *Raquel: Beyond the Cleavage*, Weinstein Books, 2010 N.Y., pp. 6, 7.

93. Edwin Tamara, Fox News, June 28, 2015. Associated Press, Raquel Welch talks about her Hispanic heritage and pride in being a Latina.

CHAPTER 6: TURBULENT TIMES: THE '60S AND '70S.

94. Edward James Olmos, interview with author, 2010, 2020.

95. Ricardo Montalban interview with author 1980, 1995. Ricardo Montalban *TV Guide* interview, January 24–30, 1970, pp. 10–12.

96. Martin Sheen Youngstown University Lecture, October 16, 2019.

97. Martin Sheen, National Public Radio interview. August 21, 2001.

98. Jack Kroll reporting for *Newsweek* magazine, Cannes Film Festival, May, 1981.

99. Pauline Kael [*New Yorker*], *Moscow on the Hudson*, film review, April 16, 1984.

CHAPTER 7. AUTHENTIC VOICES: HOLLYWOOD REIMAGINES LATINOS

100. Luis Valdez interview with author, 2011.

101. Valdez comments to American Film Institute Seminar, May 13, 1987.

102. *Ibid.*

103. NBC News Latino, *La Bamba* at 30, Director Luis Valdez, Esai Morales Talk, July 31, 2017.

104. Yolanda Machado [*New York Times*], *La Bamba* and the Lives It Changed, May 3, 2021.

105. Rita Kempley [*Washington Post*], *Stand and Deliver* film review, April 15,1988.

106. Janet Maslin, [*New York Times*], *Stand and Deliver* film review, March 18, 1988.

107. *People* Magazine, April 18. 1988.

108. Aaron Aradillas, Roger Ebert.com, The Story of who we are: Gregory Nava helps celebrate Selena's 50th Birthday, April 16, 2021.

109. Elaine Liner [*Corpus Christi Caller Times*], *Selena* Writer-Director tells story his way, March 10, 1997.

110. [*Los Angeles Times*], Real Women Have Curves Now landmark, September 7, 2021.

111. [*Indie Wire*], Comic Con @ Home, directors on directing panel, July 23, 2020.

CHAPTER 8: LATINA PROTEST AND EMPOWERMENT

112. Marc Berman *Variety*, Latinos decry H'w'd casting practices, August 7, 1992.

113. David J. Fox [*Los Angeles Times Calendar*], Frida Movie will be made vows Valdez, August 7, 1992.

114. Josh Larsen, Larsen on Film website, *Volver* review, July 20, 2014.

CHAPTER 10: NEW VISIONS: LOOKING TOWARD THE FUTURE

115. Steven Spielberg *West Side Story* screening and discussion at the Directors Guild screening, December 5, 2021.

116. NBC News Latino: Michael Pena: One of Hollywood's Most Visible Latinos, February 14, 2020.

117. Rick Porter, *Hollywood Reporter*, Linda Yvette Chavez *Gentified* co-creator on cancellation, January 14, 2022.

Bibliography

Adams, Les and Rainey Buck. *Shoot-Em-Ups* (Arlington House Publishers, NY, 1978).

Agnew, Jeremy. *The Creation of the Cowboy Hero* (McFarland Press, NC, 2015).

Arce, Hector. *Gary Cooper: An Intimate Biography* (William Morrow, NY, 1979).

Astaire, Fred. *Steps in Time* (Harper, NY, 1959).

Benshoff, Harry M., and Sean Griffin. *America on Film: Representing Race, Class, Gender and Sexuality at the Movies* (Blackwell, NY, 1986).

Berg, Charles Ramirez. *Latino Images in Film: Stereotypes, Subversion & Resistance* (University of Texas Press, Austin, Texas, 2002).

Bergan, Ronald. *The United Artists Story* (Crown, NY, 1988).

Boetticher, Budd. *When in Disgrace* (Neville Press, Santa Barbara, CA, 1989).

Brothers, Caroline. *War and Photography: A Cultural History* (Routledge, London, 1997).

Brownlow, Kevin. *The War, the West and the Wilderness* (Alfred A. Knopf, NY, 1978).

Buford, Kate. *Burt Lancaster: An American Life* (Alfred A. Knopf, NY, 2000).

Buhle, Mary Jo, et al., eds. *Encyclopedia of the American Left* (University of Illinois Press, Urbana, 1992).

Buscombe, Edward. *The BFI Companion to the Western* (Atheneum, NY, 1988).

Callow, Simon. *Orson Welles. Volume 2: Hello Americans* (Viking Press, NY 2006).

deMorales, Margarita Vicens. *Maria Montez: Su vida* (Editora Corripio, Coral Gables, Florida 2003).

De Usabel, Gaizika. *The High Noon of American Film in Latin America* (UM Research Press, Ann Arbor, 1982).

Douglas, Kirk. *The Ragman's Son* (Simon & Schuster, NY, 1988).

Eames, John Douglas. *The MGM Story* (Crown, New York, NY, 1976).

Eames, John Douglas. *The Paramount Story* (Simon & Schuster, NY, 1987).

Eyman, Scott. *John Wayne: The Life and Legend* (Simon & Schuster, NY, 2014).

Eyman, Scott. *Print the Legend: The Life and Times of John Ford* (Simon & Schuster, NY, 2007).

Fine, Marshall. *Bloody Sam: The Life and Films of Sam Peckinpah* (Donald L. Fine, NY, 1991).

Ford, Peter. *Glenn Ford: A Life* (University of Wisconsin Press, Milwaukee, 2011).

Gallagher, Tag. *John Ford: The Man and His Films* (University of California Press, Los Angeles, CA 1986).

Green, Douglas B. *Singing in the Saddle: The History of the Singing Cowboy* (Vanderbilt University Press, Nashville, TN, 2005).

Hall, Linda B. *Dolores del Rio: Beauty in Light and Shade* (Stanford University Press, Stanford, CA, 2013).

Hammen, Scott. *John Huston* (Twayne, Boston, 1985).

Hanson, Peter. *Dalton Trumbo, Hollywood Rebel* (McFarland, Jefferson, NC, 2003).

Heston, Charlton. *The Actor's Life* (E. P. Dutton, NY, 1976).

Hirshhorn, Clive. *The Columbia Story* (Crown, New York, NY 1979).

Huston, John. *An Open Book* (Alfred A Knopf, NY, 1980).

Isaac, Alberto. *Conversaciones con Gabriel Figueroa* (Universidad de Guadalajara y Colima, 1993).

Janis, Maria Cooper. *Gary Cooper off Camera: A Daughter Remembers* (Harry N. Abrams, NY, 1999).

Kagan, Norman. *The Cinema of Oliver Stone* (Continuum, NY, 1995).

Kaminsky, Stuart. *John Huston: Maker of Magic* (Houghton-Mifflin Company, Boston, 1978).

Kazan, Elia. *Elia Kazan: A Life* (Da Capo Press, Boston, NY, 1997).

Keenan, Richard C. *The Films of Robert Wise* (Scarecrow Press, Lanham, Maryland, 2007).

Knowles, Mark. *The Man Who Made the Jailhouse Rock: Alex Romero, Choreographer* (McFarland Press, Jefferson, NC, 2013).

Leemann, Sergio. *Robert Wise on His Films* (Silman-James Press, Beverly Hills, CA, 1995).

Long, Robert Emmett. *John Huston: Interviews* (University Press of Mississippi, 2001).

Maltin, Leonard. *The Disney Films* (Crown, NY, 1977).

Marin, Cheech. *Cheech Is Not My Real Name . . . But Don't Call Me Chong!* (Grand Central, NY, 2017).

McBride, Joseph. *Hawks on Hawks* (University of California Press, Berkeley, Los Angeles, 1982).

McKibben, Carol Lynn. *Beyond Cannery Row: Sicilian Woman, Immigration and Community* (Urbana, University of Illinois Press, 2006).

Meyers, Jeffrey. *John Huston: Courage and Art* (Crown, NY, 2001).

Miller, Arnold. *The Films of Robert Aldrich* (University of Tennessee Press, Knoxville, 1986).

Mirisch, Walter. *I Thought We Were Making Movies, Not History* (University of Wisconsin Press, 2008).

Mizruchi, Susan L. *Brando's Smile* (Norton, London, 2014).

Montalban, Ricardo, with Bob Thomas. *Reflections: A Life in Two Worlds* (Doubleday, Garden City, NY, 1980).

Mora, Carl J. *Mexican Cinema: Reflections of a Society 1896–2004* (University of California Press, 2005).

Moss, Marilyn Ann. *Raoul Walsh: The True Adventures of Hollywood's Legendary Director* (University of Kentucky Press, 2011).

Peros, Mike. *Jose Ferrer: Success and Survival* (University of Mississippi, Jackson, 2020).

Pilcher, Jeffrey M. *Cantinflas and the Chaos of Mexican Modernity* (Rowman and Littlefield, 2000).

Pippins, Jan, and Henry Darrow. *Henry Darrow: Lightning in a Bottle* (Bear Manor, Oklahoma, 2013).

Pratley, Gerald. *The Cinema of John Huston* (Barnes, NY, 1977).

Quinn, Anthony. *One Man Tango* (HarperCollins, NY, 1996).

Railsback, Brian, and Michael J. Meyer. *A John Steinbeck Encyclopedia* (Greenwood Press, Westport, CT, 2006).

Reyes, Luis, and Peter Rubie. *Hispanics in Hollywood: A Celebration of 100 Years in Film and Television* (Lone Eagle, Hollywood, 2000).

Rivera, Miluka. *Legado Puertorirqueno en Hollywood* (Kumaras, Burbank, CA, 2010).

Rubin, Steven Jay. *The Complete James Bond Movie Encyclopedia* (McGraw Hill, New York, NY, 2002).

Seydor, Paul. *Peckinpah: The Western Films* (Urbana, University of Illinois Press, 1980).

Schickel, Richard. *Elia Kazan* (HarperCollins, NY, 2006).

Soares, Andre. *Beyond Paradise: The Life of Ramon Novarro* (St. Martin's Press, New York, 2002).

Taymor, Julie. *Frida: Bringing Frida Kahlo's Life and Art to Film* (Newmarket Press, NY, 2002).

Tunon, Julia. *Los rostros de un mito: Personajes femininos en las peliculas de Emilio "Indio" Fernández* (Conaculta y Dirrecion General de Publicaciones, IMCINE, Mexico 2000).

Vogel, Michelle. *Lupe Velez: The Life and Career of Hollywood's "Mexican Spitfire"* (McFarland Press, NC, 2012).

Wallach, Eli. *The Good, the Bad and Me* (Harcourt, NY, 2005).

Welch, Raquel. *Beyond the Cleavage* (Hachette, NY, 2010).

Acknowledgments

Luis Torres, Martin Blythe, Jan Pippins, Nancy De Los Santos, and Sloan De Forest, who edited, guided, and vetted the initial manuscript.

Angie Macias Mendez and the staff of the South El Monte Library of Los Angeles County.

Academy of Motion Pictures, Margaret Herrick Library.

Leticia Gomez of Savvy Literary, Satir Gonzalez, Ysenia Ramirez, Andy's Coffee Shop, Pasadena, CA, Bel Hernandez / Latin Heat, Jeff Jarrett, Eddie Muller, Jesus Trevino, Rob Word: A Word on Westerns.

From Turner Classic Movies: Pola Changnon, Genevieve McGillicuddy, Heather Margolis, John Malahy, Susana Zepeda Cagan, Eileen Flanagan, Taryn Jacobs, Wendy Gardner, and Aaron Spiegeland.

From Running Press: Cindy Sipala for her dedication and masterful editorial skills and guidance, Amanda Richmond for her design work, Fred Francis, Kristin Kiser, Seta Zink, Katie Manning.

Index